Designing Your Future

Library of Congress Cataloging-in-Publication Data
Beacham, Cindy V.
 Designing your future : an introduction to career preparation and professional practices in interior design / Cindy V. Beacham, Barbara S. McFall, Shari Park-Gates.
 p. cm.
 Includes bibliographical references and index.
 ISBN 0-13-155280-5
 1. Interior decoration—Vocational guidance. 2. Interior decoration–Practice.
I. McFall, Barbara S., 1948– II. Park-Gates, Shari. III. Title.

NK2116.B43 2007
729.023—dc22 2007006168

Editor-in-Chief: Vernon R. Anthony
Acquisitions Editor: Jill Jones-Renger
Editorial Assistant: Doug Greive
Managing Editor-Production: Mary Carnis
Production Liaison: Janice Stangel
Production Editor: Linda Zuk, WordCraft, LLC
Manufacturing Manager: Ilene Sanford
Manufacturing Buyer: Cathleen Petersen
Senior Marketing Manager: Leigh Ann Sims
Marketing Coordinator: Alicia Dysart
Marketing Assistant: Les Roberts
Senior Design Coordinator: Miguel Ortiz
Director, Image Resource Center: Melinda Patelli

Manager, Rights and Permissions: Zina Arabia
Manager, Visual Research: Beth Brenzel
Manager, Cover Visual Research & Permissions: Karen Sanatar
Image Permission Coordinator: Ang'john Ferreri
Cover Design: Geoff Cassar, Koala Bear Design
Cover Image: Getty Images/Stockbyte (Royalty Free)
Composition: Aptara, Inc.
Printer/Binder and Cover Printer: R. R. Donnelley & Sons, Harrisonburg, VA

10 9 8 7 6 5 4 3 2 1
ISBN-10: 0-13-155280-5
ISBN-13: 978-0-13-155280-7

Designing Your Future

An Introduction to Career Preparation and Professional Practices in Interior Design

Cindy V. Beacham
West Virginia University

Barbara S. McFall
West Virginia University

Shari Park-Gates
Auburn University

Upper Saddle River, New Jersey 07458

Brief Contents

Contents

Profile: Ingvar Kamprad 298

Preface

Every profession has resources, both written and oral, that address its professional issues. Interior design is no exception. Our profession is becoming more visible to the public, and with that visibility comes more responsibility and accountability for the work we do and the decisions we make. National certification is an important component of design today, and many states within the United States are following suit and creating a state certification process in addition to our NCIDQ exam. As a result, a thorough knowledge and understanding of professional practices is important.

Simply reading a book and passing specific assessment requirements, however, cannot complete a designer's knowledge about the profession. Graduating design students and design professionals within their first years of work must benefit from the experience of those around them. To do this, they must first find and choose good jobs that fit with their interests, strengths, and personal requirements.

The book in your hands is unique in that it not only discusses pertinent business information important to new designers, but also helps you have a greater understanding of yourself and how your unique approach to, and interest in, design must guide you in your career choices. *The purpose of this book is to set you up for success*. We are all capable of success, but we must put ourselves in positions that support and enhance our talents instead of magnifying our challenges. This book, unlike other interior design professional practices books, will help *you*, the unique and individual reader, understand yourself a little better and how you fit into the profession with its many opportunities. We do present the traditional business information and mechanics of getting a job, but *you* are a major part of the equation. Hopefully you will enjoy this work, and it will be beneficial to you as you begin your journey into the wonderful profession of interior design!

INTENDED AUDIENCE

Awareness of our target audience was paramount in the planning and writing of this book. We have defined the audience as interior design students preparing for their first professional positions and early design professionals striving to survive and succeed in their first five years of practice. Our goal is to provide a strong foundation to build on that will lead to your ultimate personal and professional success.

This book is appropriate for use in a variety of interior design courses, including introductory design classes, career preparation courses, and professional practices courses. The class is anticipated to be a one-semester, three-credit-hour course accomplished in approximately 15 weeks, but the book can be modified to work within a quarter system by covering a chapter weekly.

We assume that you have been involved in some studio courses and have at least a preliminary understanding of design vocabulary. These initial experiences provide a basis for evaluating professional options and exploring personal preferences. The book is not limited to classes offered in the later years, however. By focusing more closely on the early chapters as a foundation for design decisions and reviewing the final chapters in less detail, the book is appropriate for use in courses offered early in your academic career.

TEXTBOOK ORGANIZATION

The text is organized to allow you to build a knowledge base and greater personal understanding as you move through the information and activities. Chapters 1 through 4 provide a unique foundation for the remainder of the book by establishing the personal characteristics you bring to your professional journey. Chapters 5 through 7 discuss traditional and nontraditional methods of finding appropriate employment situations and moving through the process of securing a position. Chapters 8 through 10 focus on the job expectations, ethics, and professional matters you will face during the first years of your career. Finally, Chapter 11 provides a "launching pad" from which to plan a career path and a strategy for moving toward your unique professional goals.

FEATURES

Throughout the book we have provided consistent features to help both students and instructors get the most out of each chapter.

- The chapters begin with an introduction to the material being addressed, followed by specific objectives.
- The text is supplemented with illustrations and photographs to clarify meaning.
- We have included professional profiles or descriptions of successful professionals and the work they perform to further demonstrate points made within the chapter.

In addition to the text, an Instructor's Guide is available online that provides additional resources to aid in the teaching of the course. These include:

- PowerPoint presentation formats for each chapter. These are meant to act as a base and be modified by instructors to suit individual teaching approaches.

- Additional explanations of approaches (e.g., PRSM) and teaching suggestions for each chapter.

- A continually expanding database of support materials for use as examples in classroom instruction.

ACKNOWLEDGMENTS

The authors want to thank everyone involved in supporting us throughout this writing and publishing process. Many people contributed to the work, and we could not have done it without them. We thank Ray Mesing from Prentice Hall for initially recruiting us to publish the book through Prentice Hall and for his continued support throughout the process. We also thank Vern Anthony for trusting us enough to sign a contract for our first published book. Finally, we want to thank Margaret Lannamann for stepping in pretty late in the project to walk us through the end process and for paying attention to our needs and unending requests.

Cindy Beacham

The support I received from my fellow authors, family, and friends has been unwavering throughout the project. Even in my most demanding times, we managed to make it through with minimal conflict! Thank you, Barb and Shari, for hanging in there and making this work. I also want to acknowledge several professionals who provided input and feedback to ensure that the information in the book truly reflects current professional expectations. These people include Craig Davis, AIA from GBD Architects, Inc. in Portland, Oregon; Dave McDonough from Hospitality Design Group in Elk Grove Village, Illinois; Steven Hefner, ASID, IIDA, from DesignWorks Limited in Delray Beach, Florida; and Jim Susman from STG Architects in Austin, Texas. On a more personal note, I want to thank my beloved husband Neal, who models love and possibility thinking for me every day of our lives together—this work would not have been possible without his never-failing love and confidence. And finally, I want to thank my parents, who have never let me

believe anything short of "I can do it"; Kim, who has always been there to celebrate accomplishments and cheer me on; and Emily, who is always a part of everything I do.

Barbara McFall

Special thanks go to the students in the Professional Practices for Interior Design class at West Virginia University, fall 2005, for their pioneering use of the initial draft of this text, and to the following very special students, who provided in-depth, chapter-by-chapter reviews. Their engagement ensured a consistent student focus and relevance that would have been impossible to achieve otherwise.

Courtney Benedum
Farrah Davis
Jillian Dorsey
Susan Nicole Emerick
Erin Gernerd
Sarah Guenther
Heather Jessness
Brittani Kokot
Stephanie Lang
Claire Paul
Lisa Perry
Lara Pitrolo
Kerri Radabaugh
Natalie Stockman
Sarah Vesneske
Lauren Williams

It has been a privilege to work with friends as well as colleagues on this project. The three of us were graduate students together. Special thanks go to Cindy, who has been the driving force that made this book possible. As always, I am indebted to my husband Bob, who provides the loving and peaceful life space in which I work, and to my treasured friends and family. You know who you are. Special thanks are due to my beloved mentors, Dr. Joe Germana and Dr. Bela Banathy, who guided the development of the Personal Resource Systems Model (PRSM). Thank you.

Shari Park-Gates

Thank you, Cindy and Barbara, for the dedication you have had for this project. Cindy, you have been the rock through all of this, and without you the book may never have materialized. I remember talking about this book when we were in graduate school, but you were the one who instigated this adventure and the one who constantly energized and reenergized all of us. I would also like to thank my former classmate, Julie Pollack, who helped find suitable interiors for the full-page photographs used in the book, and my son Brian, who photographed those interiors. It was wonderful to reconnect with Julie and a delight to work with Brian. I would like to acknowledge Mary Beth Robinson and Dr. Mary Jo Hasell, who offered valuable assistance in finding examples of student portfolios. Megan Monahan and Stephen Shutts were extremely helpful in finding the visuals that were used throughout the chapters, and I appreciate their efforts. In addition, I would like to thank mentors Joellen Kerr, Anna Marshall-Baker, Jeanette Bowker, and Eric Wiedegreen. I owe a thank-you to my faithful Friday night cheerleaders Jeannie, Bill, Peggy, John, and my trusted friend Diane Phillips. My children, Jane-Kelli and Brian, who have encouraged me and surrounded me with laughter, love, and the best of times, are a part of everything in my life, including this book. I am indebted to my mother, who is my hero and my inspiration, and also to my father, my sisters Barb and Jean, and my brother Donnie, for their unconditional love. Finally, I would like to thank Tom and dedicate this book to my students.

Designing Your Future

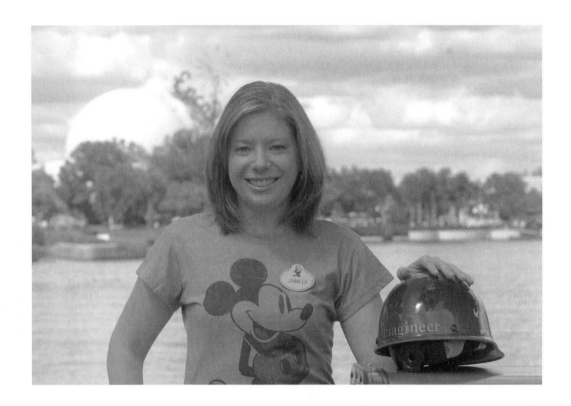

I am currently a project coordinator at Walt Disney Imagineering, the creative force behind Disney theme parks, resorts, attractions, cruise ships, entertainment venues, and more. As Imagineers, we bring to life fantastic worlds, beloved characters, extraordinary experiences, and magical encounters for Disney theme parks and resort guests throughout the world.

I first knew I wanted to design for Disney when I visited Walt Disney World on a family vacation at age 16. I was in line at the Twilight Zone™ Tower of Terror and was overwhelmed by the attention to detail and perfect theming of the queue line. The gardens looked overgrown, and the hotel building reflected years of neglect and abandon. The interior of the hotel was layered in dust, and suitcases and coats were meticulously placed as if the hotel's occupants had mysteriously

disappeared. I was excited, and I was inspired to pursue a career in hospitality design. Most of all, I wanted to be a part of the team of people who made this story come to life.

After graduation from college with a degree in interior design, I sent resumes to architectural and interior design firms across the county and searched websites for job postings. I discovered a posting on the Disney career website for a project coordinator at Walt Disney Imagineering. I posted my resume online and later went through a series of interviews and was offered the job. Initially, I was uncertain whether my skills and background in interior design would fit with project management, but it turned out to be the right decision for me. I was offered several other jobs as an entry-level designer with smaller design firms, but viewed the offer from Disney as a once-in-a-lifetime opportunity. I knew that I would learn other valuable skills that would strengthen my ability as a designer if I chose to change fields in the future.

After a year of working with the company, I had the opportunity to work with the resorts development group for Walt Disney Imagineering. I now work with a project team that is overseeing the construction of the Saratoga Springs Resort Vacation Club and working on the development of future resorts. We are responsible for managing the development of a new resort project from the conceptual phase through the construction administration phase. As part of the team, I manage all aspects of the interiors including the interior design consultant, participate in upper-management reviews, work with furniture manufacturers in developing shop drawings for custom furniture pieces, and manage the procurement and installation of all furniture, fixtures, and accessories (FF&A) items.

I started out assisting project teams on small projects mostly involved in updating various media throughout the park (films, music, posters) and changing out gallery displays in the theme parks. Eventually I began managing these projects and worked with more diverse design teams as the coordinator on larger attractions such as Crush 'n' Gusher at Disney's Typhoon Lagoon water park, Turtle Talk with Crush at Epcot, The Magic of Disney Animation at Disney's MGM Studios, and a new art gallery at the American Adventure pavilion in Epcot 's

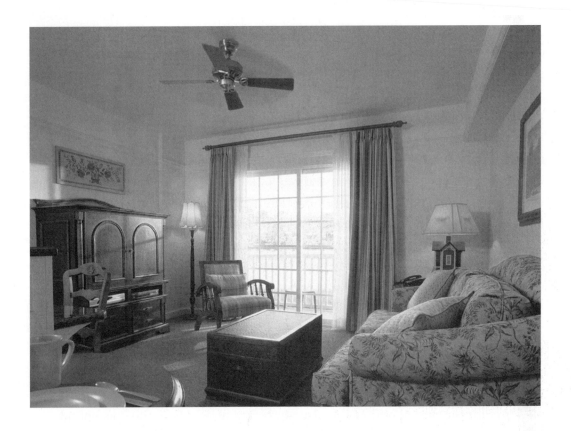

World Showcase. My responsibilities included running the project's weekly meetings, assisting in the procurement of some owner-furnished items, and following up on the progress of project activities. Although it was not obvious that I was using a lot of my interior design background, I was learning firsthand the design process and was involved in construction drawing reviews and managed budgets.

The most important learning experience for me in my career, however, has been working with a team and understanding the various roles within it. Imagineering has some of the most diverse project design teams in the design and construction fields. They include architects, engineers, show producers, art directors, sculptors, animators, ride engineers, media designers, and curators—people I would probably never have had the chance to work with elsewhere.

My skills as an interior designer have aided me in project management. At Imagineering I have been given so many amazing opportunities to travel, work with some of the top architectural and interior design firms in the country, and obtain my interior designer's license.

One of the most important things I've learned throughout this experience is to take chances and not be afraid of going the unconventional route. I thought that taking a project management position would mean giving up my dreams of being a designer, but I've found a way to merge the two. I am still very involved in the design decisions of the project and work with the team on editing drawings and overseeing the construction. In school I never imagined I would be working in project management, and now I wouldn't want to be doing anything else.

Photograph from the
Colorado Convention Center
*Photograph by
Michael Brian Gates*

Design and You

Your work is to discover your world
And then with all your heart give yourself
to it.

—Buddha

Objectives

After studying this chapter, you should be able to:

* Define design.

* Describe the professional portfolio as the product of this course.

* Identify some of your characteristics as an emerging professional.

Did you know that some of the world's largest fortunes were made in design? Ingvar Kamprad (IKEA) and Walt Disney (Disneyland/Disney World) come immediately to mind. Design thinking has also been a hallmark of many of the world's most influential people. In the 20th century, Dr. Maria Montessori and Frank and Lillian Gilbreath contributed significantly to our understanding of the impact of environments on their inhabitants. Today, with his passionate advocacy of "cradle-to-cradle" design, William McDonough is changing the way we understand our impact on the environment and redesigning our interactions to save the planet from further degradation and ultimately reverse the current trend.

The geosphere of Spaceship Earth at Future World at the Epcot Center in Walt Disney World.

The field also accommodates less intense engagement, local focus, and diverse personal values. More than a third of all designers work in small firms, many having fewer than three employees. These modest firms, often specializing in residential design, are the norm in most geographic locations. Part-time employment is not unusual in such firms and is often desired to accommodate family obligations.

Given this broad range of opportunities and challenges, your path will be one of your own design and may vary as your interests and family commitments change. By opening this text, you have signaled that you are ready to begin your future, but probably not quite sure what that beginning will entail. As authors, we hope to answer some of your questions, alleviate some of your fears, and walk the first steps with you down that road. We have found design to be an exhilarating and rewarding profession and hope you will too. You are the future of our chosen profession. We very much want you to be successful.

Discovering the rest of you: developing your personal and professional worldviews.
Source: Drawing by Shari Park-Gates

This chapter is about you and your beginning—getting that first job and loving it. We will introduce you to design in the broadest sense, preview the tool that you will develop to showcase your growing skills (the professional portfolio), and start you on the way to discovering your unique relationship to the field of interior design.

A DEFINITION OF DESIGN

You have already taken a giant step toward your adult persona by choosing design as your field. This choice will deeply influence your personal and professional worldviews in ways that you may be unaware of. The term *design* may be used either as a noun or a verb. As a noun, *design* refers to a plan developed for a specific purpose (i.e., "Ann presented her design for the office complex today"). Used as a verb, *design* refers to the process of developing and presenting that plan (i.e., "Ann designed the ABC office complex"). Either usage entails moving beyond *what has been and what currently is* to embrace *what might be better*. Design is about shaping positive change. Designers are value driven and future oriented. They view yesterday and today as raw material for a better tomorrow and actively seek out the best possibilities and potentials. They are inquisitive about new opportunities and creative in developing solutions beyond the obvious.

Design is also distinguished by its characteristic language. Whereas many professionals in other fields rely on verbal (qualitative) or numerical (quantitative) means to express themselves, designers generally present their concepts visually. This mode of expression is an integral part of the definition of design. Webster's (1997) cites the preparation of "drawings, preliminary sketches, or plans" and the "art of designing." Although the term *design* is often used specifically to imply aesthetic visual expression as Webster's indicates, we need to realize that *design* in its broadest interpretation refers to any plan or deliberate change process.

PORTFOLIO

To visually communicate your capabilities as an emerging designer, you must present to potential employers and clients your professional portfolio. The portfolio is a major component of a designer's self-marketing package and the most important element that illustrates the designer's creative ability. It allows a potential employer to view your past projects, your process, and the range of skills you could bring to the firm. We are introducing the portfolio early in this book to provide sufficient time for your portfolio design process. This section discusses the decisions about general format and page templates. Chapter 6 will elaborate on the portfolio by detailing elements to be included in the templates created in Chapter 1.

Designing a portfolio should be approached in the same way as any important design project. It is *not* an exercise to be put off until the last minute before a job interview and hurriedly constructed without careful attention to detail. Portfolios are ongoing projects that begin early in design school and essentially never end. With a little discipline, you will have a thorough, wide-ranging collection of all of your design work throughout your career. This collection is important as a record of your accomplishments, an illustration of your abilities, examples for colleagues, and a tool for job searches or project proposals.

It is often suggested that designers have two portfolios: a **master portfolio** that includes representations of every piece of work they have created or designed since they began design school, and a **presentation portfolio** that is flexible and modified for each position for which they interview. A master portfolio allows you to have an ongoing selection of prepared pages to choose from and provides a comprehensive record of all of your design activities throughout your design career.

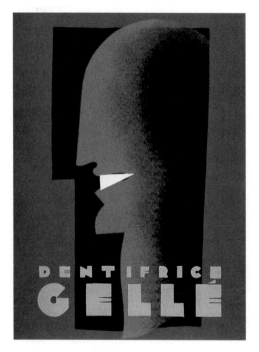

Poster from a series of 15 graphic design portfolios entitled L'Art International d'Aujourd'Hui, published by Charles Moreau, of Paris.

Creating Your Portfolio Design Project

Presentation portfolios must be designed to showcase your specific skills and interests. To help you secure a job, they must also be edited to fit the culture and requirements of each position you seek. As you move through this book, you will identify specific types of employment that fit your personality and desires. Your portfolio should be flexible enough to appeal to most potential employers.

It is also important to consider exactly what you plan to do with the portfolio you are designing. The most common thought when creating a portfolio is that it will be used in one-on-one interviews to illustrate your abilities. You may also want to consider other formats that can be sent ahead prior to your interview or left with the interviewer after the meeting is completed. Online and digital portfolios are also becoming popular; these will be discussed in greater detail in Chapter 6. Whatever your choice, the most important thing to remember is that this must be an excellent creative work that demonstrates your capabilities and talents. It must put you ahead of all of the other designers who are clamoring for the same position!

Swiss artist, writer, and
architect Le Corbusier in his
Paris studio with a letter and
a drawing from a portfolio.

Thinking through the design of your portfolio can be a bit daunting at the beginning. There are so many possibilities, and you want to use your time efficiently so you don't have to redo the work many times to get it right. Because you are thoroughly familiar with the design process as it relates to designing interior spaces, using that same process to design your portfolio should be relatively easy. Begin with programming. Ask yourself questions as you would a client. Begin with the following suggestions, but don't stop there. Add any questions relevant to you, and create your programming document to get you started on the right track!

1. What is your overall objective in creating the portfolio?
2. What types of positions will you target? What "personality" do you want to convey to people who control these positions?
3. What are some of the major messages you want your portfolio design to convey about you?
4. What are your strengths?
5. What is the range of work you want to display?
6. What format might complement the work you want to present?

Your portfolio must tell the story of *you* and be a work you can be proud of in any situation. Your choices should showcase your work in its best light.

Your personality must come through clearly in the work shown as well as in the portfolio design. The following sections discuss some of the specifics to consider when making design decisions based on your personal portfolio programming document.

Portfolio Cases

The container you choose for your portfolio will determine the character of the design, the format of the pages, and the type of content to be included. It is important to explore as many options as possible before making a final decision. Office supply stores, photography stores, craft stores, and a multitude of online suppliers carry a variety of standard portfolios, as well as more creative and unique containers that can be used to house your work. Probably the most common portfolio is the multiring, zippered version with black pages covered with acetate sheets. These are available in vinyl and leather and come in a variety of sizes.

Many designers choose a box that houses individual pages. Boxes come in different sizes, materials, and finishes and can be chosen to complement the work inside. Pages are typically loose and can be organized and shown with great flexibility during an interview. Some designers choose to design and create their own containers that meet their specific needs. When choosing this option, remember that the craftsmanship, attention to detail, and clarity of design will contribute to the overall impression of your presentation. Choose this option only if you have the time, materials, and skill to do it properly. Other options include large portfolio envelopes with handles; however, these typically do not present a professional appearance and should be avoided for interview situations.

Size is an important consideration. The most common size for presentation portfolio pages is 11″ × 14″ to 11″ × 17″. This is large enough to show both overall work and details and small enough to easily carry on an airplane, in a subway, or walking along a windy street. Portfolios sized for 8 1/2″ × 11″ pages may also work, but often leave minimal room to show important details and limit the use of negative space. Clever use of negative space lends sophistication and balance to the page.

Many students are tempted to purchase oversized portfolio containers that allow them to include large presentation boards as well as full-size drawings. Large-format pages may be difficult to design with a clarity and consistency that shows your design talents. Large portfolios may also present problems during an interview if space is limited. Visualize the interviewer trying to manipulate your 24″ × 36″ portfolio (over 4′ when opened) on her stacked desk without causing major disruption to her work environment! Larger portfolios are sometimes appropriate, but consider

carefully both the design and the physical manipulation of the portfolio before choosing this format.

General Format Decisions

Designing the format of portfolio pages can be a challenging graphic exercise. Although the design should show your creativity, it must also be clear and consistent so the viewer will understand your message on every page. The page background should not compete with its key content. To further minimize distractions, the following portfolio elements should be somewhat consistent:

- Page size
- Page orientation within the portfolio
- Use of color throughout
- Fonts and lettering style
- Logos
- Page layouts
- Organizer pages

Deciding what types of media to include in your portfolio will help you make decisions about the overall format of the pages. Portfolios most commonly contain two-dimensional work in the form of renderings, drawings, and illustrations, as well as two-dimensional work that represents three-dimensional work such as models and presentation boards. Photography is the most common method of reproducing your work, although original work may also be included to enhance the interviewer's ability to judge your skills. Scanned images are also easy to work with and can be manipulated and inserted into any page format. You may want to consider creating several page templates that can be used throughout your portfolio to make it cohesive, visually unified, and easy to compile. With page templates, you don't have to create new designs for each page, although placement of elements within the template can change from page to page. For example, you may create templates for pages containing the following components:

Template 1: Short narrative, three photographs

Template 2: Four photographs

Template 3: Short narrative, two plans

Template 4: Six small drawings or photographs

Template 5: One large plan or photograph

Template 6: One large plan or photograph with two smaller photographs

The use of consistent templates ensures that each page in your master portfolio also works in your presentation portfolio with little or no additional manipulation. Templates may also facilitate the sizing and formatting photographs. Often you will have only two to four sizes of photographs instead of different sizes on each page. Try to purchase ample materials for future portfolio pages, but remember that long-term availability of specialized items may be limited. Consider how you might use substitutions, or build in some flexibility for future material changes. The most important thing to remember, however, is that no matter what decisions you make about the container, size, or format, the quality of execution of your portfolio must be excellent to allow you to compete in the aggressive interior design job market—no exceptions!

Portfolio pages: Example of simple templates with a consistent location for the logo and any text necessary for explanation.

Getting started on your portfolio early is an important tactic for success. Using the information in this chapter, you will create your design foundation and build on that in Chapter 6 to expand your presentation portfolio. Always remember that this is a work in progress, so it doesn't have to be perfect the first time, but it *does* have to be done!

THE PROFESSIONAL YOU

Most important, your portfolio must tell the story of *you* and tell it well. Your choices should showcase your work in its best light, and your personality must come through clearly in the work shown as well as in the portfolio design. Success is a product of work experiences in which your personal strengths are well matched to the situation, weaknesses are resolved, and threats are minimized but not ignored. To find the right fit, you will have to know both yourself and the potentials of the job context. In the remainder of this chapter you will make preliminary decisions regarding the scope and character of your preferred life's work.

Scope of Engagement

Perhaps the first issue of future employment is one of degree. How central will your profession be to your life? How much attention are you willing to devote daily to interior design practice? Do you want to be employed outside the home? If so, will your employment be continuous or punctuated by family matters? Will you be seeking a job (work life secondary to other interests) or building a career (i.e., you anticipate a progressive life work)? There is no right answer, but your preference should help you make the first cut of opportunities available.

Context has often been depicted as a series of nested environments ranging from narrow and near to broad and far, each having potential implications of both time and space (see the following figure). Local and regional contexts generally allow more personal time. If your focus is more family oriented, you might prefer to consider hometown retail, small design firms, or entrepreneurship to preserve a flexible, family-friendly schedule. National and global contexts offer more public influence and recognition. Designers seeking to build a prominent or lucrative career will probably be looking for job opportunities in higher-density, affluent metropolitan areas or in large companies that offer long-term upward mobility.

Keep in mind that each choice requires some sacrifice. Operating locally, you might find it difficult to influence national or global affairs. On the other

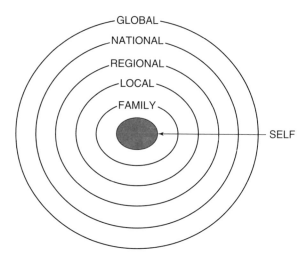

GLOBAL
NATIONAL
REGIONAL
LOCAL
FAMILY
SELF

Context may be considered a nested set of opportunities of increasing scope and complexity.

Source: Barbara McFall, 1998, 2002

hand, operating on a much broader scale might take a toll on self and family. For example, if you choose to engage in a career that provides design services primarily on a national level, you may be required to travel frequently, live in a large city that allows easy access to different methods of travel, and be away from home for extended periods of time. On the other hand, if you locate in a smaller community, you may be home to meet the kids after school.

Recent technological advances, particularly in communications and travel, have brought global experiences into local contexts, and you might be tempted to believe that you can incorporate larger and larger contexts without losing anything. However, it is difficult (if not impossible) to pay attention to a multitude of items, activities, and people at the same time. Research indicates that human attention may be limited to five to seven items at any given time. This discovery places a very real biological constraint on what you can do personally and what you must delegate to others. We are certain that you have become aware of your limited time and energy while meeting the requirements of your design studios and other courses!

In deciding how much time to assign to your work, you might picture your life as a series of nested interactions bounded by the limits of attention (see the figure on page 18). As the central actor, you would be represented by the "happy face" in the middle. The six arrows radiating from the happy face indicate potential items (people, places, things) available for consideration over a given time span.

Give careful attention to the value you place on each cluster. Elements beyond our immediate six-item attention span must be delegated to others, postponed, or eliminated altogether. The level and complexity of interactions also dictate demands on time and attention. Deliberate design rather than default should dictate your areas of primary focus.

You may, however, move from one center of operation to another at different times. Many adults begin and end each day focusing on items related to their personal lives, but spend much of the day in quite a different professional setting. Periodically, designers will also leave their own professional vantage point to view the world through the client's perspective.

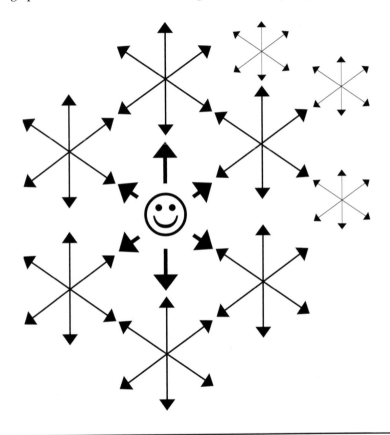

The limited-attention networked system.

Source: From *Future Promise: Designing Personal Resource Systems Management as a platform for quality of living and learning.* Ann Arbor, MI: UMI Dissertation Services/ProQuest. © Barbara McFall, 2002

Patterns of Attention

Now that you have identified the preferred scope and level of influence of your initial professional practice (i.e., local, regional, national), you are ready to examine more closely the specifics of your personal situation and begin to align your realities with workplace expectations. This will require a serious evaluation of the origin, direction, character, and ranking of your patterns of attention.

Professional practice in interior design is a dance involving the designer, the client, and various environmental influences. With every action, the designer faces a choice to lead, follow, or get out of the way. There is no one right way to respond to every situation, but it is critical that you be able to identify quickly both what is going on and your right place within the interaction. In some instances you will choose to direct your attention to an issue. In others the issue will command your time and effort.

Responding to a clearly defined situation is sometimes referred to as being "reactive." The environment (often another person) initiates an action, and your response is to react. Think about the assignments your professors give you in your design studios. Are the details provided, or do you receive a general concept or idea necessitating that you "fill in the blanks" and create your own project approach? Are you more comfortable with the assignment when details are provided, or do you feel constrained by the requirements? If you prefer clearly defined situations, you may want to seek well-defined positions within companies that are well supervised and highly structured. Clearly specified and closely supervised projects are often more comfortable for beginning designers as a way to gain experience and a greater level of confidence.

Design ideas may originate with you and affect the environment, or they may originate in the environment and influence you.

Source: Barbara McFall, 1998, 2002

On the other hand, if you feel constrained by the details provided for a project and would prefer to create your own scenarios for design, you may have a preference for a "proactive" approach to your work activities. People who are proactive initiate actions instead of waiting for the environment to take control or provide tasks. Entrepreneurs and leaders within companies are often proactive. With this approach comes recognition, but also risk and accountability. If your preference is to be proactive, you should seek leadership roles, learn from your experiences, and remain in control of your future as well as your present.

Your style may evolve as you progress through your career. Some designers take a strong lead early and relinquish control as they become more

comfortable in their work. Others prefer to follow in the beginning and take the lead as they mature. You will most likely find that you need clearly defined situations in some dimensions of your life and self-generated activities in others. Life always requires some of both, but most people demonstrate a clear preference for one style over the other.

Introduction to the Personal Resource Systems Management Model

Whether you typically initiate action or prefer to respond to demands, you will find many situations that will engage your attention daily as a design professional. More often than not, you will be working fast and furiously to either generate business or meet contract deadlines. Some opportunities and challenges will speak to your interests and talents. Others should be passed to team members with more relevant skills and interests. To make sense of the chaos, you will want a method of recognizing and sorting information quickly. You will also want to recognize your skills and interests. Many systems are available to help accomplish this goal. The one that we will be using most frequently in this text is the Personal Resource Systems Management (PRSM) model (McFall, 2002). PRSM has been used in universities, high

Environmental dimensions (intellectual, organizational, social, material, natural, financial).

Source: From *Future Promise: Designing Personal Resource Systems Management as a platform for quality of living and learning.* Ann Arbor, MI: UMI Dissertation Services/ProQuest. © Barbara McFall, 2002

schools, and junior highs schools since 1998 with positive results (McFall, 2006; McFall & Beacham, 2006; McFall, Beacham, & Shambaugh, 2006; McFall & Williams, 2004).

Dimensions

Because we can hold only five to seven items in short-term memory at one time, it is necessary to group many observations and events under a few easy-to-reference headings. The PRSM model establishes six groups called "dimensions" (intellectual, organizational, social, material, natural, financial) around which to organize a wide variety of human experiences. The name of each PRSM dimension gives you a clue as to its focus, and every person will have some interest in each dimension. You will probably spend time in each dimension daily; however, you will find that you have preferences for some dimensions over others. These preferences will suggest work opportunities in alignment with your personal interests. By understanding how each dimension applies to your life, then identifying dimensions that play a major part in your personal decision-making process, you can begin to narrow your initial career directions. Each dimension is described in detail in the next section to help you make some initial decisions.

The **intellectual dimension** includes data, information, knowledge, and wisdom. Academic disciplines, legal codes and contracts, historical styles, design philosophies, and religious belief systems are among the content found here. A clear example of a designer skewed toward the intellectual dimension is William Morris (1834–1896). Morris was very active in socialist politics and vocal in his opposition to the dehumanizing effects of early industrialization. His support of handcrafters resulted in the founding of the Arts and Crafts Movement. The equally intellectual Bauhaus designers (1919–1928) exemplified an alternate philosophy. They embraced technology, but sought to marry the new ways with exemplary art and craft. Designers favoring the intellectual dimension are often the source of our knowledge about enduring trends and extraordinary design because they tend to research, teach, and write. Will your work promote a central idea or philosophy?

The **organizational dimension** focuses on the efficient and effective work of organizations toward specified goals. Most businesses use design to brand their products and facilitate their service. For example, the famous fast-food franchise McDonald's uses recognizable icons such as the golden arches, primary colors, the Ronald McDonald character, and a theme that declares "good times, great taste" to attract customers and sell burgers better and faster than its competition. Another example of

organizationally oriented design is Frank and Lillian Gilbreaths' motion study and industrial design. In the first half of the 20th century, their work contributed to more efficient workplaces (both in industry and at home) and established the foundation of universal design. Most contract or commercial design is oriented toward the organizational dimension. Will your work enhance the bottom line of organizational activity in some way?

The **social dimension** is about love, home, home-away-from-home (i.e., clubs, hotels, etc.), family and friends—in essence, providing a refuge to support human interaction and development. Most residential design falls within the social dimension, as does hospitality design. Social dimension issues play an increasingly important role in healthcare design. The social dimension may also influence your work habits, particularly in the balance between work and family life. Social issues sometimes suggest work in a nonprofit environment (e.g., Habitat for Humanity) as opposed to for-profit venues. Dr. Maria Montessori (1870–1952) is an exemplar of the social dimension. Her work in early childhood education focused on (1) providing a nurturing environment for children; (2) observing daily activity within this environment; and (3) continually adapting the environment to support the fulfillment of each child's physical, mental, emotional, and spiritual development. The key question in this dimension is, Does your design practice support love and nurturing?

Designers favoring the **material dimension** celebrate the unique properties of man-made and human-use materials. These designers may be artists or scientists, innovators of new materials, or collectors of existing wares. For example, designers working for the National Aeronautics and Space Administration (NASA) space program have been responsible for many innovative materials. Spin-offs include fire resistant materials, flat-panel televisions, and trash compactors, as well as advances in solar energy optimization, noise abatement, and radiation insulation. Two designers exemplify material orientation in a more terrestrial mode. Interior designer Rose Tarlow is well known for replicating and adapting fine antiques for current markets. Jack Lenor Larsen led innovation in textiles design throughout the 20th century and widely disseminated adaptations of international and historic techniques. He also left a stunning collection of contemporary crafts for public enjoyment through his Longhouse Reserve. The key factor within the material dimension is an appreciation for the unique benefits afforded by diverse materials.

The **natural dimension** concerns the ongoing relationship between humans and nature. Design may be focused on mediating the harmful effects of nature on humans (e.g., heat, cold, wind, earthquake, flood, wild animals, air and water quality). Or, as with Frank Lloyd Wright's

(1867–1959) "organic design," the focus may be on creating a harmonious relationship between the built and natural environments. Currently, thanks in large part to the efforts of architect and designer William McDonough, the emphasis seems to be on sustainability— halting the harmful effects of humans on our natural resources. McDonough's "cradle-to-cradle" strategy pushes us all to think beyond the LEED (leadership in energy and environmental design) effects. Cradle-to-cradle would have us design in a way that actually improves our environment through use (McDonough & Braungart, 2002).

The **financial dimension** is a key consideration in most design projects, but serves as a primary driver for some. Ingvar Kamprad founded the furnishings giant IKEA on the principle of affordable design. He wanted to push prices so low that good design would be affordable to all who want it. IKEA pioneered self-serve shopping, flat-pack design, and home assembly to eliminate substantial production and sales costs. In-house designers work with existing manufacturing processes to produce smart designs. IKEA buyers seek good suppliers with appropriate materials all over the world and then buy in bulk to get the best price. Smart management completes the package. The famous auction houses

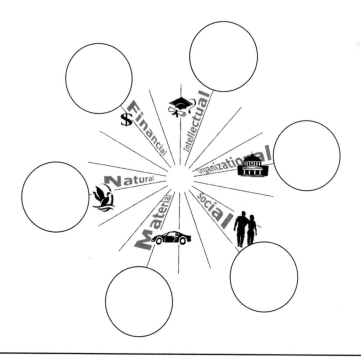

Ranked personal preferences for specific environmental dimensions.
Source: Barbara McFall, 1998, 2002

Sotheby's and Christie's, on the other hand, specialize in luxury goods. They are reported to control more than 90 percent of their market in art, jewelry, and furniture.

Aspects

Your interest in what's going on around you is only half the story in thinking about positioning yourself for successful practice. In addition to having preferred dimensions of engagement, we each have characteristic modes, or styles, of engagement. These modes can be thought of as the three personal aspects (mental, emotional, and physical). They are easy to remember and understand. All you have to do is think of the song in the movie *The Wizard of Oz* that goes, "if I only had a brain, a heart, the nerve!"

Each of the aspects helps us translate our energy into specific actions with uniquely related outcomes.

Mental (aspect) translates into thinking (action).

Emotional (aspect) translates into feeling (action).

Physical (aspect) translates into doing (action).

Once again, our preference for one way of interacting over another often defines the roles we play in society. The mentally oriented tend to be academics, consultants, theorists, and planners. Emotional people often serve as writers, poets, musicians, artists, actors, counselors, and caregivers. The physically gifted might become athletes, warriors, farmers, ranchers, builders, and manufacturers. Fortunately for you, design offers opportunities in all aspects! Most designers are multitalented and work from time to time in each of the modes. However, we all have our favorites.

Every interaction involves a matching of one dimension with one aspect. For example, let's assume that you are working as an interior design teacher in the intellectual dimension. You are exploring an idea: the Greek Revival style in the antebellum South. You might engage a design history class in different ways depending on the aspect involved (mental, emotional, physical). Students will respond best to their own preferred aspect, and preferences will vary from student to student.

Your job as a designer will be to solve a problem by either *thinking* through a rational solution, *feeling* with and through emotional issues, or *acting* to resolve a physical difficulty. Each job, and each client involved in that job, will employ different aspects and require corresponding responses from you, the designer. Design practices on the whole also vary considerably in the aspect most frequently required. Commercial design tends to skew toward rational and physical aspects. Residential design often involves emotional issues.

SUMMARY

This chapter introduced the concept of design as a unique and powerful worldview that values vision, innovation, and improvement. As a new professional, you have been introduced to the most important tool of your impending job search—the professional portfolio. At this point you should have an overview of the requirements of a professional portfolio and some thoughts about the design direction for your collection of work. You have also completed the first exercises in getting to know yourself as a design professional. More such inquiries will occur throughout this text. Now, though, it is time to turn to your chosen work. Chapters 2 and 3 will look at the interior design profession in greater detail to help you better understand expectations and opportunities.

ACTIVITIES

Activity 1

This course is intended to help you land your first job and meet the initial goals of your career as you define them. Consider the information in this chapter and think about your personal and professional preferences related to context. In the next five years, what do you see as the scope of your work (self, family, local, regional, national, global)? Now think about 10 years and 15 years in the future. Do you see your first employment as a long-term placement (e.g., the family business) or a stepping-stone to other opportunities (e.g., an internship at a midsize firm)?

Activity 2

Review the styles described in "The Professional You" section. Generally speaking, which is your preferred style? Give a one-paragraph example of a situation that illustrates your use of that style.

Activity 3

Read the descriptions of each environmental dimension in the "Dimensions" section of the chapter. When you have finished reading, consider each dimension as it relates to your professional interests. Then rank each of the six dimensions in order of importance in your life with 1 being most important.

Activity 4

Once you have ranked your preferences for each of the six dimensions in Activity 3, transfer those rankings to the appropriate dimensions in the figure on page 23. Think of the figure as a compass, with the dimensions as directions pointing the way to your new job or career. Your goal with this tool is to identify and begin to further explore a direction that appeals to you.

Activity 5

Rank your preferred aspect and action in the following boxes, using 1 to designate your most preferred mode of engagement and 3 to designate your least preferred. The following example might help you clarify your choice:

Mental (aspect) translates into thinking (action).

Emotional (aspect) translates into feeling (action).

Physical (aspect) translates into doing (action).

Example:

Mental aspect	Read about life in that geographic area during that period. Discuss the philosophy behind, and historical development of, key design elements.
Emotional aspect	Watch a movie (e.g., *Gone with the Wind*) in which emotional scenes play out against a set design of the appropriate period. What were the characters feeling?
Physical aspect	Take a road trip to Charleston, South Carolina, or Savannah, Georgia, to experience personally the physical presence of historical landmarks. How do they look, feel, taste, smell, and sound?

Alexis M. Behrens

Healthcare design has been a wonderful discovery along the path of my professional career. At the time I was completing the curriculum in the Interior Design Program at West Virginia University, the discipline of healthcare design was not a strong focus, so when given the opportunity to explore this field further, I did. Although the emphasis for interior designers to contribute to the healthcare field was clearly recognized, it was not seen as a specialized area in our profession. The field, however, has grown significantly over the past 20 years, as both clients and design professionals realize the importance of having skilled interior designers who understand the unique needs and requirements of healthcare facilities.

Interestingly, my career has consisted of working for one organization for over 15 years. Though this is not the norm with most of my interior design colleagues, it has been perfect for me both professionally and personally. I was particularly interested in settling in an area close to family and friends and wanted to be in a place that provided a good environment for raising a family. Working for the hospital system has provided me with not only those benefits, but also a chance to move from one level of responsibility to another as new and challenging opportunities were presented and my experience and knowledge increased.

My first experience at the West Virginia University Medical Center was as an intern for the hospital architect. Then I was hired as an independent contractor, paid on an hourly basis but with no benefits. As an independent contractor, my duties consisted of moving furniture, field measuring, basic space planning, and maintaining the signage within the hospital and on the surrounding grounds. Eventually I was fortunate enough to be hired as a full-time facility designer and was put on salary and given full benefits such as healthcare insurance, sick leave,

paid vacations, and maternity leave. As my experience grew, so did my level of responsibilities; I was given a new job description: project manager. With this position came new demands such as programming, budgeting, space planning, FF&E selection, and coordinating project trades and departments, as well as supervising consultants and contractors to ensure that jobs were designed and built to meet the needs and specifications of the hospital and building code requirements. My position as an in-house interior designer and project manager allows me to build a strong communication network and assemble the resources needed to get projects completed in the most efficient and effective manner. It also means that I am available to my clients on a daily basis. This accessibility

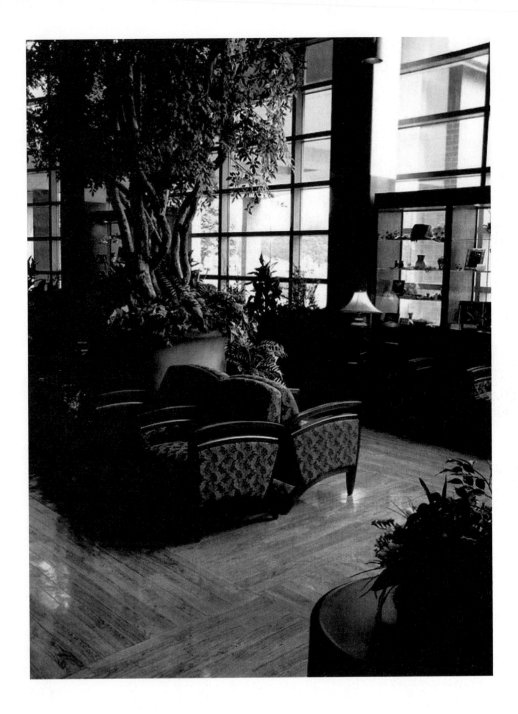

can be a very positive and comforting experience for the client during the course of the project.

Working as a project manager for Planning, Design, and Construction at West Virginia University Hospitals, or any other healthcare institution, forces a designer to look at interior design from a unique point of view. As a healthcare designer, you must constantly be aware of the effect of your spaces on the well-being of the patients, visitors, and staff. The challenge is to create a warm, friendly, and healing environment that takes into consideration the heavy abuse that the finishes and furniture are going to endure. Being the only level 1 Trauma Center in the state of West Virginia, our facility takes care of some of the most serious medical emergencies in our region. The patients and family members dealing with these situations need to find themselves in a nonthreatening, comfortable environment; however, when designing these types of facilities, we must always consider cost and longevity. Careful consideration must be given to being stylish but not trendy and to using materials that are easily cleaned and will hold up to 24/7 use from the public and staff. In addition to the Trauma Center, we have very specialized requirements for all of the units we serve. Operating rooms and procedure rooms require specialized lighting and flooring, as well as attention to detailed building codes and the needs of the physicians, nurses, and patients served within the space. In facilities such as the West Virginia University Eye Institute, the architect and I needed to understand the challenges and concerns of individuals with limited or no sight capabilities and to design the facility to support those needs. Understanding and applying universal design principles is an everyday activity with healthcare designers and a critical part of our design success.

For anyone interested in this area of design, I would highly recommend it as a challenging, interesting, and wonderfully rewarding design specialization. It will require that you have an open mind, creative spirit, and immense flexibility in your design process, plus the ability to incorporate constructive insights while promptly building those suggestions into your designs. Curiosity and a love of continual learning are also traits that will aid in your success. The world of healthcare design is ever changing, always new, and just like life . . . it is *never* boring!

Denver Public Library
*Photograph by
Michael Brian Gates*

Becoming a Member of a Profession
What Does That Mean?

2

*All our dreams can come true if we have
the courage to pursue them.*
—Walt Disney

Objectives

After studying this chapter, you should be able to:

* Explain the elements that form the definition of a profession.

* Discuss the reasons for considering interior design a profession.

* Discuss the mission and vision for interior design.

* Determine some vital issues for the future of interior design.

* Understand where your personal interests intersect with the
 mission, vision, and vital issues of our profession in order to
 develop a personal philosophy and direction within the profes-
 sion of interior design.

Now that you know a little more about yourself and what is important to you, you can consider your role as a future member of a profession and your place in the field of interior design. The next four chapters guide you through that exploration. This chapter explores the definition of a profession and how and why interior design fits that definition. It also examines a mission and vision for interior design as a profession and what that means to you and society. Chapter 3 introduces the diverse employment options available to interior design graduates. This information, combined with your personal profile from Chapter 1, will enable you to begin to define the ideal fit between your professional life and your personal life. Chapter 3 also introduces some of the "tools of the career search" that will be developed in detail in later chapters. Chapter 4 provides a background of theory for both the approach you will take throughout this book and for many of your personal decisions. Chapter 5 completes the set as you locate and evaluate potential employers in light of your knowledge of yourself, the profession, and the industry.

A DEFINITION OF PROFESSION

When you hear the word *professional*, what comes to mind? It probably sounds somewhat impressive, as though the title bearer has something special that sets him or her apart from the average worker. We tend to automatically elevate people who are a part of a profession. What are some of the common labels that come to mind when you think of professionals? Lawyers, doctors, engineers, and accountants are common titles we think of in relation to "professionals," as well as others, but what do these professionals have in common? You may think they earn a lot of money and they garner a great deal of respect, or that they are the financial and respected elite in our society. It is true that often the word *professional* denotes a certain amount of respect and status. However, a deeper understanding of the word *profession* reveals that practicing members of a profession share a tradition of service to society. This chapter will help you define and reflect on the mission of professions and your vision for contributing as a future member of a profession.

To become a responsible member of a profession, you must understand what a profession is and what it is not. A profession requires specialized education, certification or a test of minimal competency, and a mission of service to society. Once those criteria have been met, other factors are necessary to control and maintain the quality and direction of the profession.

Following is a list of elements that help to define a *profession*. These elements allow us to evaluate the legitimacy of claiming professional status

for interior design or other occupations. The list also defines why professions are important to society.

1. Professions *provide a clearly defined service* for the good of the public

2. Professions endeavor to *guarantee the quality of the service* provided and the expertise of practitioners through specialized education and certification for minimal competency.

3. Professions *establish a set of ethical expectations* to provide guidelines to practitioners regarding ethical behaviors, and identify consequences if practitioners act inappropriately.

4. Professions work to *promote their services* and fill the needs of the clients served.

5. Professions *develop new methods of providing services* and create new knowledge in their fields through continuing research, enabling them to better serve the continually changing needs of society.

Clearly Defined Service

All professions must provide some service that is needed by society in order to sustain their existence. This service must be perceived by clients as necessary and must be valued to the point that clients will pay the providers for that service. The public must have a clear understanding of what they are paying for. For that reason, professions work hard at providing a clear definition of what they do and how their activities benefit the individual client and society as a whole.

Interior design is considered a profession, and it provides a clearly defined service to its clients. Interior design is more than an art, a skill, a process, or a business. Interior design carries responsibilities that go beyond aesthetics and profit to improve the quality of life of the people interacting with the designed interior environment. As a designer, you are expected to provide a service for the good of the public and to help people understand the value designers bring to their lives. To help you with these responsibilities, definitions for *professional interior design* have been created by many design organizations. Although the wording of the definitions may differ, they are often similar in their intent.

Definition of Interior Design

The Council for Interior Design Accreditation (the Council) has endorsed the most recent version of a professional definition offered by the National Council for Interior Design Qualification (NCIDQ). The full definition and glossary of

terms may be found on their website, www.ncidq.org. Following is the NCIDQ definition of interior design (www.ncidq.org/who/definition.htm):

> Interior design is a multifaceted profession in which creative and technical solutions are applied within a structure to achieve a built interior environment. These solutions are functional, enhance the quality of life and culture of the occupants, and are aesthetically attractive. Designs are created in response to and coordinated with the *building shell,* and acknowledge the physical location and social context of the project. Designs must adhere to code and regulatory requirements, and encourage the principles of *environmental sustainability.* The interior design process follows a systematic and coordinated methodology, including research, analysis, and integration of knowledge into the creative process, whereby the needs and resources of the client are satisfied to produce an interior space that fulfills the project goals.

> Interior design includes a scope of services performed by a professional design practitioner, qualified by means of education, experience, and examination, to protect and enhance the life, health, safety, and welfare of the public. These services may include any or all of the following tasks:

> - Research and analysis of the client's goals and requirements; and development of documents, drawings and diagrams that outline those needs
> - Formulation of preliminary space plans and two-and three-dimensional design concept studies and sketches that integrate the client's *program* needs and are based on knowledge of the principles of interior design and theories of human behavior
> - Confirmation that preliminary space plans and design concepts are safe, functional, aesthetically appropriate, and meet all public health, safety and welfare requirements, including code, *accessibility, environmental,* and *sustainability* guidelines
> - Selection of colors, materials, and finishes to appropriately convey the design concept, and to meet socio-psychological, functional, *maintenance,* life-cycle performance, environmental, and safety requirements
> - Selection and specification of furniture, fixtures, equipment, and millwork, including layout drawings and detailed product description; and provision of *contract documentation* to facilitate pricing, procurement and installation of furniture
> - Provision of project management services, including preparation of project budgets and schedules
> - Preparation of *construction documents,* consisting of plans, elevations, details, and *specifications,* to illustrate *nonstructural and/or nonseismic partition* layouts; power and communications locations; *reflected ceiling plans* and lighting designs; materials and finishes; and furniture layouts
> - Preparation of construction documents to adhere to regional building and fire codes, municipal codes, and any other jurisdictional statutes, regulations, and guidelines applicable to the interior *space*
> - Coordination and collaboration with other allied design professionals who may be retained to provide consulting services, including but not limited to

architects; structural, mechanical, and electrical engineers; and various specialty consultants

- Confirmation that construction documents for nonstructural and/or non-seismic construction are signed and sealed by the responsible interior designer, as applicable to jurisdictional requirements for filing with code enforcement officials
- *Administration of contract documents,* bids, and negotiations as the clients agent
- Observation and reporting on the implementation of projects while in progress and upon completion, as a representative of and on behalf of the client; and conducting post-occupancy evaluation reports.

Other examples of interior design definitions appear on the websites of various professional organizations that are involved in furthering the professional nature of interior design, including ASID, NCIDQ and IIDA. Most definitions are quite similar to the one above.

REFLECTION

Take a few minutes and look up the definitions of interior design from the following organizations:

- International Interior Design Association (IIDA): www.iida.org
- American Society of Interior Designers (ASID): www.asid.org
- Interior Design Educators Council (IDEC): www.idec.org
- Interior Designers of Canada (IDC): www.interiordesigncanada. org
- National Council for Interior Design Qualification (NCIDQ): www. ncidq.org

Do all of these definitions indicate a scope of services offered for the public good? After reading these definitions, can you talk about the services interior designers offer for the betterment of society? Can you explain the services interior designers provide that would qualify them as members of a profession?

Education and Testing

Once the service element is in place, a profession must have some way to guarantee the quality of performance. It is a matter of protection for the public. The services offered must be performed by people who have a minimal level of competency so society is helped, not harmed, by the service. How do we regulate that quality? Because the knowledge is specialized, the best way to regulate quality comes from within the profession. In a profession, associations or organizations are formed to oversee and regulate the

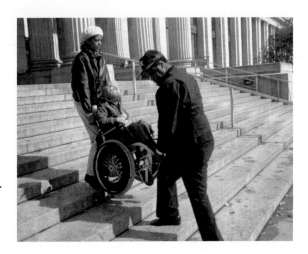

A woman and man carry a boy in a wheelchair down the steps of a building without handicap accessibility.

quality of education, testing, and professional practice. We will discuss how interior design organizations attempt to ensure quality performance from the members of the profession, beginning with appropriate educational requirements.

Education

The Council for Interior Design Accreditation (CIDA, formerly the Foundation for Interior Design Education Research—FIDER) is the association created to oversee the quality of interior design education. Its mission is to "provide the foundation for excellence in the interior design profession by setting standards for education and accrediting academic programs that meet those standards" (www.accredit-id.org). Insight into the purpose of accrediting educational programs and the important role that accreditation plays in granting professional status to graduates is valuable for you as a future member of the profession.

CIDA describes the specialized knowledge and skills necessary for interior designers and evaluates the training of those skills. The expectations for specialized knowledge are set forth in CIDA professional standards originally published in 2002, updated in 2005, and updated again in 2006. These standards are continually updated because there are changes in the needs of society and new methods necessary to offer services that will benefit the public.

Understanding the expectations of CIDA should help to define how you will be expected to practice as a professional. It may also help you to understand what is expected in your interior design classes and why. Finally, it should help you to appreciate some of the planning required to ensure

common standards for the practicing professional. Currently the major areas of emphasis and evaluation include the following:

The Curriculum Structure

Professional Values

Design Fundamentals

Interior Design

Communication

Sustainability

Building Systems and Interior Materials

Regulations

Business and Professional Practice

Faculty

Facilities

Administration

Assessment

To read the entire set of CIDA standards, visit the organization's website at www.fider.org/standards06.pdf. There are other accrediting bodies, such as the National Association of Schools of Art and Design (NASAD), which "is the national accrediting agency for art and design and art and design-related disciplines" according to its website (http://nasad.arts- accredit.org/index. jsp?page=About+NASAD), but CIDA is the recognized accrediting body of interior design programs.

▬ REFLECTION _____

After reading CIDA standards, do you have a better understanding of the specialized knowledge base associated with the profession of interior design? Some of the topics offered in your classes may take on a new meaning and level of importance now that you understand more about the expectations and purpose of accreditation for interior design programs. Can you talk about the specialized knowledge for the field of interior design and relate that knowledge to a service interior designers offer for the good of society?

Testing

Another way the profession can guarantee the quality of performance is to establish a method for certification or an examination for minimal competency. This examination is required of those practicing in the field who want

to be certified and those who want to apply for a license. The National Council for Interior Design Qualification (NCIDQ) oversees examination and certification in the United States and Canada. NCIDQ is responsible for designing and scoring the examination for minimal competency. NCIDQ is also responsible for assigning certification and maintaining continuing education units for the profession.

Education, experience, and examination.

NCIDQ's mission is to protect the public by identifying individuals who are competent to practice interior design, and this is done largely through a national examination. In order to ensure that the examination is indeed representative of the tasks consistent with current practice, NCIDQ undertakes a practice analysis every five years. (www.ncidq.org)

To sit for the exam, a person must either have graduated from a four-year school and spent two years practicing in the field, or have graduated from a two-year program and spent four years practicing in the field. Chapter 11 provides additional information about planning for the NCIDQ. For more detailed information about the exam and schedules, visit the NCIDQ website at www.ncidq.org. You must also submit an application and be recommended by certified designers. The application is reviewed, and those who are eligible to sit for the exam are notified and allowed to register. The exam is administered twice annually. When a candidate passes all the parts of the exam, she or he is granted certification recognized in both the United States and Canada.

Licensing and Registration

Testing is done in an effort to guarantee a well-developed knowledge base and to control and unify the quality of performance by those who are NCIDQ certified. It is important for a profession to maintain this control as a pledge of concern and accountability for the general health and welfare of the public. The key reason for certification and licensing is the protection of the public; the protection of the designer is incidental. Maintaining an assurance of quality and concern by the professional practitioner promotes a feeling of trust within society that is important to sustaining the profession as well. It becomes a reciprocal relationship.

Currently some states require a license for interior designers, and others restrict the use of the title of certified or registered interior designer. Two main kinds of acts have been passed by states regulating interior designers: practice acts and title acts.

A title act does not require the interior designer to be licensed, but it does regulate the use of a title. A person can practice but cannot call herself an interior designer or a certified interior designer (the title is different from state to state) unless she has met the minimum regulations identified by the state for professional interior designers. This protects the public by limiting the use of a title. If the title of interior designer, certified interior designer, or registered interior designer is used, then the public is to understand that the person has been tested and found competent to practice interior design.

A practice act requires that the interior designer be licensed. Not only does it regulate who may use the title of interior designer, but the person must also be licensed to practice interior design. People new to the field may practice under the guidance of a licensed interior designer until they become licensed. To find out more about interior design legislation, visit the American Society of Interior Designers website: www.asid.org/legislation/.

States differ in their legislation regarding registration and licensing for interior designers. To begin a study of individual states' legislation, you may want to visit the NCIDQ website (www.ncidq.org/who/agencies.htm) to find information on the state regulatory agencies. You may also contact the professional society in your state to get information on the progress of legislation in your state or the state where you plan to practice.

Ethics and Professional Regulation

Code of Ethics

A profession often carries a certain amount of autonomy. Licensed professionals claim the exclusive right to practice in their specialized knowledge base. Because the uninitiated person or layperson, theoretically does not have an

Trust is a big part of the relationship.

understanding of that knowledge base, he must trust the professional to make decisions on his behalf. Trust is a big part of the relationship between professional and client or the profession and the public. It should be sacrosanct.

Professional associations regulate licensed or certified professionals through defined and published codes of ethics. In order to fully convey the responsibilities of the profession and appropriately regulate those practicing within it, professional associations must properly educate and mentor its practitioners. A profession is not above the law. Licensing can call for a particular level of performance based on how the professional societies define the responsibilities of their profession. Besides the regulation that comes with licensing, ethics play a big part in defining responsibility and accountability for members of a profession.

The code of ethics of any profession describes or attempts to describe the areas of responsibility not mandated by the law. Because the responsibilities are described in ethical standards, those standards should be spelled out by the professional society. First, the standards should be understandable. Second, the standards should be clear enough that professional peers can determine when a standard has been broken. And lastly, if the standard has been disregarded, there must be a penalty. Penalties for disregarding ethical responsibilities must be clearly understood by all professionals and must be of a significant enough consequence to help deter unethical behavior.

Both the American Society of Interior Designers (ASID) and the International Interior Design Association (IIDA) have written external moral

codes for guidance in professional practices. The codes are similar, pointing out the designer's responsibilities to clients, other professionals and colleagues, the profession, the employer, and society in general. Visit the websites for the ASID code of ethics (www.asid.org/asid2/find/ethics.asp) and IIDA code of ethics (www.iida.org/i4a/pages/index.cfm?pageid=304) for more detail.

Examining ethics will often present difficult issues; the clarity of right and wrong may be blocked by many cloudy situations. Black-and-white conditions quickly become many shades of gray when we engage in the discussion of actual cases. That makes it hard to regulate professional members. Some believe that no matter how clearly ethics are spelled out, we are still only as good as individual members' sense of ethical behavior. Therefore, the internal standards of individual members may override the code of ethics established by the profession.

Regardless of the complexity, it is the responsibility of the profession to define ethical behavior for interior designers and make sure our future constituents are well versed in their understanding of responsible ethical behavior.

To get a better idea of the level of detail included in written codes of conduct in many states, visit the NCIDQ website, click on the Alabama State Board of Registration for Interior Designers, and read the information provided. If your state has a title or registration act, you may want to click on your state and read the information contained in that document as well. Following are some components you may find:

1. Board for registering interior designers for practice
2. Code of professional conduct
3. Rules and regulations
4. Information on continuing education
5. Roster of registered interior designers
6. Violation and reinstatement information

▬ REFLECTION

After reading the licensing and registration information on the different state and province board websites, do you have a better understanding of legislation governing interior design and the title and practice of the profession? Do all of the states have boards governing the profession of interior design? Can you talk about the need for legislation and the reasons for pursuing it? Can you relate it to a service interior designers offer for the public and the need for regulation in order to protect the public? Why is legislation and regulation an important part of a profession? Some of these questions may allow you to reflect on the status of interior design as a profession.

Professional Societies

Professional organizations are important for the support of the professionals, the improvement of performance, the advocacy of the profession, and the education of the public in regard to professional performance. Four main associations or societies oversee the profession of interior design in North America. ASID, IIDA, IDC, and IDEC are all responsible for the regulation, promotion, and direction of the profession. The purpose and benefits of professional organizations will be discussed in more detail in Chapter 11. Following is an overview of the four main professional organizations for interior design.

American Society of Interior Designers (ASID). ASID is the largest organization for practicing interior designers. It provides resources, education, job referrals, and numerous other benefits for its members. www.asid.org

International Interior Design Association (IIDA). IIDA is a relatively new interior design organization and was formed through the union of several smaller interior design associations. Like ASID, the organization provides a variety of benefits to its members related to the interior design profession. www.iida.org

Interior Designers of Canada (IDC). IDC is similar to both ASID and IIDA, but is targeted to practicing designers in Canada. It addresses the unique issues faced in the provinces. It also provides similar member benefits including job referrals, access to research, and networking opportunities. www.idc.org

Interior Design Educators Council (IDEC). IDEC is the organization specifically formed to guide and support educators in the interior design field. The organization hosts annual conferences on both a regional and international level to encourage the sharing of information and methods among educators throughout the world. IDEC also offers resources to practicing professionals through the sharing of research and continuing education opportunities. www.idec.org

The societies in the preceding list are some of the major professional societies in the United States and Canada. Following are several other organizations that are very active for specialized and related areas of design:

IDSA: Industrial Designers of America (www.idsa.org)

IFMA: International Facility Management Association (www.ifma.org)

NKBA: National Kitchen and Bath Association (www.nkba.org)

ISP: Institute of Store Planners (www.isp.org)

IALD: International Association of Lighting Designers (www.iald.org)

There are many others you may want to become familiar with. Visiting the websites of various organizations and reading information related to their areas of specialization will help you identify groups that hold a particular interest for you.

Most professions in the United States have one professional society and as such have a unified and centralized organization governing the regulation of the profession. Interior design has two primary societies for practicing professionals in the United States: IASID and IIDA. Many designers would like to combine the efforts of the two into one unified voice for interior design. A merging of organizations could be beneficial to the profession in relation to the coordination of management, financial, and legislative efforts. Currently, however, the organizations operate independently but engage in collaborative activities periodically for the benefit of their membership. Efforts to merge the groups continue within the profession.

Promoting Development

Need for Service

Service for the good of society is the common link among professions. A profession must be of ever-increasing service to society, or there is no reason for it to exist. If the need for the service disappears and the profession no longer serves a purpose to society, then it is no longer a profession. The ability to respond to external change and differences in focus brought about by the change in society is important to a profession's status and public legitimacy. A healthy profession provides a vital service that the public perceives as such.

Promoting the development of a profession involves making sure that it serves the current and future needs of society while improving the methods of practice. Promoting a profession may also mean bringing the service to areas where there is a great need but little knowledge of new methods or the importance of the service to improving the quality of life. Consider the importance of interior materials for a public space that will not fuel a fire or create toxic smoke. If there is a fire, people may be injured or, worse, die. The public may have little knowledge of new materials that are flame resistant and do not produce toxic smoke, or the material may not be available in an area. The profession should educate the public about such materials for the betterment of society.

Professional associations should promote the development of the profession by advocating research, quality education, communication, and responsive

The expansion of the profession.

services. There must also be a strong individual and collective commitment to the betterment of society and the profession in order to accomplish common goals that are critical to the survival of both. Professional associations play a strong role in promoting the development of services. If you read the mission statements of professional associations, you will discover their dedication to the promotion and development of the profession.

Research

The regulation of quality services is dependent, in part, on research. Because times change, technology changes, and the problems of society change, the methods and accepted practices of the profession must change to realign the service with the need. Also, the methods of practice must change in light of new information that challenges the validity of traditional practice. For example, asbestos was once frequently used in construction. However, research has shown that this material is dangerous. At one time it was legal to fire a female for being pregnant. As models for equality have changed, this practice has become out of sync with our societal expectations.

Research is necessary to move the profession forward and to change conventional professional practices. Research contributes to the body of knowledge in the field. Research in the field of interior design is promoted so that interior designers are better able to improve the quality of life; increase productivity; and safeguard health, safety, and public welfare.

A mission of service to society: Habitat for Humanity volunteers.

Some of the research related to interior design has been published in the *Journal of Interior Design*, found in many libraries or through IDEC. However, because of the nature of the field, related knowledge can be found in research journals that address environmental issues, creativity, the psychology of human behavior, and many more related topics. Searching for a topic rather than a specific journal in the library might be a better way to find relevant research on your topic. Large design-related companies and associations often publish "white papers" on their websites, and many very relevant topics can be found by searching their websites for current research and new knowledge related to the field.

REFLECTION

According to our reading, education, testing, a code of ethics and professional regulation, promotion of development, and research define a profession. Based on your new understanding of a profession, does interior design fit the definition of a profession? Does it have all the criteria? Is it lacking in one or more areas? As a future professional, what could you do to improve these areas? How could you, as the future voice of the profession, influence its direction?

MISSION AND VISION OF A PROFESSION

Mission

Every profession and organization must have a clear mission to define its purpose and the special charge that makes it unique. This mission is described in a mission statement that should summarize its aims and values succinctly. The mission should have a direct connection with the service that a profession offers, and it should be current. The mission must be synchronized with the needs of society now and in the future. The doctor's mission might be to heal, advocate for patients, educate, and contribute to human well-being. Lawyers protect us in a legal system that laypeople do not fully understand; they preserve justice and human rights. Spiritual leaders minister to our souls. Engineers design roads and bridges that afford us the opportunity to travel and transport the goods necessary for our survival. The published mission of each of these professions reflects its professional charge and its commitment to the welfare of humanity.

The architect's mission might be to provide shelters that are safe. The mission statement of the American Institute of Architects states: "The AIA continues to strive for quality, consistency, and safety in the built environment and to serve as the voice of architecture" (www.aia.org/about_history). The American Society of Interior Designers includes the following declaration in its mission statement: "Through education, knowledge sharing, advocacy, community building and outreach, the Society strives to advance the interior design profession and, in the process, to demonstrate and celebrate the power of design to positively change people's lives" (www.asid.org/about/).

The primary mission of a member of a profession is the responsible provision of an improvement in society. The mission is not about money; nor is it about being the elite in society. It is about making contributions and being dedicated to the enhancement of the quality of life for all humanity. If a profession makes positive contributions that coincide with the current culture's sense of what is important to the quality of life, and the public has a clear perception of those contributions, then the profession should thrive. Therefore, the mission is also closely tied to the vitality of a profession. You may want to review the mission statements already included in this chapter to solidify your understanding of a mission.

Vision

The vision and mission of a profession are interrelated. They are both important to the health of the profession. A profession must have a vision, whether it is order, utility, safety, or health. The *Oxford English Dictionary* defines

Biosphere 2 research facility in the Sonoran desert in Arizona.

vision as "the ability to think about the future with imagination or wisdom" (Soanes & Stevenson, 2004). Consider the following vision and mission statement:

The CIDA Statement:

Interior design is a multi-faceted profession in which creative and technical solutions are applied within a structure to achieve a built interior environment. These solutions are functional, enhance the quality of life and culture of the occupants, and are aesthetically attractive. Interior design includes a scope of services performed by a professional design practitioner, qualified by means of education, experience, and examination, to protect and enhance the life, health, safety and welfare of the public. (www.accredit-id.org/definition.html)

The *vision* statement in this definition would be *applying creative and technical solutions; enhancing quality of life; and protecting the health, safety, and welfare of the public.* The *mission* lays out the parameters, which in this case are *to enhance the function and quality of interior spaces.* This is the aim.

Vital Issues

Vision and mission statements supply a picture of the future and illustrate the aims of professions in terms of the betterment of society and the health of

the profession. Following are some of the vital issues identified by professional interior designers:

Ergonomics

Sustainability

Universal design

Environmental psychology

Integrating aesthetics with function

Research in our field is promoted so that we are better able to improve the quality of life.

What are some of the issues you believe the interior design profession needs to address in terms of design as well as advocacy? How will these topics affect our society in the future, and why do you think interior designers should be involved in these issues? What role will interior designers play in the interrelationship of the following:

- Interior design, service, ergonomics, and society
- Interior design, service, sustainability, and society
- Interior design, service, universal design, and society
- Interior design, service, environmental psychology, and society
- Interior design, service, function/aesthetics, and society
- Interior design, service, other vital issues, and society

▄▄ REFLECTION

If the purpose of entering a profession is not garnering money and admiration, what is it? How do we create interiors that society will value in the future? What are the issues surrounding the profession? For example, indoor air quality is an area that interior designers need to address. Preservation of our natural environment is another. To do more than provide solutions that have already been provided in the past, the focus of our thinking may need to change. There are many issues that are important to consider wrapping our interior expertise around in order to make a difference in society and our profession. Consider the following questions in relation to our professional responsibilities as designers:

1. What are some of the issues vital to the survival of interior design as a profession?

2. What issues are vital to the public acceptance of interior design as a full-fledged profession?

3. How can you begin to think and learn on a level that will allow you to approach problems vital to our society and to bring about innovative solutions that will change the course of our everyday lives for the better?

Is this the vision of our future?

SUMMARY

In this chapter we explored the definition of a profession and considered the characteristics of interior design in light of that definition. Being perceived as a profession in the eyes of the public is very important to our acceptance and enhances the perception of the value of the service we provide. As professionals, we must speak to clients about *their needs* and *our ability* to offer more than the amateur in the way of solutions. We have a charge to help solve the problems that exist in our society. Because current problems will change, we must be willing to rethink not only our solutions but also how we view the problems. Professionalism will be a part of your future, and understanding the nature of professional design will help you determine your own personal direction as a contributing member of this very important group.

ACTIVITIES

Activity 1

Using the language and tools discussed in this chapter, create a visual model of our profession. Be sure you can clearly explain that model in design language. The model should include what you consider the vital issues necessary for the survival of our profession.

Activity 2

Read the definitions of interior design on the following websites: www.fider.org, www.iida.org, www.asid.org, www. interiordesigncanada.org, www.ncidq.org, as well as definitions you find from other sources. Divide into teams and debate whether interior design offers a clearly defined service that enhances the public good. You can also debate other issues such the following:

- CIDA standards for accredited programs (does interior design have a specialized body of knowledge that relates to the public good?)
- NCIDQ certification standards (does interior design have a method in place to guarantee the expertise of our professional members, and is this important?)

Activity 3

After reading and studying this chapter, develop a personal philosophy of interior design and a mission that might help to guide your approach to your chosen occupation and influence the direction of your career.

David Rowland

It has been said that genius is one part inspiration and nine parts perspiration. David Rowland certainly wouldn't argue with that. In his case, success took many years of trial, failure, and dogged perseverance—ten years to be exact.

Intrigued with product design since childhood, David studied art and physics at Principia College and earned his master's degree in industrial design at Cranbrook Academy of Art. Then he headed for New York City. He rented a room for $40 a month and started going to industrial design offices to ask for jobs and show them his work. "They would say, 'This is fine. Here, we have an agreement

for you to sign that if you think of any patentable items during the course of your working for us, you will sign the rights over to us for one dollar.'"

David refused to sign the form. His dream was to license his designs for mass production and earn royalties for his work. So he passed up the security of a regular salary and cobbled together a living making architectural renderings, drawing graphs, and doing other odd jobs. In his spare time he worked on a design for a new chair and spent months perfecting a quarter-scale model. When it was finally ready, he took it to Florence Knoll of Knoll Associates, a major furniture manufacturer. "She took a lot of time, conscientiously critiqued my design, and then turned me down," David says.

A few months later he went through the whole process again, came up with another model "and again she carefully criticized it, and turned me down." As months turned into years, he continued working independently on chair designs and showing them to furniture companies, but nobody offered him a contract. Finally David realized that he needed to rethink the whole idea of what a chair does and come up with a feature too good to resist.

"One Sunday afternoon after church, I went home to my little room and prayed about that. The thought came to me, 'Why don't you lay out a drawing of a chair that can stack, and see how many chairs you can get to stack in how small a space.'" Stackable chairs were nearly unheard of at the time, and the few that existed could only be stacked four or five chairs high. But David found that he could get 40 chairs to stack in a height of four feet. He called his design the 40/4 ("forty in four") chair.

He knew he would need to make two full-scale models this time, and he hesitated, considering the expense. "I was poor, and I decided I first needed to get reassurance, so I visited the head of architecture and design at the Museum of Modern Art. He told me, 'Mr. Rowland, there is no market in the United States for a stackable chair.'"

Photo courtesy HOWE

Nevertheless, David was convinced he had a red-hot idea. Trusting God's guidance, he went ahead and built two prototypes, which he took to Knoll. "The two chairs, one stacked on the other, looked like just one chair. I went in and said, 'Mrs. Knoll, I want you to see my new chair.' She looked at it, and I then pulled the top chair off and said, 'Actually it's two chairs.' She sat on the chair and considered it for about 15 seconds and said, 'We'll take it!'"

But David's jubilation was cut short when his contract with Knoll was canceled six months later. Was he tempted to feel discouraged? "I have tried to discipline myself not to use that word," he says. "Disappointed, maybe, but not discouraged, because that means you have no more courage." So he pressed on, pitching his stackable chair both inside and outside the United States.

Eventually he was led to show the design to a group of architects who needed chairs for a university campus. The architects loved the 40/4 chair, and the GF company, a manufacturer of office furniture, sold 17,000 in the first order.

The rest is design history. Since it debut in 1964, the 40/4 chair has been in continuous production and is one of the bestselling chairs in the world. It has won prestigious design awards and is featured internationally in museum collections. These days David and his wife Erwin live in the Blue Ridge wilds of Virginia, but he continues to maintain a studio in New York, where he says the motto among his team of designers is, "The different is seldom better, but the better is always different."

From "Designer Celebrates 40th Anniversary of Hard-Won Success," by Nancy Mullen in the *Principia Purpose,* Spring 2005, Number 248, p. 16. St. Louis, MO: The Principia.

Kitchen by Berkshire Homes,
Westminster, Colorado.
President Cayd Bader
*Photograph by
Michael Brian Gates*

Professional Options

Choose a job that you love and you will never have to work a day in your life.
—Confucius

Objectives

After studying this chapter, you should be able to:

* Introduce careers in interior design by PRSM dimension and aspect.

* Identify the overall focus of each professional track.

* List the personal characteristics contributing to success in each professional track.

* Analyze individual jobs.

A successful career strategy will match your needs, interests, and goals to jobs offering long-term opportunities in an appropriate professional path. Interior design is a field of diverse career opportunities, each with special characteristics, responsibilities, and requirements. Our goal in this chapter is to introduce the wide variety of interior design positions available and enrich your image of a career in interior design. Your future may include additional education, further professional training, or hands-on experience. Some specialties will require it. We have detailed these requirements in the job descriptions where they apply.

Finding your focus.
Source: Ink drawing by Shari Park-Gates

The options reviewed here are by no means the only opportunities open to people with design degrees. Your personal research will ultimately determine the type of position that fits best with your goals and needs. To make it easier for you to align potential jobs and careers with your current personal profile, we present those options in the now familiar PRSM format. Broad career venues will be organized by contextual dimension (intellectual, organizational, social, material, natural, financial).

Professional expectations shaping designer performance will be explored by personal aspect (physical, emotional, mental). Additional job details and specifics will be provided in diverse thumbnail descriptions and developed through profiles of practicing designers. Interactive exercises and opportunities for reflective journaling throughout will also help you find your way into the industry.

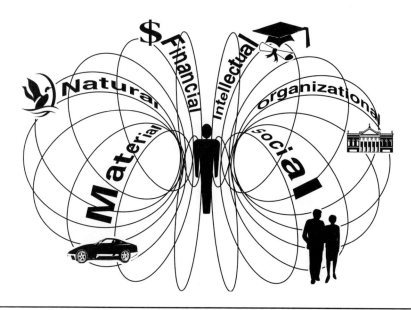

Your own unique PRSM profile will ultimately identify the design niche that best fits your goals and needs.

*Source:*Barbara McFall, 1998

INTERIOR DESIGN EDUCATOR

Interior design educators work with the ideas and content knowledge of interior design. They study and teach many design-related topics, including but not limited to the following:

- Design process
- Principles of design (scale and proportion, balance, rhythm, emphasis, harmony)
- Elements of design (space, line, shape and mass, texture, light, color, pattern)
- Specific skills necessary to communicate and realize design concepts

Design education takes on many forms and reaches people at a variety of ages (secondary, postsecondary, professional, and popular). In the secondary schools, interior design is often part of a larger curriculum within Family and Consumer Sciences; it is rarely taught as a stand-alone course. Some vocational schools, however, offer it as an introduction to a career path. Postsecondary schools (colleges, universities) offer interior design as a stand-alone major in several contexts, including Family and Consumer

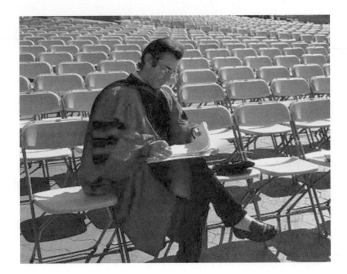

The work environment for educators is primarily classroom, studio, and office based.

Sciences, architecture, design, or fine arts. Each of these programs has a similar core of courses providing a basis for interior design practice. Each program also is unique and may focus on design as art, design as function, or design as sculpture.

Understanding the focus of a program prior to seeking a teaching or administrative position will help to increase the "fit" between your personal style and background and the expectations of a design program. Nontraditional teaching opportunities are also available and may include online courses; distance education; continuing education classes; or radio, television, or popular press offerings. In addition to teaching, a career in design education offers opportunities to conduct research in the field of design and write about issues relevant to the field, and design theory.

Physical Aspects

The work environment for educators is primarily classroom, studio, and office based. Rarely are client meetings required of educators. Visits to a job site are minimal and are usually in conjunction with a student project or community assistance program. Classroom environments vary depending on the type of class you are teaching and the type of organization you work for. Secondary teachers begin and end their days early. College and university schedules tend to run a little later, and adult offerings often target nights and weekends. Students are typically eager to learn and are interested in the subject; however, some programs at secondary and vocational levels may

target troubled youth. Further, the nature of studio work and deadlines does cause stressful reactions during heavy work periods. The ability to stay calm and help students do the same is vital during these potentially explosive times.

Nontraditional education may not take place in a standard classroom, but may use computer equipment, videoconferencing, or other technology-based tools. Different teaching strategies are necessary for nontraditional educational settings, and support is available to help with this transition. Researchers may work in a variety of settings depending on the type of research being conducted. Design journalists may work from home; in an educational office; or in the office of a trade journal, book publisher, or newspaper as required.

Emotional Aspects

Above all, people considering design education must enjoy working with others to increase their abilities to design. They must be patient and want to explore new and exciting ways to accomplish design solutions. Educators must be creative and self-directed and possess a broad understanding of design subjects. Not only must design educators be able to create well-designed spaces to provide examples for students, but they must also be able to teach others to see, appreciate, and ultimately design their own creative, workable environments. Valuing the uniqueness of each student is critical, and design educators must continually seek ways to present materials that meet the educational needs of all students, while providing opportunities for self-discovery through the design process.

Mental Aspects

Educators are generally expected to be lifelong learners. Secondary teachers are required to complete teaching certification and a student teaching experience in addition to their interior design specialty. Continuing education credits are mandatory. Many secondary teachers acquire graduate degrees. Postsecondary educators have graduate degrees almost exclusively. Colleges and universities typically require at least a master's degree in interior design or a related field; some larger institutions and research-based universities require a terminal degree such as an MFA or PhD.

Teacher—Secondary Education

Teachers of interior design in the middle and high school setting introduce personal design skills and prepare students to make informed career decisions.

Typically, the classes are taught as a part of a larger curriculum (FCS, Art, etc.) but may be stand-alone introductory courses in vocational schools.

Professor/Instructor/Researcher—Postsecondary Education (i.e., college, university)

Many colleges and universities today offer a major in interior design or a related field. Courses may vary depending on the type of program (art oriented, consumer oriented, etc.), but the core courses will be similar throughout all programs. CIDA-accredited programs have been recognized as programs that provide students with a full complement of courses and experiences to prepare them for work in the interior design profession upon graduation. Interior design researchers generally hold teaching positions in research-intensive universities and conduct research in conjunction with their teaching assignments.

Teacher—Alternative Adult Education (i.e., continuing education, online education)

Alternative education ranges from "do-it-yourself" consumer classes to online bachelor's degrees in design. Those who teach adult education courses often do so to practice design as a complementary activity, prepare for a job change, or explore new ways of improving applied designs.

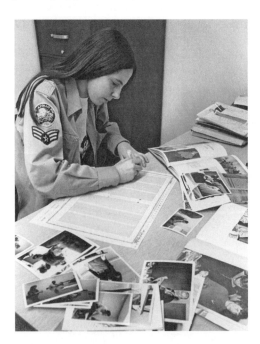

Design journalists may work with the popular press (books or magazines), newspapers, trade magazines, online publications, television, radio, or other media.

Journalist

Design journalists may work with the popular press (books or magazines), newspapers, trade magazines, online publications, television, radio, or other media. Positions may be freelance or associated with a specific publishing group, and cover a wide variety of topics. A good background in design provides a foundation for appropriate writing on the subject and allows the writer more insight into the issue being addressed.

COMMERCIAL ("CONTRACT") DESIGNER

The terms *commercial design* and *contract design*, often used interchangeably, refer to the design of nonresidential spaces in which the design professional enters into a formal contract with the client to complete design services. Commercial designers work in support of organizations. The spaces they design enable the organization and its people to do the work they do efficiently, effectively, and profitably. Contract design services include the following:

- Planning
- Programming (gathering detailed data about the type of business, climate of the business, requirements of the person in charge, requirements of workers, etc.)
- Schematic design
- Design development
- Construction documentation
- Contract administration
- Postoccupancy evaluation to ensure the satisfaction of everyone involved in the new space

Designers may work for companies that exclusively provide design services, or for corporations that maintain in-house groups to design, build, and oversee new construction and renovations of existing facilities. Contracts may be full service, or clients may identify specific activities that designers are to complete while maintaining responsibility for the remaining tasks.

Physical Aspects

The work environment in commercial and contract design is typically office based, with office hours generally required Monday through Friday.

These environments are generally professional, clean, and well designed to promote the recognition of and appreciation for the design competency of the firm. Client meetings are frequent and may be conducted in the designer's office or at the client's facility. Some commercial opportunities require considerable travel for extended periods of time. Working in different areas of contract design may expose the designer to a multitude of environments from hospitals to school facilities to retail outlets. Job site visits are required. Often these sites are under construction, making it necessary to consider physical safety and dress appropriately. Firms often specialize in particular types of design, allowing designers to become familiar with the characteristics of a specific industry.

Emotional Aspects

Commercial designers working under contract for organizations generally experience a formal working environment. Designs and specifications are less "personal" in nature and typically represent the company more than an individual. Contract designers may form strong relationships with their clients, but generally the relationships are less personal than those required for residential design. Corporate politics may play a significant role in the design process. Contract design is characteristically deadline driven, and clients have a high expectation for fast turn-around on designs. This pressure can cause a high level of stress in design offices, and it is important that the work environment allows opportunities to defuse stressful situations before they become harmful.

Mental Aspects

Contract design can be technically challenging. The designer must have a clear understanding of construction methods; building and life safety codes; federal legislations; and local requirements for the design, construction, and renovation of commercial structures. Contract designers must be able to multitask easily and not become frustrated with group decision-making dynamics. Strong communication skills are paramount, and negotiation skills are important to avoid the escalation of conflicts. Budget tracking, job scheduling, and continual coordination of activities and products are often primary activities required of the contract designer in addition to designing spaces. Different types of facilities may require different design and personal strengths.

Office Designer

The design of office space comprises a significant amount of the activities performed by contract design professionals. Projects range from small offices

outfitted with traditional or contemporary fittings to multifloor, panel-system installations. Many design firms specialize in office design, and most incorporate the design of office space at some level within their design portfolio.

Healthcare Designer

The design of healthcare spaces is the fastest growing area of design today. Healthcare design requires a level of detail and specialization not required by many other design fields. An understanding of, and increasingly additional training in, the technical nature of healthcare is an important asset for the healthcare designer.

Hospitality Designer

Hospitality design is an exciting and growing field within the design profession. Within this specialty area, designers are responsible for the design of spaces that provide social enjoyment such as hotels, restaurants, resorts, conference centers, and spas. Entertainment design is another specialty area within hospitality design and includes facilities specifically for entertainment such as casinos, theme parks, theaters, and clubs.

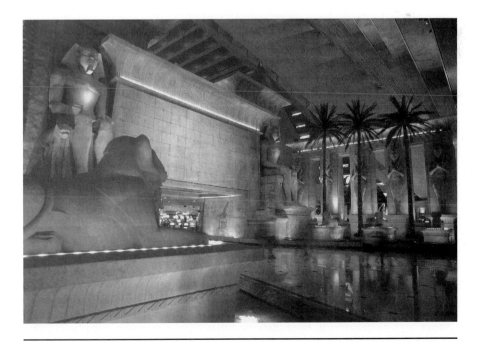

Hospitality design is an exciting and growing field within the design profession.

Government Designer

The U.S. government hires employees to design military, public, and bureaucratic spaces; procure furniture and equipment; and oversee national cultural resources such as the White House and embassies throughout the world. Government positions are often centralized in large cities or near cultural resources, and are relatively stable in terms of salary, benefits, and work expectations.

Retail Designer

Retail design requires an understanding of the target market of the client's business as well as an appreciation for the psychology of space in relation to sales and consumer behavior. Like hospitality organizations, large retailers may retain design professionals to create all of their facilities, or may hire designers associated with design and architecture firms to create specific places.

Transportation Designer

Transportation design traditionally concentrates on spaces such as airports, train stations, and other facilities supporting travel. Options may also exist,

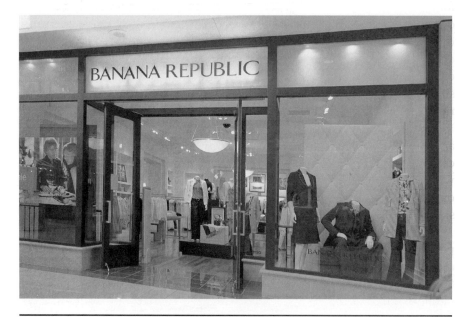

Retail design requires an understanding of the target market of the client's business as well as an appreciation for the psychology of space in relation to sales and consumer behavior.

however, within the transportation industry to influence and participate in the design of new transportation vehicles such as alternative automobiles, mobile homes, cruise ships, and customized train cars and airplane compartments.

CAD Operator

Designers with a love of computer work and a minimum need for client contact may enjoy becoming specialists in computer-aided design and drafting. Although it is important for all designers to have a working knowledge of CAD, many larger firms with complex or high-end projects employ people to work predominantly on computer drafting and detailing, allowing other design professionals more time to design, manage projects, perform administrative tasks, and supervise others. CAD operators must have a strong knowledge of computer drafting and design programs and be able to continually update their knowledge as new programs or updated versions emerge onto the market. Many firms use one or two programs exclusively, whereas others may draw on several types of programs to provide product interface; supply mechanical, electrical, and structural specifications; manage and use geographic data; as well as design and render spaces.

CAD work is generally office based, and there is seldom a requirement for the CAD operator to regularly attend meetings or be on the job site frequently. As a part of the design team, however, there may be an expectation to attend some meetings or visit a job site in the early stages of a project to increase familiarity with the project details and client needs. Appropriate equipment, supportive furniture, and proper lighting are critical for this position because the job entails prolonged interaction with a computer and peripheral equipment.

CAD operators are generally considered support personnel, but they are recognized as an important part of a full-service design team. Historically, CAD operators were simply computer drafters who translated the work done by others into digital format. Today, this is changing, and CAD operators often have the responsibility of interpreting designers' drawings, sketches, and specifications into fully cohesive digital drawing packets.

Presentation drawings may also be the responsibility of the CAD expert, and 3-D renderings and a digital "walk-through" of the space provide clients with a more complete understanding of the design created by the team. Detail-oriented people who enjoy working in a team setting and providing support to others, and who recognize the critical contribution of strong technical support to the design process, will be well suited to this type of position.

3-D renderings and a digital "walk-through" of the space provide clients with a more complete understanding of the design created by the team.

RESIDENTIAL INTERIOR DESIGNER

The work environment for residential designers is often smaller and less formal than that of other types of designers (e.g., commercial). As the name implies, residential designers work primarily with individuals and families to design and furnish their living spaces. Residential designers may work with clients with modest incomes wanting a little guidance in their planning and purchasing, or they may work with the rich and famous designing high-end residences and vacation homes.

Residential designers may work for a small company, as individual consultants, or as a part of a team in a larger organization. Some retail establishments such as department stores and furniture stores hire designers to provide a service to the customers purchasing their products. Home improvement stores such as Home Depot Expo and Lowe's Home Improvement Center also provide design consultation services to help homeowners make decisions that they will implement and install themselves. Designers occasionally establish small retail businesses to provide full-service design, furniture, and finish resources for their clients. Other professionals such as developers and real estate agents also employ designers to create model homes, help customers with design decisions as they purchase homes, and

Residential designers may work with clients with modest incomes wanting a little guidance in their planning and purchasing, or they may work with the rich and famous designing high-end residences and vacation homes.

aid in the preparation of homes to show and sell more effectively. Developers sometimes offer design services provided by in-house designers as part of the selling package.

Although the work environment of residential designers may be less formal and the schedules sometimes less hectic than that of other designers, the trade-off is that residential designers often receive lower pay than some other design specialists. Some areas of residential design (e.g., celebrity design, product sales with design services) can be more lucrative, but generally the pay scales for residential design are below that of commercial design. The work environment itself is generally pleasant, and less time is typically spent on construction sites than in some other areas of interior design. Designers spend much time "shopping," either through catalogs or in retail or wholesale establishments. Design centers are also available in most large cities, minimizing the need to travel to a wide variety of showrooms located in different places. The work itself can be intense, but the presentations and working relationships with clients are often more personal and provide opportunities for the client to help make both large and small design decisions.

Physical Aspects

Residential designers must be flexible with their schedules because they often work with clients during off times such as nights and weekends because of clients' work schedules. Because residential designers are often on the go, it is helpful to have some of the organizational structure in a portable format. Close contact with people, familiarity with trends and products, strong organizational skills, and the resources to purchase unique and appropriate items are vital elements for the successful residential designer.

Emotional Aspects

Residential designers must enjoy close contact with people. Residential clients are often less experienced in working with professional designers. As a result, building relationships is a critical part of a residential designer's job because the designer is frequently in the residence throughout the process. The clients are spending their own funds on a space that may be central to both their self-images and the smooth functioning of their daily lives. It is therefore imperative that clients be comfortable in the designer's presence and feel that their input is valued and understood. Residential designers sometimes become "part of the family" as they spend time getting to know not only the desires, but also the inner workings of families within their living spaces. Designers are ethically bound to respect and uphold the family's privacy.

Mental Aspects

Residential designers must be familiar with new trends in housing and interior furnishings and should understand construction methods to help guide clients into realistic design solutions. Organization is imperative, and residential designers must be able to keep track of time, billing, products, delivery schedules, and a multitude of other elements for each project.

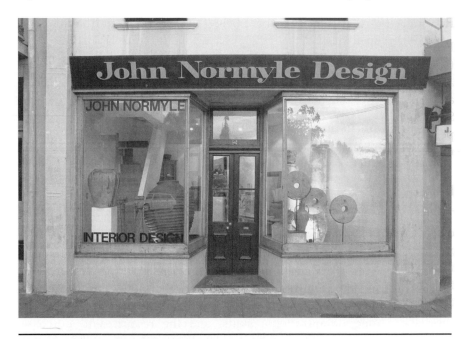

Designers occasionally establish small retail businesses to provide a full service, offering both design and products.

Retail positions are abundant and generally less demanding than those in other interior design venues.

Retail Sales or Design Consultant

Furniture stores, paint stores, home improvement centers, and other retail establishments that focus on interior products sometimes hire design consultants to provide support services to their clients. Retail positions are abundant and generally less demanding than those in other interior design venues. Sales are generally "cash and carry" or "light custom." This mode can be especially attractive to early and late career designers, as well as to those who must accommodate a spouse's career or children's schedules.

Designer—Individual Homes

The most common activity for residential designers is to work with homeowners to help them renovate an existing space or design and build a new residence. This activity can entail a number of options, each with its own focus and "personality" of design. Some designers position their services to help moderate-income families and families who want to do much of the work themselves but need some help determining the type of work that needs to be done. Designers help with planning, decision making, and sometimes acquiring furniture or finishes for these moderately priced projects.

With more upscale design, the residential designer has more input and works closely with the residents to help design a new home or renovations for an existing home. Projects of this magnitude may be undertaken alone or as a part of a team including an architect, landscape designer, and other specialists. This is generally a full-service type of project, and the design team will often contract with others to provide construction and finishing services. Furniture is sometimes purchased on contract or through other suppliers, and the designer is responsible for overseeing the purchase and installation of furniture and finishes.

Designing for national or international celebrities (celebrity design) also falls into the category of upscale design, although the budget and expectations for celebrity design may well exceed the typical upscale design project.

A final focus of residential design is the design of nontraditional homes or living spaces including yachts, mobile homes, student housing, and other specialty spaces. Each of these areas requires a level of expertise and an understanding of the use of the space as well as the specific parameters of the construction. Close contact with residents or users will facilitate a more successful design for specialty residences.

Designer—Model Homes for Developers

Designers create prototype design schemes to help prospective buyers see the potential for interior space usage and consider decorating possibilities. Developers may also employ designers to help design and plan the interiors of new prototype (or "spec") housing to more fully meet the needs of the buyers and to make the homes more marketable.

Residential Custom Product Designer

Custom-designed products are used often in residential design, and designers can create functional, aesthetically satisfying elements that add to the value of the home. Products include custom storage units, custom entertainment units, custom kitchen or bath elements, and custom computer or work stations.

Consultant for Real Estate Agents

Sellers often need help to present their homes in the best light for selling. Real estate agents sometimes employ consultants and designers, called "stagers," to work with sellers to prepare homes to show well for open houses and sales visits.

Sales/Move Coordinator

Some large companies that frequently move employees from one location to another, provide services to aid in employee relocation. Sales/move coordi-

Custom-designed products may include custom storage units.

nators help families prepare for the move, organize elements of the home for sale, and coordinate the move and relocation details for the employee.

▬ REFLECTION

In the preceding pages you read about professional opportunities for designers that include teaching, commercial design, and residential design. In evaluating your personal characteristics based on the PRSM model discussed in Chapter 1, how do you feel you would fit within each of these options? What personal characteristics draw you to one of these options over the others? Do you have any characteristics you believe might hinder you in any of these options?

DESIGNER—MATERIALS AND FURNISHINGS

Designers specializing in the material dimension are concerned primarily with the constant flow of exciting and accessible new products critical to the design industry. Specialty designers become subject matter experts through

their focus in school as well as through additional education and experiences that provide knowledge in a particular subject and an understanding of how that knowledge needs to be used to support design as a whole. They may create new market products, assemble and promote specialized collections, or develop and implement custom solutions in their unique area of product expertise. Each specialty has its own unique work environment, making it impossible to generalize about working conditions, salary, or travel expectations. However, these designers tend to prefer work in wholesale markets (furniture, fixtures, textiles, coatings/coverings, and accessories) or in support of front-line designers.

Design firms and others in the design and construction industry hire specialty designers to fill a need they have on staff, provide support to others within their organization, or elevate their reputation in a particular area. Specialists often act as consultants and work for numerous companies needing their specialty for particular projects. Some specialty positions such as window treatment designers, colorists, and kitchen and bath designers may also be associated with retail establishments and combine their specialty knowledge with sales.

Specialists may design kitchens and baths.

Physical Aspects

Materials-based design has special appeal for tactile or kinesthetically inclined people. Certain specialties may require specific abilities such as accurate color perception; small or large motor skills; or an affinity for working with specific materials such as wood, metal, or fibers.

Emotional Aspects

Some specialty designers choose to work in support roles because they work more effectively alone or prefer to provide assistance to others instead of being the "up front" person in a project. Furniture and product designers may have personal studios where they design and fabricate their own creations, then sell their designs to others. Most important, specialty designers must be passionate about their chosen areas and take responsibility for continual learning about the subject.

Mental Aspects

Self-directed learning and personal initiative are important drivers of creativity and cutting edge knowledge in these fields. An ability to educate others is also helpful, because specialty designers are sometimes called on to work as a part of a design team to ensure that their area of expertise is considered in all parts of the design.

Product/Furniture Designer

Although product design is often associated with industrial design, many interior designers become specialists in furniture, accessory, or textile design. Creating specialty items for unique projects, or designing one-of-a-kind items for sale and distribution through retail outlets, are both options for designers concentrating on product or furniture design.

Colorist

The color specialty field is a sophisticated area of concentration. At a local level, colorists may work with clients to determine the color combinations most effective for specific environments, both residential and commercial. Nationally and internationally, colorists are involved in predicting, directing, and creating new colors for future use in the design and fashion industry and shaping color ways for current production.

Many interior designers become specialists in furniture, accessory, or textile design.

Lighting Designer

Lighting has become an important specialization within the past ten years, and lighting designers provide additional expertise in showcasing homes and businesses with light as well as ensuring that functional needs are met at the highest levels. In this technical field, lighting specialists must have additional knowledge and training in areas such as optics, color, electrical elements, energy codes, and sustainable lighting practices.

Window Treatment Designer

Window treatments have become more elaborate and complex, and the design and fabrication of these treatments is a highly prized specialty. Typically, the designer of custom window treatments is fully familiar with textile characteristics and construction methods and often operates as both a designer and supervisor of fabrication.

Kitchen and Bath Designer

Elaborate kitchen and bath designs have grown in popularity and often require a specialist to maintain current knowledge about trends and product availability. Kitchen and bath specialists may work in specialty retail outlets that sell and design kitchens and baths exclusively, or they may work as a part of a larger team within a firm to provide specialty support.

Some schools provide focused course work on kitchen and bath design, preparing students for potential certification by the National Kitchen and Bath Association.

Some schools provide focused course work on kitchen and bath design, preparing students for potential certification by the National Kitchen and Bath Association (NKBA).

SALES—MATERIALS AND FURNISHINGS

The sales, marketing, and merchandising of products related to the interior design industry is an important profession that requires an understanding of both product applications and overall design. A sales professional may be employed in a retail environment such as a furniture store or paint and wall-covering outlet, or as manufacturer's representatives selling directly to design firms. Manufacturer's representatives may sell exclusively to the architectural and design community, or they may offer their products to a wide variety of both retailers and wholesalers.

Physical Aspects

Retail establishments typically depend on individuals or groups coming into the place of business to purchase or order furniture, accessories, and finishes, and must market in such a way as to draw their customers to their location. Manufacturer's representatives typically travel to their clients' location, and

their sales are primarily through catalog and sample distribution. Merchandisers may also be in sales, but concentrate on the display and context of the product, helping potential buyers see how specific items may be used in different environments. Merchandisers often work within retail establishments designing showrooms and vignettes for customer viewing. E-tailers may work from a central location or be physically located anywhere and networked to clients and product via computers.

Emotional Aspects

People who are successful in sales generally possess an outgoing personality and an ability to engage and connect with potential clients. Strong communication skills, the ability to interpret the needs of individual buyers both in terms of product and sales approach, and the motivation and ability to close a sale and deliver on commitments are critical characteristics needed for a successful sales career.

Mental Aspects

Sales representatives with an understanding of the interior design industry can communicate effectively with design professionals and the general public about appropriate products for specific design needs. Sales professionals must pay attention to details to ensure correct ordering and billing for items and be able to evaluate options and solve problems quickly as they arise with clients. Merchandisers must understand the difference between designing for client needs and designing for product sales. Successful merchandising strategies result from a careful study of buyer behavior and an awareness of the market niche of the featured products.

Retail Sales Personnel

Sales personnel are generally located within retail establishments such as furniture stores, paint stores, specialty stores, and other establishments selling directly to the public. Designers in this setting often perform the dual functions of sales representative and design consultant.

Manufacturer's Representative

People representing specific manufacturers support the retail distributors and specifiers of the products offered by the manufacturer. They visit sales facilities, introduce new products, update sample libraries, and offer assistance to

Merchandisers must understand the difference between designing for client needs and designing for product sales.

local sales and design personnel as they specify and purchase product. Sales representatives acting in this capacity are often required to travel, and their territories may range from a city to a multistate region.

Retail Visual Merchandiser

Visual merchandising involves creating showroom, vignette, and advertising displays to present products in their best applications and show items within a context. Merchandisers often work within retail companies, but may also be part of advertising firms, web sales groups, and manufacturer's design staffs to create visual displays to be photographed and include in catalogs, ad campaigns, and websites.

Showroom Manager

Showroom managers oversee all the workings of retail and wholesale showrooms including the design and installation of displays; the ordering and sales of furniture, finishes, accessories, and other items offered for sale; and all administrative activities related to directing a successful sales showroom. People chosen for these positions are experienced in management and sales. A strong background in design provides an additional advantage in the hiring process.

Materials-oriented careers require added attention to certain product lines, supply chains, and histories. Those considering a career in this dimension should further investigate the following:

- Accessories
- Architectural details
- Furniture
- Fixtures
- Floor coverings
- Paint and wallcoverings
- Windows and doors
- Window treatments

SUSTAINABLE ("GREEN") DESIGNER

Clients and regulators are beginning to demand a sustainable approach to design and specification that is more sensitive to nature. In response, design and architecture firms are seeking design professionals with competence in

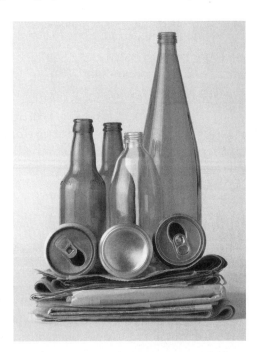

Green designers evaluate the impact of design decisions on the ecological environment.

Although environmentally
sensitive decisions should be
made in all projects, some
professionals choose to
become experts in this area.

environmentally responsible design, often called "green design." Green designers evaluate the impact of design decisions on the ecological environment. Although this may sound simple, it involves very complex issues. A perfect answer is not always available. Designers must consider how a product is made and the manufacturing process in relation to the environment. Travel and shipping requirements must also be evaluated, because both may have a negative impact on the planet. Installation is also a factor: Does the method of installation have an effect on the locale or the people involved in the installation itself? Product life cycles and disposal upon removal also influence decision making in a sustainable approach.

Environmentally sensitive decisions must be made about the interiors of buildings as well. Because poor air quality can have a significantly negative effect on the residents of the space, indoor air quality has become a major concern in facilities. Design decisions that reduce the presence of toxic fumes and minimize the use of products that produce volatile organic compounds (VOCs) ultimately help those working or living in the spaces to be healthier and more productive and to generally feel better. The organization Leadership in Energy and Environmental Design (LEED) has taken the lead in providing guidelines and a voluntary certification process to help design and construction professionals make effective decisions regarding the sustainability of new and renovated facilities. Although environmentally sensitive decisions should be made in all projects, some professionals choose to become experts in this area.

LEED Accredited Professional

Those accredited through the Leadership in Energy and Environmental Design organization (LEED) are experienced professionals capable of implementing the LEED certification process in design projects. LEED professionals are responsible for ensuring that good design decisions are being made in relation to sustainability in all areas of design and construction projects.

Feng Shui/Vastu Consultant

Many Asian and Indian cultures base design decisions on special training in energy movement and working with natural elements within a space. Vastu is the Indian practice of holistic design with a basis in the five elements of water, fire, space, air, and earth. Feng Shui, the Asian adaptation of Vastu, has grown in popularity in the United States and uses the elements along with energy movement as the basis for design decisions.

Green Design Consultant

Design consultants well versed in green design principles may choose to become specialists and offer their knowledge to support other design professionals. Consultants may or may not be LEED accredited professionals, but are experts in materials and construction techniques that lead to environmentally responsible projects. They may choose to work for one firm and be the expert resource for their colleagues, or they may be independent consultants and support many firms.

Products and interior materials are receiving more attention regarding the impact of their production on the environment.

Environmental Consultant

The environmental impact of design has led to the creation of science-oriented specialists who evaluate the effect of design decisions and products on the surrounding setting. Environmental consultants evaluate indoor air quality, toxic emissions of interior materials, and the ecological impact of construction on the site and locale. Although these people do not typically design spaces, an understanding of the design process allows them to fully coordinate their efforts with the design community to produce suitable design solutions with minimal environmental impact.

Green Product Designer

Products and interior materials are receiving more attention regarding the impact of their production on the environment. Green product designers base the majority, if not all, of their decisions on green design principles. They have a good understanding of science and ecology, as well as design, and may work with large manufacturers to develop products or on their own as specialty designers. Environmentally sensitive products range from furniture and accessories to interior materials such as carpet and textiles.

FACILITY AND PROJECT MANAGEMENT

The management of both facilities and projects requires a full understanding of the design process, construction, scheduling, budgeting, and coordination of a multitude of people and elements. Projects range from minor interior renovations with furniture installation to the design, construction, fitting out, and occupancy of a multifacility complex. Project managers may be responsible for overseeing a single project or several simultaneously, depending on the size and scope of each project. Facility management often spans many projects and is more focused on furniture and equipment procurement, inventory, management, and dispersal. Facility managers may also coordinate the construction and renovation of spaces as well as the relocation of the occupants of the facility. Project and facility managers work closely with designers and the design process, so a complete understanding of design is a positive attribute. Both positions involve constant demands, on-the-spot decision making, and frequent challenges. There is quite a bit of satisfaction, however, because the results of the work are readily visible. People in these positions are rarely bored.

The work environment for both facility and project managers revolves around the project site. This is often a site under construction, but in the case of a facility manager, it may be any site where furniture, equipment, or people are being relocated, added, or removed. Project managers may work from a central location and be assigned to projects as needed, necessitating considerable travel and time away from home. On the other hand, they may work for a firm with an in-house group that handles projects locally and does not demand extensive travel. Facility managers often work in close proximity to the groups they support. Facilities may be centrally located and all workers are located onsite, or the facility manager may have responsibilities for regional facilities covering a larger geographic territory. Facility managers generally spend more time in their "home" location and manage many of their responsibilities using computers, phones, videoconferencing, and other means of long-distance communication.

Physical Aspects

Facility managers and project managers need to be high-energy people with stamina who enjoy working with a wide variety of people.

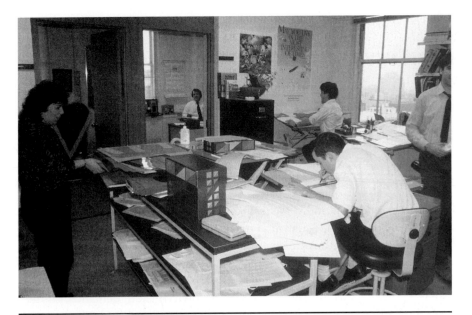

The management of both facilities and projects requires a full understanding of the design process, construction, scheduling, budgeting, and coordination of a multitude of people and elements.

Emotional Aspects

At any given time, a project or facility manager may meet with the president of a corporation, coordinate with a tenant, discuss design revisions with an interior designer, or work with construction laborers to remove debris from a construction site. Flexibility and strong communication skills are critical, and a respect for the job each person performs is vital.

Mental Aspects

Facility and project managers must be extremely organized and able to retrieve information instantaneously. Budgets and schedules often drive projects, and the manager should not only be aware of these elements, but also have clear control over them at all times. Problem solving is paramount in these positions, and quick thinking and an ability to explore creative options to challenges will lead to a productive and successful career in these fields. Project and facility managers must have an up-to-date understanding of zoning, codes, local legislation, and permits and foster strong relationships with local building officials. Facility managers must also have the ability to manage in-house programs on critical issues such as ergonomics, safety, and environmental concerns.

Interior Design/Architecture Firms

Design firms will generally assign a person to oversee each project and manage both the design coordination and administrative coordination. These people also provide the main interface with the client and are the one point of contact through which all information is routed. Project managers within design firms generally hold management positions that require significant project experience.

Corporate In-House

Many corporations hire facility managers to maintain records of furniture and equipment inventory and be responsible for overseeing issues dealing with space, furniture, and equipment. Some corporations that open new facilities on a regular basis (e.g., restaurants, retail chain stores, etc.) have a centralized group of project managers as well as other design professionals who design and oversee the construction of all of the corporation's facilities.

Facility Management Company

Smaller firms or companies with little interest in hiring in-house help to manage facilities turn to companies that specialize in this task. Facility management

firms have central locations and support a wide variety of companies with services such as furniture inventory, movement of employees within company spaces, and maintenance of company furniture and equipment assets.

Project Management Firms

Project management firms, like facility management firms, provide support for companies with little or no internal groups to oversee projects. Project management firms may be centrally located and send project managers all over the world, or they may concentrate primarily on the geographic region within which they are located. The firm provides administrative support to the manager, allowing the manager to focus on the project, rather than on communicating with the client.

Development Firms

Developers often employ project managers to oversee major development projects. These projects, again, may be local or could be worldwide, depending on the market and the focus of the development company. Large developers pay their employees' expenses for travel and relocation for positions requiring them to move.

OVERARCHING THEME: DESIGN OVER TIME

Our discussion thus far has been structured around immediate personal experience, single dimensions of practice that might be your focus in your own time and place. Many firms and designers choose to work more broadly, incorporating multiple dimensions of practice in designs that span either time or populations. Designers working over time might apply the principles of universal design to predictable life progressions. They might also specialize in design for a particular age and stage (e.g., children's spaces, geriatric spaces, etc.). Alternatively, they might choose to specialize in the preservation, restoration, or adaptive reuse of historically significant interiors.

A career in historic preservation is focused on the protection and conservation of resources from previous historic periods. Preservation is typically focused on buildings, but can also be translated to materials such as furniture, textiles, and accessories. Many opportunities are available in different venues of historic specialties, each with its own specific knowledge

base and focus. Building preservation may give way to building adaptation or adaptive reuse, allowing historic features to be preserved while updating structures to accommodate the needs of today's families and tenants. Specialists in period finishes may act as consultants in both renovation and adaptive reuse projects, as well as museum exhibits. Antiques specialists' expertise will be used in these settings as well, and may also be valuable to residential and commercial designs reproducing specific historic periods. Knowledge of historic details and a commitment to preserving the past while educating people about the importance of historic contributions is critical to success in this focus of the design field.

Physical Aspects

Work environments for this specialization are typically less hectic than those for some other positions in design, but can carry their own sense of urgency and deadlines as with any design project. Preservation on a large scale requires more on-site coordination, whereas adaptive reuse, finish restoration, and museum exhibits may require more time spent in the office, studio, or laboratory.

Emotional Aspects

Many jobs in this field are government based, such as in federal, state, and local historic preservation offices. Others, though, are with private organizations such as nonprofit preservation groups, historic period design consultant groups, adaptive reuse design or architecture firms, museums, or antique restoration and supply companies. Interaction with others is common, but the relationships are different from those in residential and commercial design. Whereas traditional designers interest with clients, people in this specialized area typically come together as a result of their common interest and commitment to history to accomplish a mutual goal. Presentations at clubs and organizations are customary because of the general interest of the public in history. This area of career can be very satisfying and rewarding for those who fully understand the background and expectations.

Mental Aspects

Historic preservation or specialization careers are based on a deep love for history and an appreciation of the contributions of past generations. Because the significance of historic items is often undervalued, resulting in the loss of

Antique dealers supply both individuals and companies with authentic period pieces.

vital pieces of history for the sake of parking lots and megamalls, a talent for educating the public and advocating for preservation are important tools in the preservation and reuse fields. The field is quite detail oriented. Whether writing nominations for the National Historic Register or restoring a single antique piece, people in this field must be able to pay attention to minute details. Enjoyment of reading and sharing knowledge with others, an ability to understand connections between historic periods as well as between cultural and world events influencing architecture and design, and a desire to make a difference by preserving icons of the past will bring job satisfaction to those in these specialized fields. Graduate study can be beneficial.

Antiques Dealer/Restoration Specialist

This employment option may fall under both historic preservation and sales, but because of the specialized nature of antiques, we are including it in this section. Antiques dealers supply both individuals and companies with authentic period pieces and often repair and restore pieces to their original condition. Dealers are constantly looking for suitable antiques, which may take them to auctions, flea markets, and estate sales on a regular basis.

Preservation/Restoration Designer

A preservation or restoration designer reestablishes the historic integrity of buildings, spaces, and elements and returns them to their originally constructed state. Preservationists must have a clear understanding of all details of the historic period in which the structure or element was built and stay true to the original intent of the design.

Adaptive Reuse Designer

Designers specializing in adaptive reuse generally work in design or architectural firms and concentrate on preserving elements of historic structures while designing new interiors, additions, or infrastructures to accommodate current tenants' needs.

Designer: Historic Period Designer

Many designers interested in history will concentrate on recreating period rooms or appropriately using antiques or reproductions in contemporary spaces. Often this specialty is believed to concentrate on residential design, but there may be numerous applications within commercial settings also.

Preservation consultants often spend their time identifying and nominating structures for state and national registers.

State Preservation Officer

Generally a state preservation officer is not directly involved in the design or restoration of spaces, but seeks out historically significant structures and attempts to have them registered on either the state or national register of historic places. This designation as a recognized historic structure encourages owners or sponsor groups to restore or adaptively reuse structures that may have been destroyed without formal recognition.

Private Nonprofit Preservation Organization Employee

Preservation organizations employ a variety of professionals, depending on the type of work in which they become involved. Architects, construction engineers, interior designers, and specialty consultants are just a few of the professionals needed to preserve and maintain historic structures.

Preservation Consultant

Like state preservation officers, preservation consultants often spend their time identifying and nominating structures for state and national registers. Unlike state officers, however, they may be hired by private groups to oversee or provide specialized consultations for specific restoration or renovation projects.

Museum Curator/Exhibit Specialist

Museum curators and exhibit specialists may be associated with one museum or with a specific exhibit that travels around the country or around the world. Exhibit specialists are responsible for designing, creating, installing, and maintaining exhibits that may focus on historic interiors, accessories, or finishes.

Museum curators and exhibit specialists may be associated with one museum or a specific exhibit.

Cultural Resource Curator

Recognized cultural resources (e.g., the White House, Biltmore Estates, Winterthur) hire people to perform many exhibit, curatorial, and educational functions. Designers with expertise in historic resources perform these functions well and can express their creativity in a variety of situations.

Exhibits may travel around the country or around the world.

OVERARCHING THEME: DESIGN ACROSS POPULATIONS

Interactions between countries and cultures have a significant effect on the design industry. As our world gets smaller and our interactions with people from other cultures become more frequent, the design industry is influenced by expectations from diverse ethnic groups. Design firms from the United States are regularly engaged to design spaces in other countries for multinational companies, and to produce culturally sensitive living and work spaces within the United States. Designers must be aware of the spatial uses and requirements of a variety of clients. Within the design field specialties have arisen that address cultural differences. In addition to ethnic and cultural diversities, design sensibilities are evolving to consider gender differences as well as differing physical and mental capabilities.

International Design Consultant

Firms working in the international arena have staff with experience designing for different cultures. They often coordinate with design professionals in the country of the project. A person in this position may have lived in the country of the project, worked there extensively, or studied the culture closely to be able to interconnect the needs of the corporation with the cultural mores of the host country. Generally, these consultants work on commercially focused projects such as resorts, hotels, and government establishments.

Specialty Designers

Residential designers commonly incorporate ethnic elements into homes for their clients. With the growth in Asian, Latino, and other ethnic populations

Firms working in the international arena have staff with experience designing for different cultures.

in the United States, an understanding of cultural roots is important to provide appropriately designed spaces. As a result, some designers are specializing in ethnic designs for particular populations.

Special Needs Consultant or Designer

A full understanding of the Americans with Disabilities Act is crucial for all designers, but with the aging of the U.S. population, more designers are concentrating their efforts on universal design, especially in residential projects. Developers are creating lines of spec houses that accommodate special needs, and designers and architects well versed in universal design approaches are needed to design these spaces.

Aging and Developmentally Appropriate Designer

Designers are regularly challenged to provide spaces that accommodate people of different ages. "Aging in place" is a desire among many people, who prefer to remain in their family homes as they age as opposed to moving to assisted living situations. Many designers are beginning to recognize the importance of filling this niche by designing spaces that allow people to remain in their homes as long as possible as they age. Designing for the opposite end of the age spectrum is also gaining popularity as designers focus on designing spaces that support children of different age groups in homes and institutional facilities such as preschools, courthouses, and museums. Each of these design areas requires specific information to appropriately accommodate the targeted population.

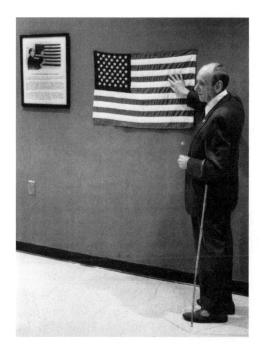

A specially designed American flag for the blind. The stars are heavily embroidered, and the stripes are of different materials for touching.

A full understanding of the Americans with Disabilities Act is crucial for all designers.

▄ REFLECTION _____

Many specialty areas of design such as historic preservation, green design, and designing for special populations require not only a passion for supporting the population, but also an ability and desire to advocate for that population. Do you believe designers have a responsibility to be advocates for specific social issues? How can you support social issues through your designs? What issues might you advocate for using your design knowledge and skills?

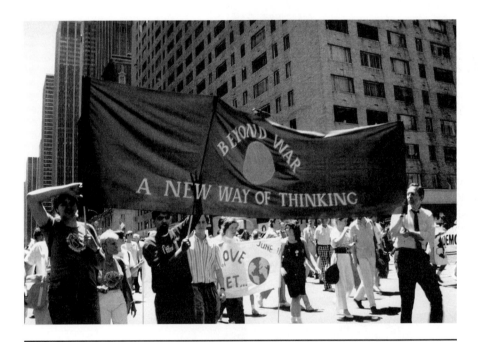

What issues might you advocate for using your design knowledge and skills?

SUMMARY

The key to success in the interior design industry, as in any industry, is to honestly evaluate your personality, strengths, challenges, and goals and make career choices that use your talents and support your life goals. This chapter provided an overview of career paths to help you understand how to evaluate particular positions in light of your personal needs. As stated earlier, the list of careers in this chapter is substantial, but it does not include every job available to you. Explore, stretch, and consider new venues that

may lead to a perfect career path for you. The following activity will guide you through a preliminary exploration of jobs that might interest you at this point in your education and career.

ACTIVITY

Choose three career paths that caught your interest as you read this chapter. Within each of the paths, identify a specific job that you think you would enjoy having one day. Using the chart on the following pages, conduct an extensive exploration of the jobs you have chosen and list the characteristics based on the PRSM model that each position addresses. Then, using the personal profile you developed in Chapter 1, compare the three chosen jobs with the elements you identified in your profile and determine which of the jobs most fully matches your needs. Write a short paragraph on each job comparing your personal profile and the profile of the job based on your research.

	Intellectual Design Education	Organizational Commercial Design	Social Residential Design
Read			
Websites	www.fider.org/ www.idec.org/	www.accredit-id.org	www.ihfc.com/ www.asid.org
Journals, etc.	*Journal of Interior Design Research*	*InformDesign* (ASID) *Contract magazine*	*Journal of Housing and the Built Environment*
Books		*Interior Design Graphic Standards Designing Commercial Interiors*	*New American Interiors: Innovations in Residential Design Space Planning for Commercial and Residential Interiors*
Attend			
Conferences	Interior Design Educators Council (IDEC) Family and Consumer Sciences Educators Association (FCSEA)	American Society of Interior Designers (ASID) International Interior Design Association (IIDA)	American Society of Interior Designers (ASID) International Interior Design Association (IIDA)
Markets	NEOCON Worldwide Trade Fair		International Home Furnishings Market (Highpoint, NC) San Francisco Wholesale Home Furnishings Center
Observe	Teachers/professors various venues	Commercial designers various venues	Residential designers various venues
Elective courses	**Education:** Introductory teaching and learning offerings (some online) **Communication:** Public speaking, peer mediation, negotiation, etc. **Human Science:** Psychology, sociology, etc.	**Business:** Accounting, marketing, and management (some online) **Communication:** Negotiation, Construction; CAD: Advanced courses	**Business:** Entrepreneurship, marketing, accounting, and management **Communication:** Peer mediation, negotiation, etc. **Human Science:** Psychology, sociology, etc.
Internship			
Licensing	Teacher certification	NCIDQ state certification	NCIDQ
Professional development	Continuing education credits (CEUs) required	Continuing education credits (CEUs) required	Continuing education credits (CEUs) required
Graduate school	www.fider.org/		

Material Manufacture/ supply	Natural Green Designer	Financial Design Profitability	Over Time Cultural Resource Management	Across Population Universal Design
	www.usgbc.org/ leed/leed_main.asp		www.cr.nps.gov /crm/ www.usbr.gov /cultural/	www.design.ncsu. edu/cud/ www.usdoj.gov/crt /ada/adahom1.htm
	www.ecoiq.com /greendesign/ *Southface Journal of Sustainable Building*		*Preservation* magazine	*ABILITY* magazine
Specifying Interiors: A Guide to Construction and FF&E for Commercial Interiors Projects	*Green Building Materials: A Guide to Product Selection and Specification*		*Places That Count, Traditional Cultural Properties in Cultural Resource Management*	*Universal Design Handbook Interior Design Graphic Standards*
	EnvironDesign		National Conference of State Historic Preservation Officers	Designing for the 21st Century II: An International Conference on Universal Design
NEOCON	NEOCON			NEOCON
Retail sales personnel Manufacturer's representatives	Designers specializing in sustainable design		State historic preservation officers Historic period designers	Designers specializing in design for special needs
Science: Fibers and textiles, materials science **Business:** Marketing	**Science:** Biology, chemistry **Political Science:** Advocacy	**Business:** Marketing, accounting, and management **Computer Science:** Management information systems	History, preservation, archeology, urban planning, cultural geography, folklore	Special education, physical therapy
Teacher Certification	LEED	NCIDQ		
Continuing education credits (CEUs) required				

I graduated from college in 1952, but chose to delay my career to raise a family. My undergraduate degree from West Virginia University was in home economics. I studied interior design at the Richmond Professional Institute and did master's work in retailing at the University of Pittsburg. Harvard University was the site of additional postgraduate work in 1978.

When my family situation was such that I could devote time to a career, I answered a position announcement in the paper. We were living around Washington, D.C., so federal service was the logical career choice.

My career with the federal government began in 1968 with the General Services Administration. I served as a designer at the White House during the presidential administrations of John Kennedy, Richard Nixon, Gerald Ford, and Jimmy Carter. For the Ford and Carter administrations, I was in charge of interiors for the East Wing, the West Wing, the Executive Office Building, Jackson Place, and Camp David. By 1976 I was head of interior design for the White House. Following that assignment I became head of interior design for the Department of Health and Human Services.

In 1988 I took the position of director of interior design for the Office of Foreign Buildings, U.S. Department of State, and became responsible for the design and furnishings of more than 1,000 posts worldwide, including all foreign embassies. In conjunction with that work I personally received a Meritorious Honor Award from the Department of State for interior design work accomplished throughout the world. Five years later my division received a Group Honor Award for outstanding international design work. My work has been featured in national publications including *Architectural Digest* and *House and Garden.*

I recently retired from government service and am currently completing my final project at State as an independent consultant. This meticulous restoration is very dear to my heart. Of the 3,500 properties that America owns abroad, only eight are listed in the Secretary of State's Register of Culturally Significant Properties. Of these, the Hotel de Talleyrand is among the most precious 18th-century

mansions in Paris. At the time it was purchased by the U.S. government (1950), the property was home to the headquarters for the Marshall Plan and central to European recovery efforts following the devastation of World War II. Today, the headquarters facility pays homage to its history as the George C. Marshall Center and houses a permanent exhibition. It is being returned to its original condition. This includes hiring the services of artisans skilled

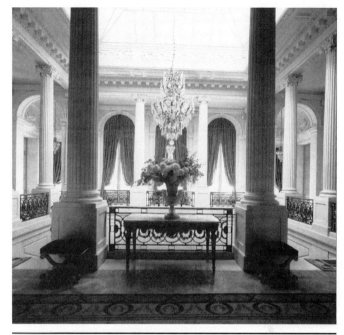

The Bosch Palace State Dining Room.
Source: Photograph by Xavier Verstraeten

in historic techniques and acquiring appropriate materials to restore parquet floors, gilded paneling, damask wallcoverings, and period furniture. The technical, logistical, and financial challenges of this project have been significant.

Today, although I still live and work in Arlington, Virginia, I am increasingly involved in community and foundation work in West Virginia. One of the more interesting projects currently in progress is the restoration of the Morgantown Metropolitan Theater (c. 1920) to its original condition. I am also working on the governor's mansion in Charleston. At West Virginia University, I have contributed substantially to the remodeling of the president's residence, the planning of two alumni centers, and the renovation of the Creative Arts Center.

My support for historic preservation and restoration has resulted in the formation of a certificate program at WVU in cultural resource management to train future generations for careers such as mine. I continue to enjoy every minute of my work.

Photograph from the
Colorado Convention
Center
*Photograph by
Michael Brian Gates*

Designing Your
Professional Path

<div style="text-align: right">4</div>

*Everyone designs who devises courses
of action aimed at changing existing situ-
ations into preferred ones.*
　　　　　　　　　—Herbert Simon

Objectives

After studying this chapter, you should be able to:

* Articulate a vision and mission for your next five years.

* Develop an initial strategy for taking the first steps toward your
 envisioned ideal.

* Explain the science and structure behind this process.

* Identify viable strategies and tactics.

Are you ready now to plan a course of action? Don't panic. You are better prepared than you might think. In the first three chapters of this text you learned about yourself, the interior design profession as a whole, and a wide variety of employment directions within the profession. That is enough to make a solid start. The goal of this chapter is to help you organize what you do know about your hopes, dreams, interests, and talents, and to start you thinking about missing pieces that you might want to acquire as you continue your education.

DESIGNING YOUR CAREER AND LIFESTYLE

The task of defining your future becomes more manageable if you break it down into pieces: vision → mission → strategy → tactics. Vision is the largest, longest-term, and least specific commitment in this sequence. Tactics are the local, daily bits that contribute to achieving the long-term goal. Vision remains relatively stable; tactics should always be flexible. As a beginner in this field, the temptation will be to begin your career from the bottom, working on whatever opportunity presents itself (tactics → strategy → mission → vision). Following that scenario, you would take the first job you could find, make the best of it, and try to find a path to the next level. A better plan, according to Covey (1989) is to began with the end (vision) in mind. That vision is what defines you as a designer.

First you must have a vision.

To better understand what we are asking you to do, think about how this process plays out in an interior design project. Presented with many options, materials, and installers, designers first partner with the client to envision and refine a clear concept of the finished product. Once the concept is accepted and enthusiastically embraced, they coordinate all activities toward achieving the envisioned goal. There are adjustments involved in any undertaking. Environments and budgets impose constraints. Clients can and do change their minds. Dye lots often don't match. Paint colors shift in the changing light. Items may be out of stock or discontinued. Craftspeople may be overscheduled and unavailable. It is all part of the project. Creativity and adaptation are the designer's stock in trade. In the end, the successful project is a fulfillment of the vision and mission articulated by the designer and the client.

On a project, and in life in general, what you see on a daily basis is the multitude of small stuff. Faced with infinite choices, you may initially feel that you can't see the forest for the trees. To clarify the situation, you will need to change your viewpoint and look back at the to-do list from the vantage point of the ultimate goal. Looking backward from the goal gives you the advantage of hindsight while there is still time to make the right choices. Generally, you will be able to tell which paths will eventually lead to your preferred destination.

For example, suppose your vision includes becoming a respected professional interior designer in a major metropolitan area. You may not yet know how you prefer to specialize, but in many states you will be required by law to pass the NCIDQ exam and become certified to practice. To take the exam, you must have the mandated six years combined of education and experience under a certified interior designer. Your five-year plan might look like this:

Vision Delivering professional interior design services to clients in the New York metropolitan area for premium prices.

Mission NCIDQ certification (requires six years of education and experience and passing a standardized test)

Strategy Acquire the education and experience necessary to qualify for the examination (pick one of the following)

1. 120 semester hours or 180 quarter credit hours (with 50 percent of the course work interior design related) and 3,520 hours of experience

2. 60 semester hours or 90 quarter credit hours in interior design–related course work and 5,280 hours of experience

3. 40 semester hours or 60 quarter credit hours in interior design–related course work and 7,040 hours of experience

Tactics Choose your school (list alternatives and pick one)

Complete the course work necessary to fulfill your educational commitment (develop a plan of study and work your plan)

Locate viable firms (offering NCIDQ certified supervision) in the desired geographic area and research them thoroughly (narrow your selection via the web and then seek summer internships at a select few)

Prepare a targeted portfolio

Apply and interview for permanent employment

Alternately, your fondest dream might revolve around a vision of traditional family life in your rural hometown. Or, you may envision a career in design-related sales or in technological support services. What might that path entail?

Keeping on a steady path to success.

THE SCIENCE BEHIND THE STORY

As you contemplate your unfolding story, it might help to know a little of what research has taught us about the universal journey of human kind. Of the reams of materials produced in recent years, a few findings are particularly significant to our discussion. These principles apply not only to your

current career exploration, but also to the goal-seeking behavior of your future clients and employers. A clear grasp of these simple principles will do the following:

- Point you toward fun, flexibility, and continuous assessment in your life's work
- Give you direction and keep you from fumbling blindly in the dark as you go about your daily business
- Comfort you when things don't go as planned
- Ground you when fortune seems too good to be true
- Keep you on a steady path to success

 For your purposes, the core principles are as follows:

1. Your immediate goal, or mission, lies within your dimensions of interest (remember those from Chapter 1: intellectual, organizational, social, material, natural, and financial) just beyond your current routine. The quest will be intrinsically rewarding if your attention is fully engaged and your skills are developing to meet new challenges (Csikszentmihalyi, 1990).
2. Achieving both growth and balance is a hit-and-miss affair. Success is generally achieved through a series of course corrections. Course corrections can be tracked using "fuzzy logic," the logic of thermostatic control (Kosko, 1993).
3. Accurate, reliable, and timely feedback is essential to staying on course. Personality type and family history may bias your perceptions of success or failure. Competing agendas may skew external evaluators' feedback. High-quality, unbiased mentoring is invaluable (Lindsley, Brass, & Thomas, 1995).
4. Quality of life is a complex, multifaceted construct. Keep one eye on the big picture (McFall, 2002).

These principles will be explained in further detail in the pages that follow.

Pursuing the Ideal

Your vision (ideal end) and mission (attainable subend) probably appeal to you because they seem enjoyable. Perhaps you can see yourself experiencing pleasure with these outcomes. If that is your intent, it would undoubtedly

help to know something about the structure of enjoyable experiences so that you can target your efforts appropriately.

Psychologist Mihaly Csikszentmihalyi (1990) has spent a lifetime studying the pleasurable state in which the actor and action are in harmony with the context and time is irrelevant. He called this experience *flow*. Athletes report this feeling when they are performing effortlessly at extraordinary levels. They often say that they are "in the groove" or "in the zone." Artists and designers experience flow while immersed in their creations. Scientists find flow in new discoveries. The research suggests that this remarkable experience occurs (1) when attention is engaged (2) at a point just beyond your routine, where (3) new skills are developing to meet new challenges.

Targeting the attainable ideal where skills and challenges are matched just beyond the routine.

Source: B. McFall, 1998, 2002. Adapted from M. Csikszentmihalyi, 1990, 1988, 1975.

Educational psychologist Lev Vygotsky (1978) identified the point at which learning happens as the *zone of proximal development (ZPD)*. Vygotsky suggested that the size and scope of the ZPD were determined by the availability of appropriate scaffolding. In other words, learning progresses only as far as there are mentors and tools to support development.

Making Adjustments

The path to your ideal will seldom be straight. And, when you do find it, the flow experience will be fleeting. The founders of this country spoke of the rights only to the *pursuit* of happiness for good reason. People and environments change constantly, making it very difficult to find and sustain ideal circumstances. More often than not you will find yourself in a somewhat less than ideal situation that signals the need for adjustments. The trick is to make small adjustments early and often to keep your career and life on track within a tolerable range.

Charting an initial strategy toward an envisioned ideal.

If your skills grow faster than the challenge presented, you will experience boredom. Boredom is a signal to look for more, different, or more difficult challenges. However, if you get overzealous in accepting challenges (or the situation changes suddenly to exceed your growing skills), you will experience anxiety. Anxiety is a signal to either turn back or find appropriate help to bridge the gap in the form of a mentor, new tools or knowledge, or new skills.

Mathematician Lotfi Zadeh described this zigzag path as "fuzzy logic," the logic of thermostatic control (Kosko, 1993). Fuzzy logic provides

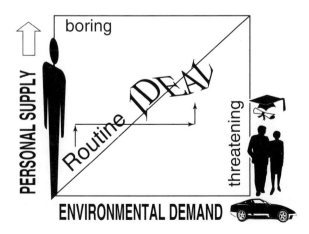

The path to the ideal is often indirect, requiring a series of adjustments.

Source: B. McFall, 2002. Adapted from B. Kosco, 1993, New York: Hyperion.

a quantitative tool to describe precisely how far you are from your current ideal and the course correction required to get there. The specifics of this method are beyond the scope of our current discussion, so we will leave it at that for now. Those of you who want to continue with graduate work in design might want to revisit this powerful analytical tool.

Valuing Quality Feedback

Lindsley, Brass, and Thomas (1995) described the tendency to over- and undershoot the goal in terms of efficacy-performance spirals. Efficacy-performance spirals are "deviation amplifying loops in which the positive, cyclic relationship between efficacy and performance builds upon itself" (p. 645). In other words, people tend to pursue one path until persuaded by circumstances to change (see the Figure below).

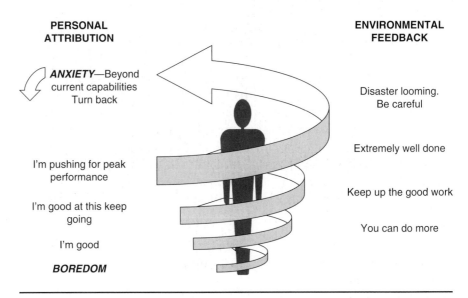

Critics shape confidence—realistic feedback is most helpful.

Source: B. McFall, 2002. Adapted from D. H. Lindsley, D.J. Brass, & J. B. Thomas 1995. Efficacy-performance spirals: A multilevel perspective. *The Academy of Management Review, 20 (3),* 645–648.

Self-correcting spirals are healthier than unrelieved positive or negative spirals. Unrelieved, positive spirals move quickly up and out (toward greater scope and complexity) until the activity attempted is far beyond current capabilities, resulting in maximum anxiety. Unrelieved, negative spirals have

precisely the opposite effect, forcing performance down and in (smaller scope and simpler) until all opportunity is lost, this is the position of least challenge and maximum boredom. In plainer language, we often refer to behaviors as reckless or timid.

Current feedback clearly affects your belief in your abilities, but that feedback is often skewed by your history and existing self-image. People tend to give more weight to feedback that is consistent with their existing self-image and to discount other data. Critical thinking and reliable mentors will help you see your true abilities and challenges at this point in your life.

THE UNIVERSAL STORY

This is merely one more telling of the universal story of mankind. Every one of us acts out this journey over and over again throughout our lifetimes. Indeed, you have done this before—when you started school, first went to camp, left home for college, and began your first internship. When you stop to think about it, you will find that the process is as familiar as your earliest memory of fairy tales.

Mythologist Joseph Campbell (1973) studied thousands of myths and stories from around the world. In *The Hero with a Thousand Faces,* he examined cultural variations of the universal process he termed "the hero's journey."

1. The youth becomes dissatisfied with his or her current routine and decides to embark on a quest. Mythologically, this quest has often included rescuing fair maidens, slaying dragons, and acquiring treasures.

The hero's journey: Continuing the routine.

Source: Drawing by Shari Park-Gates

2. The hero begins to gather tools and skills that might help him or her accomplish this quest. There may be a significant mentor such as Yoda or Merlin. Magic rings, cloaks, swords, and the like, generally play a role. As in the James Bond movies, it is important to have just the right tool for the job.

The hero's journey: Embarking on the journey.

Source: Drawing by Shari Park-Gates

3. The hero embarks on the journey and soon meets the villain or challenge, which might be a black knight, a dragon, or a dismal swamp.

4. The hero meets the challenge in exemplary fashion using his or her skills and tools.

The hero's journey: Meeting the challenge in exemplary fashion.
Source: Drawing by Shari Park-Gates

5. The hero continues on to collect the prize.

6. The hero returns to his or her village to enjoy the admiration and reward of peers and countrymen.

The hero's journey: The hero returns.
Source: Drawing by Shari Park-Gates

QUALITY OF LIFE

In this chapter we have talked about the goal of the hero's journey as a well-defined and singular goal, as it must be to achieve flow. You must also remember that, important as they are, goals evolve and change. You will define treasure differently as your life develops. Today, your focus is probably on graduation and perhaps the development of an important relationship. Tomorrow, you will be intent on landing that first job. Within the decade, family matters might take precedence. Nature can turn the whole scene upside down in a blink with illness or severe weather events. Successful people learn to live and work through all this, maintaining balance in their public and private lives. They realize that stunning achievement in a single aspect or dimension is seldom sufficient to ensure overall quality of life.

The final point in this chapter is that you must look occasionally at the big picture to understand quality of life as a complex and multifaceted construct. You can consider your life as a series of daily interactions (qualities of living) between your personal aspects (physical, emotional, mental) and experienced environmental dimensions (intellectual, organizational, social, material, natural, financial). Each of these considerations is important to your satisfaction and well-being in your future job.

As a new graduate, you might be tempted to pursue an employment opportunity based solely on salary expectations (financial) or a firm's stellar reputation (organizational). Once you are in the job, the financial and organizational incentives soon become routine. In the flow model, routines have neutral value (0). They are neither positive nor negative. Other dimensions that may have been sacrificed to pursue the opportunity will then gain importance. For example, you might become dissatisfied in the following dimensions:

- Social Dimension—from leaving the family or love interest behind
- Intellectual Dimension—from leaving a learning environment to perform menial support duties
- Natural Dimension—from lack of outdoor activities or an unfamiliar climate

These are the dragons that you must slay with swords appropriate to the task. For example, earning more money won't cure loneliness unless some of those funds are dedicated to resolving the relationship problem. The table shows these interactions in matrix format.

	Mental	Emotional	Physical	*SATISFACTION*
INTELLECTUAL				Intellectual Satisfaction
ORGANIZATIONAL				Organizational Satisfaction
SOCIAL			Physical-Social Quality of Living	Social Satisfaction
MATERIAL				Material Satisfaction
NATURAL		Emotional-Natural Quality of Living		Natural Satisfaction
FINANCIAL				Financial Satisfaction
WELL-BEING	Mental Well-Being	Emotional Well-Being	Physical Well-Being	**QUALITY of LIFE**

The PRSM matrix.

© Barbara McFall, 1998, p. 146.

Aspect entries will total to describe your personal physical, emotional, and mental well-being. Dimension entries will total to describe your satisfaction with the experienced environment in each dimension. The grand total represents your overall quality of life.

When the path you are on doesn't seem quite right, stop for a moment to ask why. Use the matrix to pinpoint the source of the problem. With a new goal in mind, you can then design an appropriate action to resolve that problem.

SUMMARY

Designing your career path can be fun and stimulating. And if you pay attention to details, you may succeed in following it. The tools provided in this chapter will help you to understand the structure of your experience as you move forward in this process and to use that structure to your advantage.

ACTIVITIES

Activity 1

Looking at your profile from Chapter 1, pick a dimension of particular interest to you as a design professional. Describe the point just beyond your current routine (or zone of proximal development) in that dimension. Can you see a career-related mission for you in that context? Define it. What mentors and tools will you need to succeed in this scenario?

Activity 2

Where would you currently place yourself in your quest for employment? Are you still within the comfortable routine? Have you become bored with your present situation? Do the emerging challenges seem formidable given your current knowledge and skills? Describe your current position on the design career path and plot your next course correction.

Activity 3

Create a visual of, and write the narrative to, your own version of the hero's journey.

1. Identify your *vision*—the ideal or dream outcome.
2. Define your present *mission*—the currently achievable subend.
3. Formulate your *strategy*—the means that you will employ to achieve your goal.
4. Anticipate the *tactics* involved—think through daily events as they might unfold in this scenario. Can you function effectively in this context?
5. Pay attention to the feedback loop. Will your current mission, strategy, and tactics advance your progress toward your ultimate vision?

I was always interested in furniture and modern design, but my first job in New York City out of college was as design assistant for a designer named Michael Love. I learned a lot from her, including the fact that there are women named Michael. She was a tough and no-nonsense designer and taught me many things about interior design—most important, that it is a business and you have to treat it as such.

As a small firm, we worked on residential projects mostly, with only occasional commercial jobs. While working on a contract project, I learned of a job with a furniture showroom (M2L) that needed an in-house designer. M2L was a trade showroom so the job involved showroom layout, furniture drawings for custom pieces, and the most particular—dealing with the Dollies.

In New York City you have the good and the bad, and you have the Dolly Decorators. Some may not know this term, but in New York this is what we call the housewives with no formal training who come in from Long Island thinking that they are designers. Simply having a good eye does not ensure a successful outcome. Successful designers also understand the principles and elements of design, so dealing with the Dollies was also in my original job description.

The company was growing and changing all the time, so one day the owner approached me about doing showroom sales. He admired my skill with people and knew I had a deep knowledge of the collection. He also mentioned the fact that there would be more money, which is always a good thing. Gradually I became more and more involved with sales until I worked my way up to doing full-contract furniture sales. I started with a few accounts and grew with those. One of my largest accounts is Gensler, and I work very closely with them on commercial projects. The largest project to date was the Hearst Corporation's new headquarters in New York in conjunction with Norman Fosters Architect of London.

The unique thing about my work is that it is rarely the same and is completely what I make it. With contract furniture sales I get to travel, and I am out of the office a lot. I visit my clients in their offices most often, so I get to see their spaces and how they work. I sometimes feel I get to see behind the wizard's curtain.

I love that I am always meeting new people, that I work with product I respect and desire, and that change is the norm. The biggest challenges in my business come at the beginning and end of the project. In the contract furniture world, closing the sale is very much about the numbers. Although design is key and can be very cut and dried, there is always a lot of red tape, as well as meetings and mock-ups, before the check is signed. Customer service is a huge factor at the end of the project. Ninety percent of the project can go great, but the final 10 percent can drag on forever. I like my clients to be happy because I want to be happy, but that can't always be the case.

To be successful in a job like mine, you would need to be an outgoing people person who is organized and has the ability to follow through. You would be working with interior designers and architects, furniture makers, fabric reps and mills, upholsterers, and many other business- and tradespeople. You need to be professional. M2L is very much involved in supporting the architecture and design community and believes in the integrity of design. For me, the combination

of the project-oriented business, the furniture factor, and the earning potential has generated growing interest and a rewarding learning opportunity.

My advice to young designers like myself would be, "Don't be a Dolly Decorator!" Be patient, pay attention, polish your skills, and become a professional.

Capitol building,
Denver, Colorado
*Photograph by
Michael Brian Gates*

Targeting Employment

I will prepare myself and the opportunity will come.

—*Abraham Lincoln*

Objectives

After studying this chapter, you should be able to:

* Identify relevant employment issues.

* Explain the differences in geographic markets.

* Establish realistic salary expectations.

* Understand diversity of workplace cultures.

Chapter 5 begins the process of looking for employment. In previous chapters you explored your own interests as well as the diverse opportunities available in interior design. Hopefully you have established a number of "best fit" options for further exploration and are ready to move forward. This chapter explores locations, salaries, values, and personalities within the industry in an effort to further refine your focus. There is no single right employment answer for everyone. Some new graduates will be anxious to tackle the most competitive and financially rewarding venues. Some will prefer to begin more modestly. For others, career will take a backseat to other considerations such as geographic ties or family time demands. Once again, you will be looking for the "best fit" opportunity for your unique situation.

EMPLOYMENT FACTORS

Understanding where designers are currently employed will help you evaluate your employment options in the interior design profession. Information gathered by ASID revealed that approximately 35 percent of interior designers are self-employed. Another 16 percent are employed by interior design firms; 13 percent work for architectural firms; and the remaining 36 percent work in the wholesale and retail home furnishings, construction, education, government, and entertainment industries as well as for various business services.

No reliable figures are available for self-employment income, but it is worth noting for comparison that many self-employed designers work

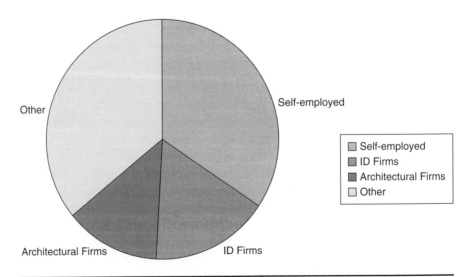

Where designers are currently employed.

part-time, many have no health or retirement benefits, and all cover 100 percent of their own taxes. For those employed by others, starting salaries in most states range from the mid-20s to low 30s. Average salaries nationwide are reported in the mid-40s, with dedicated interior design firm employees earning at the higher end of the range. The largest firms, the Top 100 Interior Design Giants, reported median salaries in 2002 of $58,000 (designers), $75,000 (project managers), and $120,000 (principals) (American Society of Interior Designers, 2004). Elite designers working for celebrities, sport figures, and top executives are paid considerably more.

Some parts of the country support many designers with substantial annual incomes; others, relatively few. California, Florida, Texas, and New York are home to approximately 42 percent of all interior design firms (not including self-employed designers). Ohio, Georgia, Colorado, Illinois, Michigan, and North Carolina round out the top ten states for interior design employment. Predictably, design firms tend to cluster in larger, more affluent cities; however, no single city can claim more than 5 percent of the total. The top ten locations are Chicago, New York, Los Angeles/Long Beach, Atlanta, Dallas, Houston, D.C. Metro, Seattle/Bellevue, Orange County, and San Francisco—followed by Philadelphia, West Palm Beach/Boca Raton, Detroit, Boston, Phoenix/Mesa, Denver, Nassau/Suffolk (New York), San Diego, Oakland, and Minneapolis/St. Paul (ASID, 2004).

Employment Follows Clientele

Employment in interior design, as in any business, is ultimately dependent on the consumer. The consumer is defined as the person or group that:

1. Perceives the need for your product or service
2. Is willing to buy
3. Is able to buy

To remain employed, you must be in the proximity of a sufficiently large target population. That population must be sophisticated enough to appreciate the value of professional interior design and be willing to pay the price to obtain it. Lastly, the would-be client must actually have the discretionary income to spend on such things.

Smaller design groups with reasonably priced offerings and broad-based appeal may be able to develop a sufficient customer base in all but the tiniest communities. Larger design groups or firms offering premium-priced, cutting-edge design or firms targeting a specific niche in the design spectrum will probably find it necessary to locate in larger, more affluent, and sophisticated communities.

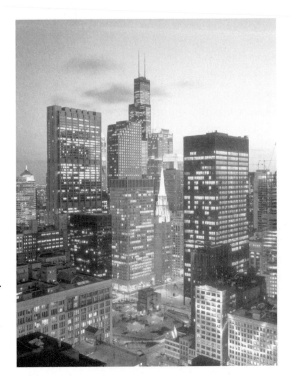

Predictably, design firms tend to cluster in larger, more affluent cities. One of the top ten locations is Chicago. The Sears Tower, seen here, dominates the lighted skyline of Chicago.

CHARACTERISTICS OF FIRMS BY SIZE

Large Firms

Large design firms often have a relatively sophisticated evaluation process to determine geographic locations that will provide the greatest opportunity for success. Most organizations use statistics provided by the U.S. Census Bureau to locate favorable population distributions that will support their business. They are typically interested in large populations of affluent consumers. To rank locations by desirability, they often multiply the most recent population ranking by per capita disposable personal income (DPI) ranking (population × DPI) to get a composite score. For instance, in the published state rankings, New York is the third most populous state and ranks fourth in per capita DPI. New York would have a composite score of 12. Montana, on the other hand, ranks 45th in population and 44th in affluence. It would have a composite score of 1,980 (see Table 5-1).

Each year *Interior Design* publishes a list of the "Top 100" and "Second 100" design firms in the United States (Davidsen, 2005, 2006). Data from the most current report have also been entered in Table 5-1. Interestingly, nearly three quarters of the top 200 firms are located in the 11 states having

composite scores ranking (population × DPI) under 100. The Mid-Atlantic states of Pennsylvania, New York, New Jersey, and Maryland, along with the District of Columbia, account for 31 percent of the total, with the highest concentration of firms in the New York Metropolitan Area and the District of Columbia. California is home to nearly 15 percent of the country's top design firms, while Chicago reinforces the Great Lakes area with 10 percent of the total. New England (Connecticut and Massachusetts) hosts 9 percent. Florida completes the "under-100 composite score" group with an additional 2 percent of the top 200 firms, but that southern locale lags several percentage points behind the top performers in the next bracket. Of the remaining 25 percent (having composite scores of 100 to 500 points) Atlanta, Georgia (4 percent); Minneapolis/St. Paul, Minnesota (3 percent); and Ohio (3 percent) are the heavy hitters. The 26 states showing scores over 500 had no top 200 representation, nor did higher-scoring New Hampshire, Indiana, and Delaware. The specific data included in this table will vary from year to year, but the principle remains stable over time.

The top 200 firms became successful by targeting large projects with large profits. More than 90 percent of those projects were contract or commercial design. Among the top 100 firms, office design brought in 35.49 percent of total fees. Healthcare came in second with 13.25 percent of the total, and hospitality took fourth place. The second 100 firms credited office design with 44.48 percent of their total. Hospitality was second at 24.56 percent, and retail was third at 6.38 percent. For the second 100 firms, residential design accounted for 6.01 percent of work.

Not surprisingly, you will find that the big firms are attracted to regional urban centers offering both high local demand and convenient access to national and international transportation. The 100 largest cities in the United States are listed by state in Table 5-1 for your convenience.

Support Services

Environments that support large firms also support a host of secondary services. Design centers emerge to meet the growing demand for the goods and services required to realize ambitious designs. The major design centers are also indicated in Table 5-1. For the most part, they are where you would expect them to be: in Chicago, New York, Dallas, and other large cities. The only surprise in that column is the design center in High Point, North Carolina, traditionally home to the American furniture-making industry and the spring and fall International Home Furnishings Markets. High Point became a furniture manufacturing center in a century when most labor was local and the availability of raw materials (hardwoods, water power) was more important than proximity to consumers. The most recent High Point Market

Table |5-1| Employment Information for Interior Designers

Population Rank (2000 census) (1 = most populous)	State and Top 100 Cities Ranked by Population	Firms by Rank	Disposable Personal Income 1996–2001	Composite Rank (Population × DPI)	Total # Design Centers	Status RE: NCIDQ
1	California	12 Top 100: 1, 5, 7, 19, 20, 27, 52, 72, 73, 79, 88, 94 17 Second 100: 2, 10, 12, 32, 42, 46, 55, 63, 65, 67, 70, 78, 79, 86, 87, 88, 94	14	14	10	State self-certification title act
	2—Los Angeles 7—San Diego 11—San Jose 14—San Francisco 32—Long Beach 36—Fresno 37—Sacramento 43—Oakland 51—Santa Ana 52—Anaheim 61—Riverside 65—Stockton 66—Bakersfield 89—Modesto 91—Freemont 92—Glendale 95—Chula Vista					

				22	44	6	Act pending
2	**Texas**	4—Houston 8—San Antonio 9—Dallas 16—Austin 20—Fort Worth 22—El Paso 48—Arlington 63—Corpus Christi 71—Plano 82—Garland 90—Lubbock 98—Loredo	**5 Top 100:17, 18, 28, 93, 96** 15 Second 100:1, 4, 11, 13, 22, 36, 43, 47, 51, 64, 68, 93, 96, 97, 98				
				4	12	8	Title act
3	**New York**	1—New York City 60—Buffalo 84—Rochester 99—Yonkers	**16 Top 100: 3, 10, 14, 24, 29, 30, 39, 40, 45, 61, 64, 68, 69, 75, 82, 87** 13 Second 100: 9, 23, 29, 33, 49, 50, 71, 73, 74, 77, 82, 95, 100				

Population Rank (2000 census) (1 = most populous)	State and Top 100 Cities Ranked by Population	Firms by Rank	Disposable Personal Income 1996–2001	Composite Rank (Population × DPI)	Total # Design Centers	Status RE: NCIDQ
4	**Florida** 13—Jacksonville 46—Miami 55—Tampa 70—St. Petersburg 78—Hialeah 94—Orlando	**2 Top 100: 11, 42** 3 Second 100: 5, 76, 90	24	96	4	Practice act
5	**Illinois** 3—Chicago	**9 Top 100: 6, 37, 41, 46, 54, 55, 85, 95, 97** 3 Second 100: 28, 30, 75	8	40	1	Title act
6	**Pennsylvania** 5—Philadelphia 54—Pittsburgh	**8 Top 100: 22, 25, 31, 34, 62, 66, 71, 76** 4 Second 100: 8, 17, 41, 89	15	90		
7	**Ohio** 15—Columbus 35—Cleveland	**3 Top 100: 21, 32, 57** 3 Second 100: 16, 52, 80	26	182	2	Legislation introduced

	56—Cincinnati 58—Toledo 86—Akron					
8	**Michigan**	**1 Top 100: 77** 1 Second 100: 45	18	154	1	Legislation introduced
9	**New Jersey** 64—Newark 73—Jersey City	**3 Top 100: 12, 48, 63** 3 Second 100: 15, 31, 84	2	18		Title act
10	**Georgia** 41—Atlanta	**4 Top 100: 51, 65, 83, 98** 4 Second 100: 18, 37, 81, 85	27	270	2	Title act
11	**North Carolina** 21—Charlotte 57—Raleigh 77—Greensboro 96—Durham	**1 Top 100: 59**	36	396	4	
12	**Virginia** 39—Virginia Beach 72—Norfolk 88—Chesapeake	2 Second 100: 20, 83	31	372		Title act
13	**Massachusetts**	**10 Top 100: 15, 50, 53, 58, 67, 70, 80, 89, 90, 91**	3		1	Legislation introduced

Population Rank (2000 census) (1 = most populous)	State and Top 100 Cities Ranked by Population	Firms by Rank	Disposable Personal Income 1996–2001	Composite Rank (Population × DPI)	Total # Design Centers	Status RE: NCIDQ
	23—Boston	5 Second 100: 19, 25, 35, 61, 91				
14	**Indiana** 12—Indianapolis 80—Fort Wayne		30	420		Legislation introduced
15	**Washington** 24—Seattle 100—Tacoma	**2 Top 100: 9, 13** 1 Second 100: 21	11	165	2	Legislation introduced
16	**Tennessee** 17—Memphis 27—Nashville Davidson	1 Second 100: 99	31	496		
17	**Missouri** 38—Kansas City 53—St. Louis	1 Second 100: 72	29	493		Title act
18	**Wisconsin** 19—Milwaukee 81—Madison	**1 Top 100: 23**	21	378		Title act
19	**Maryland** 18—Baltimore 54—Pittsburgh	**2 Top 100: 26, 78**	5	95		Title act
20	**Arizona** 6—Phoenix 31—Tucson		38	760		

	State / Cities	Top 100				Notes
	40—Mesa 76—Glendale 83—Scottsdale 87—Chandler					
21	**Minnesota** 47—Minneapolis 62—St. Paul	**3 Top 100: 16, 36, 43** 3 Second 100: 26, 66, 92	9	189	1	Act pending
22	**Louisiana** 34—New Orleans 79—Baton Rouge 97—Shreveport		41	902		Practice act
23	**Alabama** 74—Birmingham 93—Montgomery		42	966		Practice act
24	**Colorado** 26—Denver 48—Colorado Springs 59—Aurora	**1 Top 100: 74** 2 Second 100: 6, 54	7	161	1	Permitting statute
25	**Kentucky** 68—Lexington Fayette 69—Louisville		43	1,075		Title act
26	**South Carolina**		40	1,040		

Population Rank (2000 census) (1 = most populous)	State and Top 100 Cities Ranked by Population	Firms by Rank	Disposable Personal Income 1996–2001	Composite Rank (Population × DPI)	Total # Design Centers	Status RE: NCIDQ
27	**Oklahoma** 29—Oklahoma City 44—Tulsa		39	1,053		Legislation introduced
28	**Oregon**	**2 Top 100: 47, 100** 1 Second 100: 53	32	896		Legislation introduced
29	**Connecticut**		1	29		Title act
30	**Iowa**		33	990		Title act
31	**Mississippi**		50	1,550		
32	**Kansas** 50—Wichita		28	896		
33	**Arkansas**		49	1,617		Title act
34	**Utah**		46	1,564		
35	**Nevada** 30—Las Vegas 85—Henderson		17	595		Practice act
36	**New Mexico** 33—Albuquerque		47	1,692		Title act
37	**West Virginia**		48	1,776		
38	**Nebraska** 42—Omaha 75—Lincoln		23	874		

39	Idaho		44	1,716	
40	Maine		37	1,480	Title act
41	New Hampshire		6	246	
42	Hawaii 45—Honolulu CDP		19	798	
43	Rhode Island		16	688	Title act
44	Montana		45	1,980	
45	Delaware		10	450	
46	South Dakota		34	1,564	
47	North Dakota		36	1,692	
48	Alaska 67—Anchorage		13	912	
49	Vermont		25	1,225	
50	Wyoming		20	1,000	
NA	DC* 25 Washington, D.C. *also includes Arlington, McLean, and Alexandria, Virginia	**5 Top 100: 33, 35, 44, 81, 99** 8 Second 100: 14, 27, 48, 56, 57, 59, 62, 83*		1	Title act

Source: Data retrieved 8/11/2005 from Largest 100 U.S. Cities (www.citymayors.com/gratis/uscities_100.html); Resident Population of the 50 States (http://txsdc.utsa.edu/txdata/apport/table4.php); Per Capita Disposable Personal Income by State and Region (www.bea.gov); IIDA State Licensing Guide (www.iida.org/custom/legislation/statelg.cfm); Top100 Firms (www.interiordesign.net/id_article/CA498691/id?stt=001); Second 100 Firms (www.interiordesign.net/id_article/CA626734/id?stt=001)

Larger design groups offering cutting-edge design or firms targeting a specific niche will probably find it necessary to locate in larger, more affluent, and sophisticated communities. Seen here is the Metropolitan Opera House, Lincoln Center, New York City.

showcased 80,000 exhibitors, many of whom maintain permanent exhibit spaces. For those interested in the material dimension, the suppliers housed in design centers and elsewhere throughout large cities represent excellent opportunities for first employment. In most large cities, suppliers tend to be clustered around a single street or district for easy access. A quick glance at the local yellow pages will point you in the right direction.

Large firms are characterized by formal hierarchies, differentiated tasks, and progressive compensation. As a beginner, you will be at the bottom of the hierarchy, performing the most mundane tasks for very modest compensation. In return you will enjoy the chance to learn at the very highest level, log a highly respected entry on your resume, and perhaps even benefit from multiple opportunities to move up.

Midsize Firms

Midsize firms pick up where the large firms leave off. In the largest markets, they serve the smaller client or the more modest jobs. Many of these design opportunities are both exciting and profitable, but are not sufficient to support

the overhead inherent in a large firm operation. Midsize firms often have a flatter organizational structure, less task differentiation, and occasionally more favorable starting salaries. Because of their leaner operation, midsize firms tend to employ generalists rather than specialists. They typically have a more balanced portfolio of commercial and residential jobs; however, they may choose to concentrate on one market over another depending on the strengths and preferences of the principals. Some beginning professionals feel more comfortable starting their careers in a midsize firm because there may be more opportunity to participate in a variety of design activities more quickly than in a large firm. If your interests are broad, you may find that a midsize firm offers many varied opportunities to learn and sharpen your skills.

The exception to this rule would be the midsize firm that serves a unique niche, such as yacht interiors or kitchen and bath. These specialty design opportunities are growing, but are most often located in geographic areas that support their specialty market. If you are interested in niche market design, you may have to do additional research to find firms. You should also be ready to relocate because such firms rarely have branch offices like some of the other more generalized firms. It will be beneficial to have at least one project in your portfolio that illustrates your interest in a specific area of specialty design. Consider entering related design competitions, doing independent studies, and finding internships with companies that focus on your design area of interest.

Specialty design opportunities are growing, but are most often located in geographic areas that support their specialty market. Canada Place is a waterside architectural marvel of white sails and glass that houses a hotel, two convention centers, and a cruise ship terminal.

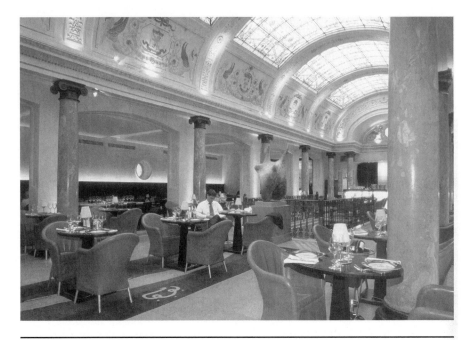

The midsize firm may serve a unique niche, such as yacht interiors or restaurant design, or adaptive reuse.

Midsize firms also take advantage of local and regional pockets of affluence that are not sufficient to attract the largest national and international players. Both residential and commercial designers can make a solid living in healthy midsize cities. Charlotte, North Carolina; Honolulu, Hawaii; Phoenix, Arizona; New Orleans, Louisiana; and Memphis, Tennessee are thriving design venues that lack substantial competition from the biggest players, but offer many and varied entry positions for young designers.

Small Firms

Small firms include the 36 percent of all designers reporting self-employment as well as some portion of those reporting employment in interior design firms, architectural firms, and other design sectors. With large firms confined primarily to the 11 states most favorable for their size, small to midsize firms are the rule in over 75 percent of our nation's towns. The majority of these firms report having one to three employees and credit residential design for 80 percent of their work. Small firms may offer a family atmosphere with all employees pitching in to the best of their abilities. Small firms may also be able to offer more flexibility with regard to work schedule, but salaries are generally modest across the board. These firms offer enormously satisfying

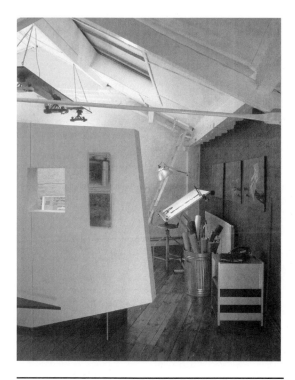

Many creative people find happiness owning small businesses.

opportunities for young talent, but little opportunity for advancement.

Smaller firms may or may not have an NCIDQ certified lead designer. If you anticipate sitting for the exam, you might explore whether your experience in a particular firm will qualify you. These issues may not apply to you if your primary concerns are geographic constraints (because of spousal employment or other family ties) or time flexibility (to accommodate small children). If that is the case, small firm employment may be right for you.

Many creative people find happiness owning small businesses. It gives them the freedom to explore their unique design vision in an environment tailored to their own preferences. Although ownership is the ultimate form of self-expression, it is not a venue for the naïve or fainthearted. Generally it is best left until after you have gained some experience in the industry. If you think that you might prefer self-employment, experience in a small firm could prove most valuable. You might also want to pick up some courses in entrepreneurship if they are offered at your school, or in marketing accounting, management, and law in a more traditional business school. These courses provide information you will need to know when you are responsible for charting the course of your business, preparing your business plan, and making the payroll.

REFLECTION

Consider for a minute a geographic location you believe you would enjoy working and living in after graduation. Using the information in Table 5-1 and the personal preference information you put together in the previous chapters, identify some of the relevant characteristics that would affect your potential success in the job search.

EMPLOYMENT COMPENSATION

Comparative Salaries

ASID provided data on both the number of designers employed and their mean annual incomes in 2002. Table 5-2 provides a comparison of the ten highest and lowest employment states for interior designers.

Table **|5-2|** Ten Highest-and Lowest-Employment States for Interior Designers

Top Ten States	Designers Employed	Mean Annual Income 2002
California	4,500	$ 45,180
Florida	4,230	45,140
Texas	3,100	39,110
New York	2,460	52,140
Ohio	1,890	39,630
Georgia	1,850	40,780
Colorado	1,720	69,140
Illinois	1,690	37,610
Michigan	1,520	43,440
North Carolina	1,240	35,680
Bottom Ten States	**Designers Employed**	**Mean Annual Income 2002**
New Mexico	100	37,660
New Hampshire	100	36,280
Idaho	90	30,900
Arkansas	90	31,680
West Virginia	80	34,210
Montana	50	38,100
Vermont	50	42,590
Wyoming	40	35,870
South Dakota	40	31,160
Alaska	40	48,050

Source: Compiled information from ASID and realtor.com.

There are other factors beyond raw salary and job availability to be considered. Those of you who have lived in one area most of your life may not be aware of the cost of living in other geographic areas. Cost-of-living measures report comparisons across geographic locations (i.e., Mayberry to New York City) and are not to be confused with consumer price index (CPI) data, which compare a single locale over time. As a general rule, urban areas are much more expensive than suburban or rural areas, and some parts of the country are significantly more costly to live in than others. What may seem a generous salary at first glance may be totally insufficient to sustain life when adjusted for regional differences. Cost-of-living adjustment figures are readily available both online and through local chambers of commerce. At the time of this writing a city-by-city comparison was found at www.realtor.com on the link The Salary Calculator under the Moving tab. Two other sites that may be helpful in evaluating salary and cost of living are www.homefair.com/homefair/calc/salcalc.html and www.bankrate.com/brm/movecalc.asp.

Standard cost-of-living measures compare an equal basket of market goods across all locales. This may not hold for certain areas of the country (large and small) where one can regularly walk or bike to work. In New York City, for instance, many residents do not own cars and consequently do not carry yearly car or liability insurance; nor do they budget for gas. They walk, bike, and take public transportation. On occasions that they leave the city, they rent a car and acquire short-term insurance coverage. This represents a considerable savings in the typical budget, especially for the young.

The other factor that might affect salary consideration is benefits. Larger companies will likely offer group health insurance, provide some type of retirement plan, and allot sick days. They will probably deduct all or part of your insurance from your pay, but the rate will often be much less than comparable coverage on your own or through a smaller firm. Benefit packages vary widely and may include less traditional offerings such as child care, fitness center memberships, company cars, and compensated time for volunteer activities. Benefit needs are very personal, and their value to you must be included in your comparisons as you make your career decisions.

Finding Specific Opportunities

Evaluating your personal preferences and assessing your professional options is only the beginning of actually landing your first job. At some point you must decide on specific companies you want to market yourself to. A wide variety of methods and resources are available when you get to this point, and it will help you greatly if you take advantage of as many resources

Benefit needs are very personal, and their value to you must be included in your comparisons as you make your career decisions. A small town may suit you.

as possible. Most universities have career centers, so this may be one place to begin gathering preliminary information. Some career centers host career fairs during the school year. Be sure to visit any career or job fair, take your resume with samples of your work, and talk to anyone and everyone with companies you think might be interesting.

Another resource widely used today is Internet employment sites. Although general sites such as www.monster.com, www.careerbuilder.com, and www.hotjobs.com are very helpful and have many listings for positions around the country, there are also websites specifically for interior designers. Three sites that post positions exclusively for designers are www.interiordesignjobs.com, www.job-e-job.com, and www.idec.org. The IDEC site primarily offers positions in academic or teaching environments, whereas the other sites provide opportunities in varied areas of design.

Finally, don't forget to take advantage of alumni of your program and members of professional organizations such as ASID and IIDA who are working in geographic areas you are interested in exploring. Contact them for informational interviews (discussed in Chapter 6) or simply to ask questions about the realities of working in their specific areas of design. Yellow pages and organization membership directories can be good resources for finding professionals to talk with in specific geographic areas.

Find a place you would like to explore such as this small town, Costieri Amalfitana, Italy.

In addition to the resources already identified, some books also have valuable tips and suggestions for finding that "perfect" firm with which to interview. Richard Bolles, who has written, revised, and published the career guide *What Color Is Your Parachute?* annually for over 35 years suggests that the best way to find a job is to do your homework and then work your contacts. His ten commandments for job interviews are as follows:

1. Don't target large firms exclusively. Go after small organizations, with twenty or less employees, since they create 2/3 of all new jobs.

2. Hunt for interviews using the aid of friends and acquaintances, because a job-hunt requires fifty eyes and ears.

3. Do thorough homework on an organization before going there, using Informational Interviews plus the library [and Internet].

4. At any organization, identify who has the power to hire you there, for the position you want, and use your friends and acquaintances' contacts to get in to see that person.

5. Ask for just 20 minutes of their time, when asking for the appointment; and keep your word.

6. Go to the interview with your own agenda, your own questions, and curiosities about whether or not this job fits you.

Find the place and type of firm that best fits your professional aspirations.

7. Talk about yourself only if what you say offers some benefit to that organization, and their "problems."

8. When answering a question of theirs, talk only between 20 seconds and 2 minutes at any one time. [Be brief, not boring.]

9. Basically approach them as if you were a resource person, able to produce better work for that organization than any predecessor.

10. Always write a thank-you note the same evening of the interview, and mail it at the latest by the next morning (Bolles, 1992; text in brackets added).

In short, take a personal approach that lets you stand out from the mass of faceless paperwork inherent in the hiring process. People who know you and like you will want to work with you. Give them that opportunity. Widen your professional circle every chance you get.

SUMMARY

With this chapter, you are now moving into the process of finding and pursuing your first professional position as an interior designer. Knowing the makeup of businesses in design will help you target your efforts appropriately to a position that suits you based on your personal profile. The differences among large, midsize, and small firms may hold significance for you as part of your decision-making process. Salary, cost of living, and benefits are

other critical considerations that you must give your utmost attention before making your final decision. This chapter provided several tools and resources to guide you through this initial activity of identifying companies you are interested in pursuing employment with. The following two chapters will provide guidance in creating your self-marketing package to make your job search the ultimate success!

ACTIVITY

Using the information from this chapter, determine whether you would like to work for a large, midsize, or small firm and identify a geographic area where you would like to live. With the resources provided, answer the following questions:

1. What are the advantages of working for a firm of this size in this area?
2. What are the potential disadvantages of working for this size firm or in this geographic area?
3. What salary would I have to make to be able to live in this part of the country?
4. What firms are currently hiring in this geographic location?
5. What types of positions are available from the firms currently hiring?
6. Are there specific jobs that look interesting? What are the characteristics of the firms that have interesting-looking positions open?

Your responses to these questions mark the beginning of your evaluation of areas, companies, and locations. Be sure to use the information you have gathered in answering questions 1 to 6 above to inform your decisions before expending a great deal of energy in your job search.

Melinda Graham may already be a familiar name. She has appeared on NBC's *Later Today,* the Discovery Channel's *Home Matters,* Lifetime's *Our Home,* and the Do It Yourself Network. Her home has been featured in *Woman's Day* and a Christmas book by Mary Engelbreit. She's also penned a design Q&A for *Budget Decorating Ideas* magazine.

Melinda didn't intend to be a media presence. Immediately following graduation she accepted a position in a local firm doing residential design. Disappointed in the experience, she next contemplated joining an architectural firm in nearby Pittsburgh, where her drafting talent and interest in restoration could gain greater exposure. As she vividly recalls, it was during an interview with one of these firms that she re-evaluated her life's plan. Immediately she quit her job and started her own business, offering design consultation from her home.

"It started with my parents' friends saying things like, 'I really want to re-model my powder room' . . . really basic stuff." After each job she would leave behind her trademark "thank you gift" to build her clientele. A client once asked if she had ever thought about venturing into retail by selling her handmade gifts. She immediately dismissed the suggestion, as she had worked in retail sales while attending WVU. However, Melinda soon realized that this was the route she needed to take if she wanted to make some money, and thus, the search began.

"I began buying things and filling my car with crafty stuff and selling things out to various businesses in town." While making a delivery for a client, she noticed a store that was available for rent. Out of pure naiveté, with no money to her name, she called the owner of the building. To her surprise, she was able to rent it. Melinda was in business and "Surroundings" was born.

Surroundings began as a design studio rather than a retail business, but the decorations shortly became as popular as the design work. As her business grew, so did her notoriety and the opportunity for exposure, particularly that of the broadcast media. When asked of her television exposure, she laughs and confesses, "Television was a fluke." She recalls that one day while watching Lifetime television, the network extended an invitation to women in business with a unique beginning to submit their stories. She jumped at the opportunity to promote her business. In a few months, Lee Field, producer at the Lifetime network, informed her that she would be appearing on the show. Within a week she was flown to New York. After the show, her business exploded. Because of the positive feedback the show received, Melinda was invited to be featured on *Our Home*. This new wrinkle took her business to the next level. She received an offer to appear on HGTV, an NBC affiliate, regarding more work in television.

She recalls taping segments with Willard Scott on his farm in Virginia. "They turned Scott's barn into a studio, and there we designed outdoor gardening crafts and [shot] entertaining segments." A couple of years later, she was contacted by the Discovery Channel to appear on *Home Matters* with Susan Powell.

Surroundings interior design business continues to grow. Melinda offers residential and commercial services and is currently working on the private floors of the Radisson Hotel on the Waterfront.

Today 50 percent of what Melinda produces is retail. "This may sound crazy, but my greatest accomplishment to date is still being in business after all these years. Being located in a small college town can be a challenge and test your will to do it, but it allows me to keep a tighter hold on the business and do what I enjoy most—being creative."

Adapted from "Melinda Graham: Alumni Spotlight" by Latifa Forbes. Retrieved 9/20/2006 from http://alumni.wvu.edu/spotlight/view/melinda_graham/.

Photograph from the
Children's Museum of
Denver: Space designed
by the exhibits team
for the museum.
*Photograph by
Michael Brian Gates*

Self-Marketing
Showing Them Your Best Self

6

There is very little difference in people, but that little difference makes a big difference. The little difference is attitude. The big difference is whether it is positive or negative.
—W. Clement Stone

Objectives

After studying this chapter, you should be able to:

* Explain the importance of self-marketing in the job search.

* Introduce several tools that make up a self-marketing package.

* Create a targeted, cohesive marketing package.

* Identify the components of creative and effective resumes and cover letters.

* List the elements of a well-designed portfolio.

* Describe the elements of digital representations of your work.

* Coordinate a brief job presentation with your visual tools to form a coherent and exciting presentation.

Preparing materials that will support your upcoming job search can be intimidating, but with proper preparation and support, you will be able to easily create personal marketing tools to target specific positions. You used the tools in previous chapters to identify career options that match your personal interests and strengths. This chapter helps you think through the tools you want to create and how to coordinate all of your efforts into a cohesive, effective marketing package.

This chapter focuses on designing a self-marketing package based on your design philosophy and your personal "fit" into specific jobs. It includes finalizing your portfolio and creating a resume, cover letter, web presence, and digital portfolio. The chapter also addresses the presentation skills and personal interaction skills necessary for successful communications with your potential employer. Interview skills are another critical component and will be discussed in Chapter 7.

DESIGNING A MARKETING PACKAGE WITH A GOOD "FIT"

Information and activities provided in the previous chapters led you through a reflective process to determine your personal characteristics and identify some career paths within the interior design profession that may match your unique personality. The next step is to create a unified self-marketing package that will support you in selling yourself to potential employers in your area of choice. Using the contextual dimensions discussed earlier (intellectual, organizational, social, material, natural, and financial), we will help you create a self-marketing package that will appeal to employers focused on each specific dimension.

Read all information available on the company to prepare for the initial interaction.

Intellectual Dimension

Positions within the intellectual dimension typically consist of jobs that educate and inform. These may be found within the academic arena or in training and product education within the design community. Academic careers often require additional schooling, and the marketing package should stress your ability to teach and creatively convey information to a wide variety of students. For positions in training and product education a little homework is necessary. Your self-marketing package will be most effective if it includes information about methods you might use to educate others about the specific products or services offered by the company with which you are interviewing. Although this may be a little more time consuming, it shows the company that you are serious about educating yourself and taking initiative. It also allows you to showcase your ability to talk intelligently about their products or services.

Organizational Dimension

Within the organizational dimension, most positions will fall into the commercial design area. There are a wide variety of specializations within this area, and you will want to remember that your tools must project a very polished, professional impression to appeal to the employers in this category. If there is an area of specialization you are interested in (e.g., healthcare design, hospitality design), you may consider targeting your package to that area of specialization. Another more prevalent approach for new design professionals is to use your marketing package to provide a broad overview of your abilities and show that you can handle a variety of types of projects to begin.

Social Dimension

Design careers within the social dimension require personal interactions with clients and often have a residential emphasis. The personal nature of these jobs may allow for your self-marketing package to include more personalized elements and have less of a corporate, polished appearance. If the position you want includes responsibilities such as move coordination or sales, your package should emphasize your ability to schedule and organize work. Showing evidence that you have a clear understanding of activities such as formulating budgets, creating realistic schedules, and attention to detail could also be helpful.

Material Dimension

Pursuing careers within the material dimension means you are focusing on more of the tangible elements of design. Materials may be elements such as furniture, flooring, light fixtures, or other concrete items used in interior design. As a designer, you may specialize in the *use* of any of these materials, or you may actually be the *designer* of these materials.

The positions in addition to interior design that fall within the material dimension are varied and span many arenas. Individuals who design, manufacture, and/or sell fabrics, accessories, area rugs, and other items important to interior spaces would be operating within the material dimension. Specialists who develop and supply interior finishes such as flooring, paint, plaster, wallpaper, tile, doors, windows, and hardware also fall into this dimension. Fixtures and equipment specialists, including those who manufacture and market elements such as kitchen and bath items, are also oriented toward the material dimension. Finally, specialty design positions within the material dimension may include product designer, colorist, lighting designer, custom carpet designer, and other specialized areas of design within the industry.

If you are applying for a position that requires specialized knowledge about specific materials, your self-marketing package must show that you are capable of performing the responsibilities associated with the specialty area with a high level of competency. This does not mean you are expected to perform at the level of a 20-year professional, but it does mean that you need to show overwhelming evidence that you have concentrated on this area of design throughout your college career and have created projects specifically targeted to address the specialization area.

Natural Dimension

Interior design positions within the natural dimension typically address environmental issues. The recent concentration on sustainability and green design has opened up various job opportunities for designers. Although sustainable design can (and should) be incorporated into all types of design, professionals concentrating on the natural dimension typically need to show a greater understanding of the science behind the design and use of sustainable materials. A conversational knowledge of LEED certification, green products, and the future direction of sustainable design are also indispensable in establishing your expertise in the subject area. All of these elements should figure prominently in any self-marketing package you create for positions in this dimension.

Financial Dimension

The financial dimension of the design field requires more of an economic background and experience that indicates an ability to incorporate the practical application of financial principles into a project. In short, this dimension is concerned primarily with the transfer of money within design.

If you are inclined to work with money, budgets, and estimating, your self-marketing package should emphasize your experience in the financial areas of a project. Information organization and attention to detail are also critical when dealing with money issues and should also be highlighted in your documentation.

All designers must keep good financial records, but there are also specialty positions that work more closely with the financial aspects. These positions include business managers, estimators/specifiers, sales associates, and project managers. It is vital to reinforce your financial experience in your marketing package to show your potential employer that you are well suited to positions of this type.

Specialty Area: Design Over Time

Working with design in a historical context falls into the "design over time" category. Positions in historic preservation, cultural resource management, adaptive reuse, and sales and restoration of antiques are some common jobs within this category. To pursue a career in this specialty area, you must include in your self-marketing package evidence of detailed projects designed within a variety of historical contexts. Provide examples of your work that illustrate the appropriate use of historic elements and styles and a clear understanding of the relationship between historic and current design approaches. Extracurricular activities that indicate a strong interest in the history of design will also reinforce your expertise and interest in this area of design. Your knowledge of historic details and elements may also be reinforced by the details and formats chosen for items within your self-marketing package.

Specialty Area: Design for Special Populations

Design for special populations is not limited to design for people with special needs. As our clients become more diverse, we must develop our understanding of environmental and spatial needs for clients of varying age groups as well as any specific client needs related to ethnicity or physical or

mental differences. As with other areas of specialization within the design field, pursuing a position designing for special populations requires that your self-marketing package reflect a strong understanding of differences and the ways design can affect lives. Projects should show a focus on supporting your chosen group or reflect cultural differences in creative and sensitive designs that do not reinforce stereotypes and are not condescending. If you have been involved with special populations through volunteer efforts or other activities, indicate that connection clearly in your self-marketing package to reinforce your commitment to assisting people with specific challenges.

Coordinating the characteristics of the job you are pursuing with your unique individuality allows you to present a coherent, convincing case of your suitability to a potential employer. Designing a total "sales" package ensures that components are highly synchronized and visibly reinforce each other. You are a designer, and you are about to embark on one of the most important design projects of your career—enjoy!

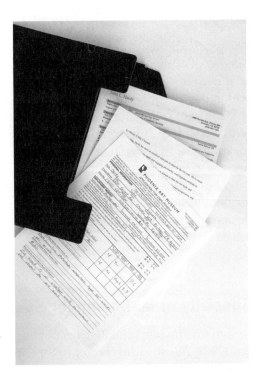

Present a coherent, convincing case of your suitability to a potential employer.

INITIAL CONTACT, RESUME, AND COVER LETTER

Initial Contact

People often overlook the initial contact with a potential employer—often a phone call—as an important interaction in the job-seeking process. Whether you are responding to an ad in the newspaper or on the Internet or making a "cold call" to determine whether a company has openings, you want to make the best impression possible in this first connection. Following are some tips to remember for your first contact:

1. Read all information available on the company. Be well informed about the type of work they do, the geographic locations they operate within, and any areas of specialty they concentrate on. Many companies have websites that are very informative. Trade magazines also have information on special projects firms have designed. Making reference to a project a firm had published in a magazine shows that you have done some research about the firm and have a special interest in their work.

2. Try to find the most appropriate person to talk to. Asking the receptionist is the easiest method; however, sometimes an employment contact is identified on the firm's website.

3. Be clear about what you want to say, speak slowly, and use appropriate grammar. Don't ramble or try to carry on irrelevant conversations, and be professional during the entire conversation. Before you call, ask yourself, What exactly do I want to accomplish with this call? What outcome am I trying to achieve? This outcome could be an interview, a clarification about materials needed to apply, or additional information about a position.

4. If the firm is advertising for an employee, know what they are looking for. Ads generally contain key pieces of information, so read the narrative carefully. Then go to the website to try to learn more about the position they are looking to fill. Doing this background work will allow you to discuss characteristics you possess that directly address their needs. In addition, your demonstration of interest in the firm will entice them to spend time with your follow-up materials when they arrive.

5. Above all, be confident, do your research, and use professional language to assist the employer in understanding exactly how your characteristics will benefit the firm. Then send your written or visual information promptly, with a reference to your conversation in the cover letter.

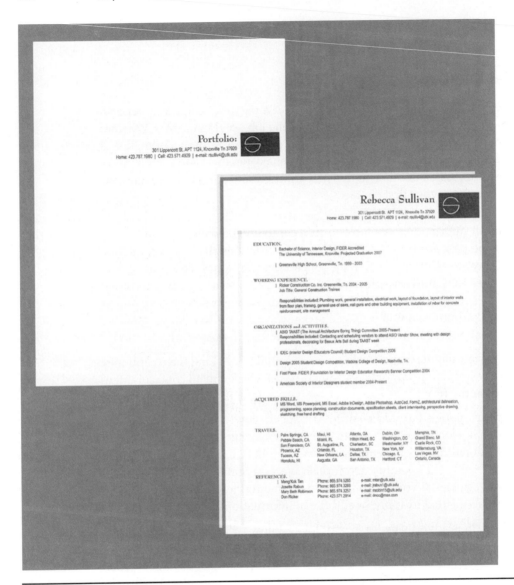

Example of logo for portfolio cover and resume.

Source: Rebecca Sullivan, student, College of Architecture and Design, University of Tennessee, Knoxville. Mary Beth Robinson, faculty sponsor.

Resume

Your resume is the element in your self-marketing package that is the most descriptive of your past history and qualifications related to the position for which you are applying. The resume is a concise, targeted narrative that

showcases your background experiences and your abilities. As a part of the overall package, it should be visually coordinated with your portfolio, cover letter, digital presence, and other items in your package. The fonts you choose should be interesting but easy to read. The overall spacing of elements as well as line spacing demonstrates your understanding of the use of positive and negative space to create balance, interest, and focal points. The organization of information is also critical; emphasize points that directly relate your abilities to the job you are seeking. Be sure that your format is consistent. For example, align titles of previous employment, responsibilities of previous employment, and dates of previous employment for a visually organized page. The use of bullet points also provides opportunities to be organized, succinct, and include important information without wasting valuable space with unnecessary narratives. Provide enough information to show your abilities related to the job, but don't give them your entire life history!

There are many standard templates available for resumes, and often the career services group in your institution is available to help. The standard formats give a good idea of what needs to be included, but a resume for a creative position must demonstrate that you can use those creative talents to go beyond the standard format. Employers rarely spend more than 10 to 20 seconds reading a cover letter and less than a minute scanning a resume during an initial screening of candidates. Use your talents to stand out and make it through that first cut!

Typically, your contact information is the first item placed on the resume. This acts as an introduction and ensures that the reader knows how to contact you directly if you are chosen for an interview. Be sure to include current phone numbers and addresses. If you are in the process of moving, provide a cell phone number that will remain consistent throughout your relocation, and a permanent address (possibly a family member or good friend) who will alert you immediately if mail comes for you. Listen to the voice mail greeting on your cell phone to make sure it is appropriate and will give your potential employer a good first impression of you if she calls to set up an appointment. Providing an e-mail address is also a good idea, but be sure to check it at least daily if you give it to prospective employers. Businesses use e-mail extensively and expect responses quickly, not a week after the message has been sent. Evaluate your e-mail address to make sure it gives a professional and positive impression to an employer. If there are any questions, get a new address for your job hunt. The difference in the impression an applicant will make with an e-mail address of hotbikinikid@anymail.com versus IDdevotee@anymail.com is significant and should be taken seriously.

Objectives are often included as a part of the resume and, if written appropriately, can provide a potential employer a quick snapshot of your fit with the position being sought. If you choose to include an objective, write a statement that defines your place in design, not a generic sentence that could apply to any person applying for any job. An objective such as "my objective is to obtain a professional job as a commercial designer with a large design firm" really doesn't tell the employer why she should interview you for this position. What are your unique goals? You used the PRSM activities in earlier chapters to identify specific elements about yourself and places that fit your needs; use that information to inform your objective.

Providing your educational history is good; include your degree and the date received. If your program is CIDA accredited, you may want to include that information on your resume so there is no question about the quality of your education or your potential to take the NCIDQ in future years. Although it is tempting to include all of your course work on your resume, your potential employer will assume that you have had the basic design course required for graduation. This will be reinforced by your portfolio, which will have examples of your work from various design studios throughout your college career. Instead of listing all of your classes, you may want to highlight any studio project work that might be relevant to the position, unique strengths you developed through specific courses, and your proficiency with particular computer programs.

Your work history is another component that will enhance your potential employer's impression of your abilities. It is important to evaluate all of your previous jobs to identify the skills they required and what you learned. Although the title of your previous positions may seem irrelevant when applying for a position in interior design, the skills and responsibilities often translate directly from one field to another. For example, if you worked as a server in a restaurant for three years, the title "waitress" may not carry any weight on your resume. But indicating your experience in working with the public, communications, selling, money management, negotiations, problem solving, and teamwork will directly relate to most professional positions in design ranging from a design intern to the president of a company! Think about what you actually did; then relate those skills to the specific skills necessary for your interior design job.

Awards and extracurricular activities show an employer that you are a well-rounded person with interests beyond design. As with your job history, go beyond simply listing organizations you joined and include *how* you were involved. Show that you were more than simply a name on a role; explain that you took leadership positions, served on committees, and made a difference within the organization. It is easy to be a member of an organization, but it takes more effort to be a contributing member. When identifying awards, indicate the purpose of the award and the activities that led to your

receiving it. For example, if you received a local honor, you might want to indicate that you received first prize out of 40 entries in the Eileen Gray Design Award competition for your custom-designed table accessory piece. Of course, you will want to include illustrations of this design in your portfolio!

Finally, as with all of your work, proofread your resume several times; then have friends review it to be sure there are no mistakes, the organization flows well, and the overall document makes sense. Invite friends both with and without design experience to participate in the review to get a variety of feedback. Remember that people without design backgrounds might be reviewing cover letters and resumes to make the initial decisions about people to interview. Don't get so "out of the box" that your real message gets lost in the uniqueness of the package.

REFLECTION

What are the three most important things you would want a potential employer to know about you? How would these characteristics positively contribute to your performance as a professional? How would you clearly provide that information in your interview?

Cover Letter

The cover letter accompanying your resume is typically the first visual element a potential employer will see. A cover letter should graphically integrate with all other parts of your self-marketing package. It should be visually interesting yet easy to read. As with all other parts of your self-marketing package, the cover letter should be designed with the reader in mind. Designers are often tempted to use a variety of fonts or fonts that are reminiscent of architectural lettering. Evaluate any font you use for ease of reading; sometimes the hand lettering fonts become tiresome to the eyes when used for longer narratives. Using appropriate font sizes is another important factor in creating a document that is easy to read. Eleven- or twelve-point fonts are generally acceptable. Also consider your line spacing as well as the use of positive and negative space. Position the letter on the page so that the spacing around it is interesting and says that you have made conscious decisions about the overall balance and visual impact of the letter. You may also choose to use a graphic on the letter that provides a unifying element throughout your self-marketing package. As with all two-dimensional designs, consider the harmony of line, color, and placement of the graphic in relation to all other elements on the page.

Many new professionals make the mistake of using the cover letter to restate the information included in the attached resume. Although there may be particular items you want to call attention to in the cover letter, a better use of this narrative is to provide information not included in the re-

sume but that may be of interest to the reader. For example, if you attended a Designer's Showhouse and saw a room the design firm created, you might say that you saw the example of their work and that motivated you to seek a position at their firm. Cover letters may elaborate on targeted elements from the resume that show the employer more clearly how your experience relates to the position you are applying for. Be succinct and do not deviate from your objective, but provide enough information to excite interest. Additional information can always be provided during an interview.

Cover letters are often organized in the following manner. You may choose to reorganize the following information or include additional specifics, but remember to keep the letter concise and to the point.

- **Date, name of firm, name of contact, and mailing address.**
- **Salutation.** Find a person's name to use in the letter. If this is impossible, determine the title of the position that will be receiving the correspondence. Often this is the director of human resources, vice president of employee relations, personnel manager, design director, or the president of the company.
- **Introduction.** Introduce yourself, identify the position you are applying for, tell where you heard about the position, and say why you want to work for this firm.
- **Body of the letter.** Discuss why you believe you would be a good fit for the position (this is where the self-evaluation and research of the firm is helpful).
- **Closing.** Ask for what you want (an interview, the position, an internship), and say that you will follow up with a call within seven to ten days. Don't forget to include your contact information (both address and phone numbers) in the closing section or as part of the inside address at the top of the page. Hopefully they will be so impressed that they will call you before you have a chance to follow up!
- **Closing salutation.** Don't get too familiar or trendy with this. Simply "Sincerely" or a similar salutation is appropriate. Sign your name, and type your name under your signature in case they aren't able to easily read your signature. As a matter of format, be sure to put "Enclosure" at the bottom of your cover letter to indicate that you have included additional materials in the packet.

Proofread every part of the letter several times; then have a friend read it for typographical errors, grammatical mistakes, and general flow of information. Two sets of eyes are always better than one. The last thing you want is to have a cover letter with glaring mistakes be an employer's first impression of you!

Resume

Lindsay Hannah Helton
641 Crescent Drive
Gatlinburg, Tennessee 37738
865.654.0415
helton3@utk.edu

Education
The University of Tennessee, Knoxville
Interior Design Program, Accredited
2003 - 2007, 3.46 GPA

Study Abroad Program, The University of Tennessee, Knoxville
LeCorbusier in France, Maiterm 2005

Gatlinburg Pittman High School, Gatlinburg, Tennessee
1999-2003, 3.84 GPA, Top Ten Percent

Business Experience
BarberMcMurry Architects, Knoxville, Tennessee
Intern - Completed Construction Documents, Interior Design Schematics, Material Selection

Verbon's, Gatlinburg, Tennessee
Sales Consultant - Greeted Customers, Shipped Orders
2004-2005

Cotler and Company, Gatlinburg, Tennessee
Server - Helped Customers, Created Wholesale Orders
2001-2003

Scholarships and Honors
National Merit Scholar
Frederick T. Bonham Scholar, The University of Tennessee, Knoxville
Ned McWherter Scholar
Hope Scholar
Senior County Credit Union Scholar, Senior County Credit Union
Chancellor's Honors Program, The University of Tennessee, Knoxville
Frederick T. Bonham Scholarship Dinner Student Sponsor, 2006

Organizations
American Society of Interior Designers, The University of Tennessee Student Chapter
TAAST Officer, 2005-2007

Alpha Omicron Pi Sorority
New Member Educator, 2006-2007
Recruitment Committee, 2004-2006

College of Architecture and Design
Peer Mentor, 2004-2007

Juried Competitions
University of Tennessee Hospital, Neonatal Intensive Care Unit Welcome Wall Finalist 2006
Interior Design Educators Council Student Competition 2006
Design 2005 - Architecture for Humanity Charrette
Foundation for Interior Design Education and Research Banner Competition 2004

Skills
Autocad, Form2, Microstation
InDesign, Photoshop
Word Processing, Excel

Cover letter

Lindsay Hannah Helton
641 Crescent Drive
Gatlinburg, Tennessee 37738
865.654.0415
helton3@utk.edu

July 31, 2006

Kelly L. Headden, Senior Vice President
BarberMcMurry Architects
623 Lindsay Place
Knoxville, Tennessee 37919

Dear Mr. Headden,

I am a third year interior design student at the University of Tennessee College of Architecture and Design. I am seeking information regarding a summer internship with your firm.

As a design student, I am very passionate about the quality of work that I strive to achieve in every project. I am goal-oriented designer with a strong focus on creating functional, exciting spaces. I have seen the quality of your work, and I would love to add my own talents and style to your design team.

Thank you for reviewing my resume, and I look forward to meeting with your firm for a personal interview. I will contact you within the next week to arrange a convenient time.

Sincerely,

Hannah Helton

Keep a cover letter concise and to the point.

Source: Hannah Helton, student, College of Architecture and Design, University of Tennessee, Knoxville. Mary Beth Robinson, faculty sponsor.

PORTFOLIOS REVISITED

Chapter 1 provided an introduction to portfolios and gave you an opportunity to make preliminary design decisions about your cover and page templates. Now we will discuss more of the details about what actually goes into those beautiful templates you created earlier!

What to Include and How to Include It

A recurring question from students is, What should I put in my portfolio? Often students choose to put every design project they created from their first year throughout design school in their portfolio, thinking that quantity will have a greater impact on the interviewer. This is not necessarily the case. When creating a presentation portfolio, quality is *always* more important than quantity. Having a great deal of excellent projects illustrated well is best, but if your high-quality designs are limited, create a portfolio that showcases the few excellent pieces of work you have and forget trying to "fill up" the rest of the pages. Including mediocre work to add quantity will only lessen the positive impact of your excellent work.

Include a variety of elements in your portfolio.

Decide what to include in your portfolio by evaluating the position you are interviewing for and targeting your work to that company. Interviewers will want to see that you can take a project from programming and concept development through to completion, including construction drawings and specifications. Seeing that you have a coherent process through a design project can be a critical component in an interviewer's evaluation of your abilities. Highlight your design abilities and creativity through illustrations of your design projects. Include a variety of elements that show your creative abilities, including photos of models, sketches, renderings, presentation boards, finish choices, and presentation plans. Demonstrate your technical abilities by including CAD drawings, construction details, and code evaluations for your projects. Highlight your use of sustainable materials and processes and your rationale for your choices whenever possible. You can illustrate your business and time management skills by including budget sheets, project schedules, and specification sheets for projects. It is not necessary to include every specification or budget sheets for every item, but showing your ability to engage in the business side of design as well as the creative side will boost the interviewer's awareness of your abilities. The pockets of your portfolio are a good place to store supplemental information or resources for use during your interview.

Your portfolio should begin with a dynamic and striking introductory page. The design and format of pages, as well as any relevant graphics you include, will provide unifying elements that give a visual cohesiveness to the portfolio. Page orientations should be consistent so the viewer does not have to move the portfolio to a different position each time a page is turned. There should be a logical progression through all of the work shown, and an effortlessness understanding of the organizational structure. If you are applying for a position in a firm doing primarily residential design, you would want to put your residential projects at the front, moving logically from the beginning to the end of a project before moving to the next project. You may then want to include smaller commercial projects with a more residential feel. If the firm does any commercial projects, conclude with larger commercial projects to show your abilities to work on larger-scale facilities.

As a student or new professional, you will primarily use projects you created in your design studios. Because you want to showcase your best work, pay attention to any comments and suggestions from professors, reviewers, and jurors and make improvements to your projects before entering them into your portfolio. You may also want to supplement your course work with other projects that support your interest in a particular type of design. Creating project scenarios and then designing solutions is another way to show your initiative and ability to produce your own ideas. Getting periodic input

from a design professor or local professionals will help you to keep the quality of your work at the highest level. Be sure to indicate whether you created the project yourself or with a group.

Adding labels and small amounts of text will provide additional clarity to your portfolio presentation. Include some narrative for each project to provide an overview of the work, but do not include the entire assignment given by the professor. Make sure the text describing project work is clearly associated with the work it is describing and that any labels are placed adjacent to the items they describe. It should go without saying that the craftsmanship and attention to detail on every page must be flawless. Photography should be excellent, with images cropped and sized appropriately for the page. Make sure your pictures are crisp, well focused, and lit correctly. Pictures should also focus on the elements you want to showcase. If your photo is of a presentation board, crop it to include just the board, not the room behind the board. When representing color schemes, make sure the colors in the photograph represent the colors chosen as closely as possible. You may also want to photograph or scan parts of boards (i.e., renderings) to enlarge as better representations of your rendering abilities. If you do not have a camera or studio where you can produce professional-looking prints of your work, consider hiring a professional to photograph your projects. Professional digital images are easy to manipulate and print.

Remember that your portfolio should express who you are. (Washington Allston, 1779-1843, American painter and author, holding portfolio)

The portfolio is your key visual element for selling yourself to a potential employer. Treat it as a serious design project, pay attention to the details of every element, include your best work, and make sure it is clearly organized so as to answer any questions that may come up in the viewer's mind. By maintaining a continually updated master portfolio, you will be able to create a presentation portfolio targeted to each interview. Make this a fun, creative, and ongoing part of your design career.

Digital Work and Web Presence

Creating a web presence and providing digital representations of your work are becoming common in today's market, and in some cases expected because of the potential travel expenses involved in interviewing. As you are aware, a digital portfolio is different from a website, although your portfolio may be housed on your website or on a CD for physical distribution. We cannot cover all of the information you need to create a website or digital portfolio in this section, so we will address the principles to consider in the design process only. For technical support we suggest that you refer to the many resources listed at the end of this chapter. You may also contact a professional web designer if you prefer to work with a specialist.

The first thing to know about creating any digital representation of your work is that the digital version is only as good as the quality of the photographs. As with a physical portfolio, you must begin with excellent photos of your work and then design the portfolio to enhance your work. A great portfolio design will not make up for sloppy or unprofessional photos! Digital media allow greater flexibility than standard photographs, and you may want to take advantage of the differences to really make your digital work unique. Digital formats allow you to include visual walk-throughs of your spaces, 3-D images of models, clips of your presentations, and other multidimensional examples of your work. Use your design skills to design any digital media correctly; doing a mediocre job on a website or CD and then presenting that to potential employers as an example of your best work will only spell disaster. Remember that anything you submit to an employer will be interpreted as an example of your design abilities. Make the impressions positive.

Several software programs are commonly used to create webpages and digital portfolios. These include Front Page, PageMaker, Dreamweaver, PowerPoint, and Publisher. Many other options are available in a variety of price ranges and levels of sophistication from shareware to AutoCAD enhancements. The programs vary in complexity and the tools available to

manipulate media. Spend time researching programs before you make a decision, and be careful to choose a program that is simple to use and easy to understand, and that offers tools and options that allow you to create the type of digital work you desire. There is a learning curve to each program, so be realistic about the time you will need to become proficient in using the software.

When creating a CD to send to potential employers or to leave with them after interviews, use common fonts and a widely available program such as PowerPoint to ensure that employers have the software to open and view your work. If you are concerned about this issue, you can send a .pdf file of your work; however, you will lose any animation or sound with this format.

A personal website is an easy and efficient method of showing your work to potential employers, alleviating the need for the viewer to have specific software to view your work. Registering for a personal web address is a simple undertaking. Many Internet service providers now offer limited website hosting as a part of their services. Web addresses should be simple and professional and should lead directly to an easily identifiable home page. Any links from your home page to other pages should be straightforward with labels that indicate the contents of the link. A logical, linear progression through the site is the best approach for "self-marketing" websites. If you have a tendency for more circular thinking (as most creative designers do), get a little help from a friend or two on this (your math major friends may be *very* helpful!).

Many designers are lured into complex graphic representations and "intuitive" navigation icons. Your goal is for the viewer to get to the important items quickly and to understand them completely. Don't expect others to be able to interpret your graphics if there are no other clues regarding the content of links, and don't expect them to spend a great deal of time surfing your site. Another temptation is to fill the site with lots of "stuff" for character. As with interior design, don't embellish your site with useless frivolity; animation, sounds, and cute graphics typically get in the way unless there is a strong design reason for them to be included. Ask yourself, How does this enhance the message I want my future employer to take away from this? Also, watch the use of "canned" clip art. It is usually obvious and is often perceived as a space filler, detracting from your original work. If you feel that the design needs a graphic, design it yourself or use something innovative and unique. Finally, be careful with copyright clearances. Music may really set the stage for your work, but it is illegal to embed copyrighted music into your work without paying royalties to the artist. This will send a message to your employer about your ethics and business sensibilities. If you feel you can't live without lots of subtlety, kitsch, or personal elements, create a second personal website for those

elements and leave your professional website clean, simple, and focused on your work!

Check any website you create on a variety of computers because different operating systems may read your information differently. You want to be sure that the information is clearly conveyed and easily uploaded if the viewer is using Apple OS 10, Microsoft Windows XP, Microsoft VISTA, or another operating system. Employers want to see examples of your work quickly and will make fairly rapid assessments about your potential as an addition to their team. The easier you make their job, the more positive their impressions will be.

While we are discussing digital media, it is important to address any other web presences you may have. Many employers today conduct Internet searches of potential employees and view sites where they may be sharing personal information, pictures, and so on. Websites such as www. facebook.com and www.myspace.com may seem quite removed from your "professional life," but be aware that any information shared on sites such as these becomes public property. It is perfectly legal for a potential employer to view it. Employers can use the contents of these sites to form opinions about your character, work ethic, and ability to represent their company. Be sure to review any sites you have contributed to and see that they represent you well to anyone who might view their contents before beginning your job search efforts.

Example of a portfolio cover and a page from the portfolio.

Source: Student work by Samita Sahoo, Master of Interior Design graduate from the University of Florida. Dr. Mary Jo Hasell, faculty sponsor.

SUMMARY

Designing a comprehensive self-marketing package is a key component of a successful job search. You can aid yourself and your potential employer in evaluating your suitability for any job by identifying your personal characteristics and goals and then relating them specifically to advertised positions. Formulating well-constructed cover letters and resumes that directly associate your strengths with the job responsibilities, having a presentation plan for your interview, creating an excellent portfolio that reflects the strengths identified in your paperwork, and having an appropriate digital presence all work together to inform employers of your potential.

Each part of your self-marketing package must be excellent and show your highest-quality work and attention to detail. The following activities will help you think through design decisions about each of the components discussed in this chapter.

Remember that the primary purpose of your portfolio is not to keep the rain off your head. It is to sell yourself to the firm of your dreams.

ACTIVITIES

Resume Activity

1. Make a list of the important information you believe should be included in your resume.

2. Design a graphic template for your resume. Use your design talents to keep it simple and easy to read, but striking enough to capture the attention of the reader.

3. Merge the information from your list with the template you designed to create the first rough draft of your resume. Review the overall effect and make changes as needed.

Cover Letter Activity

Conduct research about positions and locate a job you would be interested in pursuing. Based on the information available about the job and your knowledge about yourself from previous activities in this book, write a cover letter to the contact person. Introduce yourself and provide a well-written, compelling reason for the person to review your materials further and consider you for the position.

Portfolio Activity

1. Review the portfolio decisions you made in Chapter 1. Evaluate your page templates and make any adjustments you now feel are necessary.

2. Using your portfolio programming and page templates, create a preliminary presentation portfolio for your job search.

RESOURCES

Adobe Photoshop CS2 One-On-One by Deke McClelland (Cambridge, MA: O'Reilly Media, 2005) ISBN: 0596100965.

Designing a Digital Portfolio (Voices That Matter) by Cynthia Baron (Berkeley, CA: New Riders Press, 2003) ISBN: 0735713944.

Digital Portfolio: 26 Design Portfolios Unzipped by A. T. McKenna (Gloucester, MA: Rockport, 2000) ISBN: 1564964671.

How to Wow: Photoshop CS2 for the Web (Berkeley, CA: Peachpit Press, 2005) ISBN: 0321393945.

Portfolio Design (3rd ed.) by Harold Linton and Steven Rost (New York: Norton, 2004) ISBN: 0393730956.

I had never planned to become an interior designer. In fact, I had no idea that interior design existed as a *legitimate* course of study until my second year of college. And it was a happy accident that led me to my discovery of this varied, exciting, and endlessly rewarding profession. Choosing a career in interior design has given me the opportunity to earn a living while expressing my creativity and, in the process, has helped me to define my own capabilities, strengths, and weaknesses.

When I graduated from high school, I enrolled at West Virginia University in the political science program with the intention of eventually becoming an attorney. My freshman year went well, but it became clear to me by the first semester of my sophomore year that something was missing. All my life, I had been surrounded by a family that was very artistically inclined and aesthetically aware. The more time I spent studying the inner workings of the bureaucracy, the more I realized that I could not fully commit to a career that did not allow me to express my creativity. So, one weekend I read through the entire University course catalog, studying each major and the classes involved. I kept returning to interior design: the courses looked interesting as well as creatively oriented. After researching career possibilities for interior designers to be sure that I wasn't setting myself up for disappointment, I changed my major.

If I had ever doubted the seriousness of the profession or its necessity before, the vast amount of information that we were required to absorb in order to graduate in four years from a FIDER-accredited program quickly changed my mind. As graduation loomed closer and we were preparing our resumes to send out to possible employers, I was uncertain of what area of design to go into—commercial,

residential, or something more specialized. Then one day, a former interior design student came into our professional practices class. She worked as a designer for Model Home Interiors, an interior design and merchandising firm based in the Washington D.C./Baltimore area that did design work primarily for residential homebuilders. She explained that the larger homebuilding companies construct one model example of the product they are offering to buyers and hire a design firm to design, furnish, and merchandise the entire model from top to bottom. It is similar to residential design, but the client is the builder instead of the home-owner. She showed us a few presentation boards and examples of MHI's work, and I decided to send in my resume.

I interviewed with another firm before I got a call to interview at Model Home Interiors, but my mind was made up after an hour. The people at MHI were friendly, the pace was fast, and there was a buzz in the atmosphere that bespoke

a lot of creative energy. Best of all, the firm had recently made the transition from hand drafting to AutoCAD, and they needed designers who had the necessary computer training. That clinched it for me: the fact that I could immediately and directly contribute to the success of the company. I accepted the job one week before graduation.

Although I had learned a great deal during my four years of college, I learned more in three months working at my new job. The builders research their target market of homebuyers based on where the housing development is going to be located. They meet with the marketing representatives at MHI, who then take the information to one of the design teams to interpret into a specific design, which is presented to the builder. Turnaround time for a design can be as short as a few days. As a junior designer for the first year, I floated among all of the senior design teams and assisted them with the completion

of each phase of their design. Each week I was with a different team, and each day was filled with new experiences. Some days I would work on AutoCAD, other days would be devoted to searching for the perfect furniture or fabric to complement a design.

Often we work outside the office. Once a model has been designed and approved, the merchandising phase begins. MHI supplies most of the accessories needed out of its large warehouse, but sometimes we have to shop for special or hard-to-find items. Getting paid to go shopping is always fun . . . even if you aren't shopping for yourself! Another important part of the job is installing; the designers and crew travel to the job sites to unpack the accessories and set up the models. MHI works with builders all over the country, and I traveled for two to three weeks each month during my first year at MHI.

After a year of floating among teams, I was placed with one particular senior design team to assist them exclusively. This training has been an important step, with the goal being that I will eventually create my own design team. Over the past year, I have become more attuned to what the builders are looking for in a product, have taken on more responsibility, and, most excitingly, have been able to follow each design through the process from beginning to end. One of the facets of my job that I enjoy most is how quickly I see the results of my design input. Our team designs everything about a model from the color-way, to the bedding, to the architectural moldings. In a matter of months, our ideas have come to life. I can't describe how satisfying it is to walk into a successfully designed room and know that you played a key part in its creation.

Although I am new to the career of interior design, I have trouble imagining myself in another profession that could offer me the same level of personal fulfillment that I have now. It is not always easy—salaries are never very high in entry level jobs, and it is more expensive to live in the city now than it has ever been before. I would advise students who are considering becoming interior designers to be certain of their commitment and their passion, and to be willing to take any opportunities that come their way. With talent, hard work, and a little luck, anything is possible!

Home built by Brookline Homes,
Denver, Colorado.
Owners Scott and Tara Carter.
Photograph by Michael Brian Gates

Successfully Navigating the Job Interview

Who you are speaks so loudly I can hardly hear what you say.
—Ralph Waldo Emerson

Objectives

After studying this chapter, you should be able to:

* Describe methods of choosing and contacting firms to let them know you are interested in them.

* Identify the various types of interviews and how to prepare for each.

* Explain the use of your self-marketing tools in the interview process.

* Describe appropriate interview etiquette, manners, and physical appearance.

* List appropriate follow-up activities after the interview is complete.

* Explain methods of handling job offers and negotiations.

The interview process goes well beyond the time you spend face to face with a potential employer. It begins with your first contact, then quickly moves into negotiating an interview, preparing yourself for the meeting, completing the phone or on-site interview, appropriately following up after the interview, and finally, completing the process with job negotiations. Each step in the progression gives you another opportunity to use the tools you previously developed to show potential employers your unique qualifications for their specific job.

This chapter describes methods of preparing for the activity of interviewing. We discuss different types of interviews you may encounter, using your self-marketing tools to enhance your interview experience, preparing for the face-to-face interview, and tips that will help you be remembered positively after you have left the company's office. It is important to look at the interview as a *part* of the larger whole of the self-marketing endeavor, and to work hard to integrate all parts of your package into a coherent presentation of *you*!

LETTING THEM KNOW YOU ARE INTERESTED

The first half of this book led you through activities and exercises meant to help you determine your distinctive talents, desires, and characteristics. This information is essential in helping you determine work positions that interest you and are a good fit with your personality and requirements. Conducting research on specific areas within the design field that interest you is the first exercise you need to complete. Information and activities in Chapter 3 informed you about professional options within the design industry. Chapter 5 guided you through the process of evaluating employment situations and gave you methods of finding specific jobs and firms that provide a good fit for your individual needs and resources. Once you have identified a list of appropriate firms, you must somehow let them know you are interested and would like an opportunity to compete for a position in their company.

We discussed your initial contact with a firm in Chapter 6 and provided some tips to help make that communication successful. At the risk of repeating information, there are some important things you must remember when making that connection. If you are calling on the phone, practice your "phone presence" and make sure it is professional. Some professionals believe that standing while on the phone improves the quality of your voice. Try this with a friend to determine your preference.

Know the focus of the firm you are talking with and have as much information about them as possible so you can discuss the position intelligently. Read the position announcement carefully, if the position has been advertised, and have any questions about the firm or job written out so you can remember them and articulate them clearly. Determine the specific goal(s) of your call and stay focused; don't ramble or try to move into informal conversations. Above all, remember that your primary objective is to introduce yourself and make a good impression so that when they receive your materials, they remember you positively and will spend time looking at your work.

Introduce yourself and make a good impression over the phone.

TYPES OF INTERVIEWS

Most new graduates believe that an interview is a straightforward affair. In today's competitive environment, interviews have taken on a variety of features that often surprise an interviewee expecting to enter an office, sit in a chair, answer traditional questions, and leave. Although the traditional interview is still the most widely used interview technique, you should be aware of some of the other formats you may encounter. Following are brief descriptions of several types of interviews, some typical questions you may encounter in each, and generally what the interviewer is trying to evaluate. Typically, an interviewer will not discuss the interview format with you prior to the interview unless it is a phone interview. However, interviews conducted over meals are generally scheduled as such, so you will know that dining will be a part of the process.

Many books and articles have been written on each of the interview methods presented here. You may want to spend some additional time reading about them to be better prepared when you begin the process. Practice is also helpful. Working with professors, mentors, or other students to role play interview scenarios is a good way to alleviate some of your concerns. Finally, be sure you bring a pad and pen to take notes during each of your interviews. Information becomes confused or quickly forgotten as you talk to different people.

Traditional Interview

A traditional interview takes place in the company's office, includes specific (and often predictable) questions, is limited in time, and may involve meeting with other professionals within the firm. This interview style is the most common, and most people assume this will be the type of interview they will encounter. Traditional interviews may be any length of time, but typically range from one hour to half a day in most cases.

Many students ask, What will they ask me when I go for an interview? There are numerous answers to this question, and much has been written about potential interview questions and appropriate responses. We will discuss several examples, but for a more comprehensive review of possible questions, see the resources at the end of the chapter. Many interview professionals have identified a variety of questions often addressed in interviews. They may include some of the following:

1. What are your professional goals?
2. What characteristics do you have that make you a better candidate than the other people we are interviewing?
3. What is it about our firm that attracted you to interview for our position?
4. What are your weaknesses?
5. What are your most positive attributes?
6. What salary would you expect?
7. What was your favorite previous job and why?

Each of preceding questions is crafted to draw out specific types of information and to determine whether you have done enough research and self-reflection to understand what the firm does and how you may fit within its operation. Fortunately, you are using this textbook to guide you through your own professional and self-evaluation, so you will be well prepared for these types of questions! It is important to always be honest in your

Do your homework before the interview.

responses and to use your portfolio and other work to reinforce your answers. Try to end any response to a question designed to bring out a negative (e.g., What are your weaknesses?) with a positive. For example, if you identify the fact that you work to deadlines, meaning that you may procrastinate or not be as balanced in scheduling your workload as you could be, you may want to end your response with a positive such as "and I'm developing my own method of identifying and working to internal deadlines so work is completed well before the actual due date." This response shows the interviewer that you recognize traits that need to be changed and are implementing methods to change those traits. Be careful when asked about previous positions that were difficult; try to frame your responses in a positive light. If your previous boss was unbearable, instead of launching into an outburst about his negative qualities, you may simply indicate that you had different interpretations about ethics, or business decisions, or personnel management, or whatever the case may have been.

A growing trend in many companies is to administer skills tests as part of the interview process. Interviewers may ask you to demonstrate your proficiency with AutoCAD, a 3-D modeling program, or sketching during your interview meeting to evaluate your technical abilities in addition to your portfolio-based designs. Be sure that you accurately represent your skills in

your resume—you may be asked to demonstrate them on the spot! Some larger companies and corporations with a diverse workforce will give general employment tests to all potential employees. These tests typically evaluate decision making, problem solving, interpersonal skills, and comprehension abilities. These companies may also require drug tests before hiring any employee. Drug tests are not administered as part of an interview, but it is important to know that this may be a part of the overall job search process.

Interviewers have expressed their concern about and surprise at the number of interviewees they meet who have done little preparation for the interview, have limited knowledge of the type of work their firm specializes in, and can identify very few professional goals beyond "being a designer." Do your homework. Know everything about that firm that is available to learn. Don't be timid when discussing your strengths and how they will benefit the firm. You are selling yourself, and interviewers want to see that you have sales abilities so they can be assured that you can sell your designs to clients! You may also want to share what you hope to learn from your employment at their firm in addition to what you have to contribute. Show your personality, show your confidence, and show how you are an ideal complement to their organization.

Behavioral Interviews

Behavioral interviews may initially seem like traditional interviews in format, but the questions are significantly different. Behavioral questions are designed to show the interviewer how you acted in previous situations (business, school, organizational) under the assumption that previous actions are somewhat of an indicator of future actions (Doyle, 2005). An interviewer who asks a question such as, What is an example of a goal you reached, and how did you reach it? is looking to learn about your depth of thinking, your ability to analyze situations, your past actions, and the results of your decisions. Following are some common behavioral questions:

1. What methods would you use to convince a client to eliminate a beloved piece of furniture that severely compromised your design of the space? How would you handle the situation if the client refused?

2. How would you react if a colleague constantly insisted on interrupting your work schedule?

3. How would you motivate a team to become enthusiastic about a project that did not interest the team members?

4. How do you handle constructive criticism of your work? Give an example of your approach when you agree with the criticism and when you disagree with the criticism.

Answering honestly and providing details and self-reflection about your actions are critical to help the interviewer understand your process. Preparing for a behavioral interview can be challenging, especially because you will rarely be aware that the format will include behavioral questions before you begin the interview. In your interview preparation time, devote some energy to thinking about examples of specific situations in which you used professional judgment, made difficult decisions, and made a difference. Make a few notes to have as reminders if necessary, and allow yourself a little time in the interview to craft your responses before beginning to answer. Remember that the interviewer, like you, is looking for a good fit with his firm. There are no "right" answers to the questions, just honest responses to determine a connection between your process and the expectations of the company. Reflecting about your unique process is a good way to prepare for this. Activities at the end of this chapter will also help you think through your personal approach.

Case Interview

The case interview is similar to the behavioral interview, but instead of using specific experiences from your past to determine your decisions and actions, the interviewer provides a scenario or set of scenarios to attain your reactions (Peterson, 2005). Like the behavioral interview, the case interview requires you to think quickly, evaluate situations, reflect on your approaches, and provide examples of how you would deal with the conditions presented.

Reflect on your approaches and give honest answers.

Scenarios provided in case interviews often reflect real-world situations faced by design professionals on a regular basis and may include ethical issues, sales issues, conflict resolution, client relations, and team challenges. The interviewer may give scenarios in a written or oral format, and you may be asked to describe your approach verbally or in writing. Taking notes while a scenario is described verbally is generally acceptable and is advisable to help you formulate an appropriate response. Scenarios may be very detailed or may have sketchy information, requiring you to make assumptions or ask questions to gather additional information.

▮ REFLECTION _____

Following is an example of a case interview scenario. How would you respond to this situation in an interview considering your responsibility to the client, your company, the junior designers, the lead designer, and the rest of the design professionals on the team?

You are the lead person on a team assembled to design a fast-track project for a high-profile client. The programming is complete, and the team is moving into the schematic design phase of the project. It is the beginning of summer, and you have two junior designers working for you on this project in addition to other design professionals. You are depending on the junior designers to organize the programming information, complete all CAD-based building drawings, and support the lead designer and you by interacting with the manufacturers and suppliers to provide samples of furniture, finishes, and accessories. This week you discovered that one of the junior designers has submitted a letter of resignation, and the other is very tentative about her abilities and does not want to take the initiative to contact the suppliers. You have also been informed that the other lead designer must be out of the country for several weeks on an international project she is completing. The client is calling you daily to schedule a presentation and has implied that he is beginning to doubt your ability to handle the project effectively. How would you approach this situation?

You must consider the situation from many different points of view and determine not just the "best" way to handle each element, but also the most realistic solutions you can assemble. Making notes about each factor and identifying specific components to address will help to break the problem into manageable parts so you can quickly think of methods to handle each situation. As with the behavioral interview, there is no one right or wrong response; the interviewer simply wants to see if there is a match between your process and the overall approach of the firm.

Phone Interview

Phone interviews are becoming customary as design firms hire more employees from far away. Typically a phone interview is an initial screening to

create a "short list" from several viable candidates. Phone interviews reduce travel costs and give employers a good (although not complete) view of the interviewees, allowing them to identify the most suitable people to bring on site for formal interviews. These interviews generally occur between the interviewee and one representative of a company, but sometimes conference calls are conducted to allow several people from the firm to evaluate the candidate.

When scheduling a phone interview, provide the company with a land line phone, not your cell phone. You want the connection to be as clear as possible; you do not want to risk losing a signal or running out of battery power in the middle of the interview. Check your location for background noise, and ask roommates, friends, and family members in the same space to leave or be very quiet during your conversation. If possible, be alone in the room during the interview to minimize distractions and allow you to concentrate on what the interviewer is saying. Be prepared to take notes, and ask for clarification if you do not understand what the interviewer is asking. In a phone interview, you do not have the advantage of reading facial expressions or body language, so you have to attend to voice inflections carefully to make sure you are responding appropriately.

Questions asked during phone interviews typically fall in the "traditional interview" category, although you might encounter some abbreviated scenarios to react to. Some students are tempted to forgo their preparation for telephone interviews, believing that the lack of face-to-face contact will allow them to maneuver their way through questions they were not ready to answer. Do not fall into this trap! Interviewers may have a list of five to ten viable candidates they are trying to narrow to two or three for on-site interviews. The more preparation you do for the phone interview, the greater your chances will be of being chosen for the final interviews.

Interview Over a Meal

Client-oriented professions often conduct meetings over meals, and some companies like to evaluate a potential employee's ability to professionally combine work time with social time. To do this, they schedule interviews during lunch or dinner with one or several people from the firm. As with the phone interview, questions may take any format, but they are typically more traditionally oriented. With mealtime interviews, though, you must pay attention not only to the questions and your responses, but also to your table manners and mealtime etiquette. We are not going to spend time in this chapter telling you which fork or spoon to use for which meal course, but we will offer a few tips to help alleviate some of your concerns. Resources are provided at the end of the chapter to help you become more familiar with etiquette. If you want more hands-on instruction, this may be a good program

for your student ASID or IIDA chapter to sponsor! Many colleges and universities have career services offices that have information or workshops on dining and interviewing, so check for support at your institution. Professors and other adults are generally willing to work with you also, so never be afraid to ask for assistance.

Remembering three basic things will make interviewing over meals less daunting. First, know that the true purpose of the meal is not to relax and enjoy a wonderful meal. You can do that when you are celebrating after you have the position. The true purpose of the meal is still the interview, and for the interviewer to evaluate your manners and behavior in social and dining situations. Continue your professional behavior and you will be fine.

Second, if you are unsure of anything, observe your hosts (interviewers) and do as they do. They should be seated first, set the direction of the meal in terms of cost (generally you want to order a medium-priced item that is easy to eat), set the pace for the meal, and pay the bill. Always place your napkin in your lap as soon as you have been seated, and ask the interviewers for meal recommendations if you are unfamiliar with the menu. If you are in doubt as to which utensil to use when the food arrives, watch the interviewers and follow their lead. You will probably want to deviate from this recommendation, though, when it comes to alcohol. Even if you are of legal age, it is not advisable to order alcohol with any meal during the interview process. If the interviewer is insistent, a glass of wine sipped slowly through the meal is acceptable.

The true purpose of the meal is the interview.

Finally, keep your actions inconspicuous and refrain from drawing attention to yourself. If you drop a napkin or utensil, subtly catch the eye of a member of the wait staff and ask for a replacement. If you find something

distasteful in your mouth, remove it quietly and discreetly with your fork. If you have food allergies or are a vegetarian, order something agreeable from the menu without making an announcement of your food preferences. And be sure never to engage in any activity at the table that could be considered grooming. This includes using a toothpick, blowing your nose, reapplying lipstick or makeup, and touching or working with your hair. It is appropriate to excuse yourself at the end of a meal to go to the rest room and check your appearance before parting company or continuing the interview.

Mealtime interviews can be somewhat stressful, but if you practice ahead of time, have confidence in your etiquette, and remember the true goal of the meal, your interview should go smoothly. Always remember to thank the interviewer at the completion of your dining event.

DURING THE INTERVIEW

Interviewers will be observing more than simply your design skills during the interview. They will be watching your ability to interact with others, your comfort level when presenting your designs and responding to questions, and generally your personality related to the character and personality of their firm. Because they want the person filling the position to be successful, they are watching for cues to assure them that you are a good fit with their firm.

Interviewers also want to enjoy their interview experiences. Meeting and evaluating designer after designer can be demanding, so the more you can contribute to an upbeat experience, the more favorably they will remember you. Ask yourself, How can I make this a positive encounter for both myself and the others involved in the interview process? This does not mean that you need to memorize a repertoire of jokes and funny stories. It simply means that by remembering that you are not the only one involved in this experience, you may be able to contribute to making their job, and your interview experience, easier.

Conducting Yourself with Grace

First and foremost, *be on time*! In an interview situation, this means walking through the front door of the firm ready for the interview about ten minutes early. You may want to take a minute before you enter the firm's front door to compose yourself; take your overcoat off if you are wearing one; organize your portfolio, purse, or other items you may be carrying; and turn off your cell phone. If you want to visit the rest room to do a final check on your appearance, do that before entering the firm if possible.

When you arrive, go to the receptionist's desk and politely introduce yourself, indicating that you are there to meet with Ms. Johnson for a job

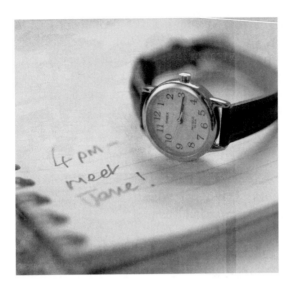

It is important to be on time.

interview. Receptionists and secretaries are often very influential in offices. Never underestimate their talent, abilities, and importance when interacting with them throughout your career. Treat them with the same respect and consideration you would expect or appreciate.

When meeting the interviewer and others in the firm, introduce yourself, make eye contact, and shake hands firmly with each person. Be genuine in your conversations; professionals can generally see through pretense and do not react well to insincere compliments or observations. Prior to the interview, reread your cover letter and resume to refresh your memory. You may want to use your cover letter to introduce some topics to address in the interview. Reviewing them before the interview will ensure that they are fresh in your mind as conversation starters. Always bring a few additional copies of your resume for people who may need one during your meetings. As with the cover letter, always reread your resume beforehand and know what you want to say in relation to every item on the page. The interviewer will be familiar with your written qualifications or will be using your resume as a prompt for his or her questions. Don't rely on your memory—structure your comments related to your resume *before* the meeting.

Your comfort level with various people will probably range from very comfortable to extremely awkward throughout your series of interviews. Even if you feel a strong connection to the interviewer, avoid the temptation to be too "familiar" in your actions or conversation. There will be time to become friends later; this is still an interview setting, and your actions should be easy but always professional. At the end of each meeting, always thank

the person for spending time with you. Before you leave, ask her if there is anything else you can provide.

Presentation Skills

Presentation skills are most often associated with your ability to explain and sell your designs after you have completed a project. These skills are also vital for selling yourself to prospective employers. The presentation you make to potential employers may not be as formal as a client presentation, but the skills are no less critical. You must convey confidence and show the interviewer that you can organize and deliver a coherent presentation of yourself and your work. An effective "performance" with relevant content indicates that you can prepare and deliver successful presentations that will sell projects to future clients.

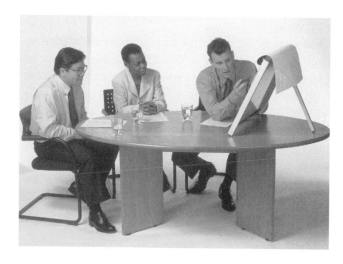

Show the interviewer that you can organize and deliver a coherent presentation of yourself.

Preparation is necessary when delivering an interview presentation that could change your life. Begin your preparation by thinking about your audience and the information that would be most interesting to them. Then think through the organization of information as you would a project presentation, considering what you are presenting and the major goals you want to achieve. You may want to elaborate on information provided in your resume to further target your qualifications to the position. Identify the information you want to enhance, allowing for additional cues that may arise during the interview. By listening for cues from the interviewer, you can be even more direct regarding your potential contributions to the firm.

Explaining your portfolio is another element of your presentation. What is the most important thing you want the interviewer to understand about each page? What are your special strengths, and how does your portfolio demonstrate those strengths? How does the work you show in your portfolio illustrate your ability to meet the needs of the firm and perform in their specific position? Place the projects most related to the position first in your portfolio. Be sure to speak slowly and explain your projects clearly. Although you know them intimately, the interviewer is seeing them for the first time and is not familiar with the assignment.

A mistake many students make when presenting work from their portfolios is depending on their memory of past projects to get them through. After spending months creating a design, we believe we will remember every detail of the project for the rest of our lives. These details, however, soon fade, and we may have trouble remembering major design decisions we made for the project, not to mention the *reasons* we made them! Review all projects in detail before an interview, and identify specific elements you want to emphasize or briefly explain.

As a rule, interviewees are given very little time to present detailed information about their portfolios, so brevity and clarity are your goals! Instead of spending lots of time explaining the expectations of the professor (the assignment), touch on that briefly and then discuss your process, the decisions you made, what you learned from doing the project, and how the project could relate to the work you could be doing in the position you're interviewing for. If the interviewer wants to hear more, he will ask questions. Your job is to use your interview time efficiently and provide as much information as possible in a limited amount of time to convince interviewers that you are the perfect candidate for the position.

Practice, practice, practice. It is easy to go through the information you want to share in your head, but until you actually say the words out loud, you won't know what type of impact they will have. Because the presentation will probably be more interactive, you need to stay flexible, but the more confidence you can gain through practice, the more successful you will be in emphasizing your primary points. Many classes include mock interviews as a practice exercise for students. One tool that can be tremendously helpful is a videotaped recording of the mock interview that allows you to review and critique your performance to identify areas in which you need to improve.

Asking Questions During the Interview

Most interviewers expect you to ask questions during an interview. Many believe that an interviewee who does not have questions has not done any homework on the firm and is not prepared for the interview. Familiarizing

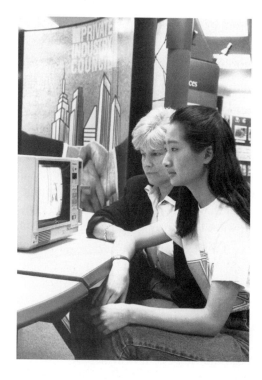

A videotaped recording of a mock interview allows you to review and critique your performance to identify areas in which you need to improve.

yourself with the type of work a firm specializes in before your interview allows you to ask questions that reflect your knowledge and to show that you are interested in the deeper issues of their designs.

Prior to the interview compile a list of questions that may be suitable for each meeting. Additional questions will arise during the process, and you will want to make a note of them for future reference. Following are some sample questions:

1. I saw your recent hotel design published in *Interiors and Sources*. What was the structure of the design team responsible for the project? (This type of question shows that you are familiar with their projects, and the response will tell you about the organization of project work for larger projects.)

2. In my research I learned that you have offices in New York, Atlanta, San Diego, and Milan. Do the offices work collaboratively with one another on some projects? (Again, this shows your familiarity with the firm, and the response may tell you about both travel and transfer possibilities.)

3. Could you provide some details about the responsibilities of the position for which I am interviewing?

4. Are most of your projects designed by teams? If so, what is the typical makeup of a design team?

5. What do you like most about working in this environment?

6. What is your time frame for making a decision about this position?

7. Can I provide you with any additional information?

Asking questions about salary are not recommended in the initial interview. Interviewers often introduce the topic, but if they do not, it is normally considered improper for you to ask what your salary would be if hired. If you are invited for a second interview, or are offered the position, salary negotiations should take place at that time. Be prepared to interview the interviewer—remember that you want to determine if this position is a good fit for you too!

Illegal Interview Questions

Most interviewers are experienced in recruiting and evaluating potential employees, and they know that there are several topics that cannot legally be addressed during an interview. Some interviewers, however, have limited experience in the interview process and may unknowingly ask questions that, by law, you are not required to answer. These questions deal primarily with personal issues.

As a rule of thumb, interview questions should pertain directly to the position for which you are interviewing and your ability to perform any activities related to that position. Questions dealing with the following topics are considered illegal, and you should be prepared to handle situations in which these topics are introduced.

- Nationality, country of origin, citizenship
- Age
- Marital or/family status
- Physical characteristics
- Personal finances
- Military history
- Religion

If you are asked questions that you feel are inappropriate, you may ask for clarification, assuming that the interviewer is seeking appropriate information but is asking inappropriate questions to obtain it. As another

option, you may politely refuse to answer the question, explaining that you are unclear as to the relevance the question has to the position. All career services offices have detailed information on determining whether interview questions are illegal, so become familiar with this topic before you begin the interview process.

What to Leave with the Interviewer

The most important thing to leave with the interviewer at the completion of the interview is a great impression. To reinforce your abilities, you may want to leave a digital version of your work or something extra you put together exclusively for that interview. This could be a CD, brochure, or anything that will remind them of your amazing fit with their firm.

Use your creativity. Show that you stand out from the crowd and that you really want to work at their firm. You may want to reserve this special treatment for the firms you target as your favorites, because this will take some additional effort and you may not have time to individualize a small project for each firm with which you interview. This personalized reminder is in addition to, not a replacement for, your thank-you note, discussed in the next section.

Promptly compose a thank-you letter expressing your appreciation for the interview.

Follow-Up

The follow-up after an interview typically consists of a thank-you letter expressing your appreciation for the interview. Because this has become an expected part of the process, failure to send a note may be seen as impolite

or offensive. The letter also provides an opportunity for you to reiterate your interest in the firm and include information not addressed in the interview that you believe is important. It is also a chance to elaborate on a response to a question you don't feel you addressed as well as you could have. How many of us have had the experience of knowing *exactly* what we should have said in response to a particular question—the next day! If, after the interview, you feel that the company is not a good fit for you, the follow-up letter provides a vehicle for you to withdraw your name from their consideration list.

A thank-you letter should be typed, professional, and in the same format as the rest of your self-marketing packet items. Tailor each letter to the individual firm by including specific references to your interview and give examples of topics discussed if appropriate. Ideally, your thank-you note should be sent the day following your interview, but under no circumstances should you wait longer than one week. Be sure you address the letter to the appropriate person (or people, if you interviewed with several people in the firm). You may consider sending individual letters to each person who interviewed you. Spelling all names correctly is essential; if you have questions, call the company and confirm the spelling with the receptionist. Many interviewers indicate that misspelling the company's name or the names of the partners of the firm quickly removes some people from potential opportunities in their firms.

PHYSICAL APPEARANCE

Your physical appearance during an interview speaks volumes about you and creates an immediate impression that is difficult to change. We've all heard the term *dressing for success,* but what does that mean in the context of an interview for an interior design position? As with so many elements of the job search process, your research may give you a starting point from which to build. The level of formality in an interview setting may vary in different parts of the country, but those generalizations must be moderated based on the company itself and its specific location. Generally, the Northeast tends to be more formal and conservative in business settings. The Southeast may be somewhat less formal, but still relatively conservative from a professional standpoint. The Midwest is very practical, but expects professionals to show respect and moderation—no extreme trends or excessiveness. The Pacific Northwest and California are less conservative, but depending on the firm, expectations may range from formal to informal. The Southwest is similar to the Pacific Northwest in expectations and can range from formal to informal depending on the firm and specific

location. These descriptions are very broad generalizations, however, and you must do your homework on the firms that interest you to learn about their individual cultures.

Professional dress is important.

Your choice of clothing should be conservative.

Clothing

Your choice of clothing for an interview should generally be conservative, but not bland. Many new graduates purchase one or two new high-quality suits or outfits for the interview process. Clothes should fit well, and you can individualize a basic suit with jewelry or accessories that are tasteful, but show your unique flair. Women's tops should be long enough to completely cover the waistline, and necklines of blouses and sweaters should be moderate. Skirts should be about midlength, not too short or long. Men should wear suits or pants with sport coats that are stylish but not baggy or too trendy. Depending on the location and firm, a white shirt is most likely the prudent choice, with an appropriate tie that complements your overall

presentation. You may want to call the firm prior to your interview to find out if the company has a dress code and tailor your outfit to match their requirements. New design graduates are often tempted to make radical statements with clothing during interviews, but it is advisable to wait until you have been hired. At that point you will have more freedom to express your personal style.

It should go without saying that all clothes must be clean and carefully ironed before the interview. Always try on your outfit at least a few days before the interview as a precaution to check for stains and fit. It is easy to assume that your "standby" suit worn once or twice a year will be fine, but your body may have changed during college. The last thing you want is to put on your suit the day of the interview only to find that those extra ten pounds from winter semester are centered in the waistline of your skirt!

Black has become the signature "color" for designers' clothing, often for good reason. It provides an appropriate background for presentations and does not compete with colors and suggestions being offered to clients. Black may also be a good clothing color for interviews, but interviewers have indicated that interviewees wearing some color can be a pleasant change from the expected signature. It is still important to remember that your goal is to show your work and your personality in its best light; your choice of clothing and color should reinforce, not compete with, that goal.

Shoes are another important consideration in your visual packet.

Shoes

Shoes are another consideration in the creation of your visual packet, although their impact is somewhat less than that of other elements of your appearance. If you are a woman, your shoes should be coordinated with your outfit and stylish. You should be able to walk gracefully in them and look professional when sitting and moving. Low to medium height heels work well, and generally closed toes are more acceptable in professional situations. Higher heels may make it difficult to walk long distances for city interviews, and if you are not used to wearing them, you may appear less coordinated than you are. Shoes with stocky heels may also be appropriate if in style, as long as you can walk quietly in them. If you are a man, your shoes should be leather or leather-like, clean, and polished; they should fit well and provide a professional look. Tennis shoes, sandals, and informal shoes such as hiking boots, clogs, or Birkenstocks are not appropriate for professional interviews.

Makeup, Jewelry, and Accessories

As with your cover letter, resume, and portfolio, you are creating a coherent visual appearance package with every wardrobe decision you make for your interview. As with your designs, choose your personal details to strengthen your overall design concept, not create a completely different design direction that competes with the rest of your message. Makeup should be natural to enhance your features, not cover them completely. Eye colors should be subtle and appropriate for daytime wear, not nighttime socializing. Jewelry and accessories such as ties, scarves, and purses should also coordinate with your overall look. They may be interesting and add accent to your outfit, but should not attract so much attention that they distract the interviewer from your presentation.

Students today often express their creativity and individuality with tattoos and extensive body piercings. Although these methods of expression are quite acceptable in a school or an informal social setting, they often create a less than positive first impression in a professional interview. Tattoos should be covered during an interview if possible to avoid attracting undue attention. Body jewelry should be kept to a minimum, and studs or rings through the tongue, eyebrows, mouth, and nose should be removed for the interview. Earrings should be planned to coordinate with your outfit and not make a strong statement themselves. Men with pierced ears should wear small studs or remove earrings altogether for the interview. Once you have the job, you can be more adventurous in

your self-expression, depending on the firm and the expectations of your superiors. Remember, you are entering a professional workforce that interacts with a variety of clients from ultraconservative to very liberal, and you need to show the interviewer that you can represent the company appropriately.

This may create less than a positive first impression in a professional interview.

Perfume, cologne, and aftershave lotion should be used sparingly. Many people today have acute allergies, sensitivities to specific fragrances, or a personal dislike for some scents. If your interviewers happen to be sensitive, you don't want to overpower them with your signature fragrance! Finally, consider your hairstyle several weeks before you begin interviewing. If you want to change your look, experiment with the new style far enough in advance to give you time to get used to it. On the day of your interview, have your hair neat, clean, tastefully styled, and secured to keep it from falling into your face as you present or talk to the interviewer. Constant hand or head movements to remove your hair from your eyes or mouth can be very distracting and annoy some interviewers.

If you are concerned about your decisions related to makeup, clothing, hairstyles, accessories, or other elements of your wardrobe, play "dress-up" and consult with a trusted adult. Many of your professors may be willing to

provide feedback on your choices, as may parents or other people with experience in professional settings.

JOB OFFERS AND NEGOTIATIONS

Design firms typically want to fill positions as soon as possible, so job offers are generally made as soon after the completion of their interviews as practical. Some private companies may accomplish this process in a matter of days (sometimes hours if they *really* want a particular candidate!). Larger companies and publicly held corporations may have weeks of red tape they must negotiate before they can legally contact their chosen candidate to make an offer. It is appropriate for you to inquire about their time frame for making a decision during your interview.

When you have completed your interviews and compiled all of the information about your favorite companies, it is time to return to your PRSM self-evaluation. You will have learned a great deal about the expectations, compensations, and attitudes of a variety of companies through your interviews. Before the job offers begin rolling in, it is a good idea to use the PRSM model to determine what is most important to you. This will help you determine which positions best fit your personal requirements. One company may offer higher pay but require you to travel extensively. Another firm may have a reasonable salary and benefits package, but require a great deal of overtime with little or no compensation. In other words, there may not be a clear "best" offer until you have evaluated them all through your PRSM filter. At that point you should determine which position and offer best suits *you*.

Accept the position and offer that best suits *you*.

When *the* call finally comes and you are invited to join the firm's team, it is important that you contain your excitement and conduct a rational and professional conversation. Armed with your priority list, ask any questions regarding salary, benefits, work environment, and expectations you feel are necessary to complete your profile of the position. You may also want to ask the person making the offer to send a letter or e-mail confirming the terms of the offer and clarifying any concerns you have raised. This ensures that the information you are comparing is accurate. Before you end the conversation, be clear about the best method of contacting them and their time frame regarding your decision about the position.

It is not uncommon to receive a job offer from a firm that is not necessarily your first choice while waiting for an offer from a more desirable company. Each situation is different, requiring that you evaluate it on an individual basis to decide the best approach. If you know the time frame of the more desirable company and it is relatively close, you may just wait it out and hope the first company will be patient. If you are not aware of the decision-making time frame of the more desirable company, you may choose to call the interviewer, explain the situation briefly, and ask whether he can provide any guidance or time frame for his company's decision. Explaining to the company that made you the offer that you want to wait to see if a more desirable company will offer you a position is not a wise decision and should be avoided at all costs. This is an insult to the company providing the offer, and if you should choose to accept their position, you will begin your career in a very negative environment.

An understanding of the employment climate can also help you in such a situation. If design jobs in your area are scarce, you should consider any offer more seriously than if they are more abundant. In any case, the job should fit you well, or it will not be a pleasant experience for you or for the company. Above all, you must make a decision within a reasonable time frame and either begin your career or withdraw from the running for the position and wait (and hope) the position from the more desirable company is offered to you in a timely manner.

SUMMARY

This chapter addressed the details of the interview process. Interviews can take a variety of formats, and being fully prepared is the only way to be successful when sitting with an interviewer. Preparation includes understanding

the different interview formats you may face and knowing how to respond to a variety of questions. Interviews over meals are becoming more common, and having a clear vision of the purpose of the dining experience and mealtime etiquette will help keep you focused on the task at hand: to show the interviewers how well you would fit into their firm.

Your self-marketing tools must come together in a unified package throughout the interview process. Let your cover letter pique the interviewer's interest and introduce topics to discuss. The resume should initiate conversation about your previous experiences and how they relate to the available position. Finally, your portfolio is the most critical element in illustrating your abilities related to the job responsibilities. Another element of self-marketing is your appearance. Clothing, makeup, and accessories should be coordinated and reflect your personality while complementing the overall character of the firm. Finally, following up appropriately at the completion of an interview is essential and reinforces your interest in the company. Negotiating job offers can be a bit intimidating, but with the PRSM evaluation completed earlier, you should have a clear understanding of your priorities. This should help you evaluate the appropriateness of any job offer.

ACTIVITIES

Interview Activity

Choose a partner from your classmates and roll play a traditional and behavioral interview for a position that interests you. Be sure to create appropriate questions for each interview type, and practice using your presentation skills and portfolio during the interaction. Critique each other and provide suggestions for improvement. For a better critique opportunity, videotape each interview and evaluate them as a group with each person providing a positive observation and a suggestion for improvement.

Mealtime Interview Activity

As a class group, plan a lunch or dinner at an upscale restaurant. Prepare for the meal as you would a mealtime interview. Dress as though this were an authentic interview, and practice mealtime etiquette throughout the meal. Choose a partner and observe each other throughout the meal. Critique each other and offer suggestions at the end of the activity.

Personal Appearance Activity

Look through your current wardrobe. Based on discussions in this chapter and information provided in the resources at the end of the chapter, plan an appropriate outfit for your first interview. Consider all details including shoes, jewelry, accessories, and makeup. Now try your outfit on and have a friend give you feedback on what is working well and what elements may need to be changed for a more professional appearance. Make a list of items you need to purchase or repair to complete your outfit.

RESOURCES

Etiquette

Business Class: Etiquette Essentials for Success at Work by Jacqueline Whitmore (New York: St. Martin's Press, 2005) ISBN: 0312338090.

EATiquette's The Main Course on Dining Etiquette: A Step-by-Step Guide to Dining with Confidence in the 21st Century by David Rothschild (Bangor, ME: Booklocker.com, 2003) ISBN: 1591134161.

Letitia Baldrige's New Manners for New Times: A Complete Guide to Etiquette by Letitia Baldrige and Denise Cavalieri Fike (New York: Scribner, 2003) ISBN: 074321062X.

Interview Techniques

Best Answers to the 201 Most Frequently Asked Interview Questions by Matthew J. DeLuca (Columbus, OH: McGraw-Hill, 1996) ISBN: 007016357X.

A Better Job Interview: Questions and Techniques—The Interview Secrets That HR People Don't Want You to Know by Damen LC Choy (Deerfield, NH: Pushbuttonpress.com, 2004) ISBN: 1410000656.

The Interview Rehearsal Book by Deb Gottesman and Buzz Mauro (New York: Berkeley, 1999) ISBN: 0425166864.

Winning Job Interviews: Reduce Interview Anxiety/Outprepare the Other Candidates/Land the Job You Love by Paul Powers (Franklin Lakes, NJ: Career Press, 2004) ISBN: 1564147789.

Professional Dress

Attention to Detail: A Woman's Guide to Professional Appearance and Conduct by Clinton T., Greenleaf, III and Stefani Schaefer (Austin, TX: Greenleaf Book Group, 1999) ISBN: 0966531930.

Chic, Simple Dress for Smart Men: Wardrobes That Win in the New Workplace by Kim Johnson Gross and Jeff Stone (New York: Warner Books, 2002) ISBN: 0446530433.

New Women's Dress for Success by John T. Molloy (New York: Warner Books, 1996) ISBN: 0446672238.

Ready to Wear: An Expert's Guide to Choosing and Using Your Wardrobe by Mary Lou Andre (New York: Perigee Trade, 2004) ISBN: 0399529535.

While attending the CIDA accredited design program at the Interior Design Institute of Denver, I had the opportunity to do my internship with one of my professors, assisting her in the designs of a hotel and a healthcare facility, as well as gathering information for her class lectures. I found both of these pursuits to be incredibly interesting and rewarding. Upon graduation, I continued in the hospitality/healthcare design field and was also asked to teach an introductory design course at the Interior Design Institute.

Although I loved hospitality and healthcare design, I quickly realized that my passion was for design education. The opportunity to explore design from a theoretical, philosophical, historic, as well as practical perspective opened my eyes, my mind, and interestingly—lots of doors. For example, in 1996 I became the Interior Design Department Chair at Rocky Mountain College of Art + Design and was able to introduce one of the first green design courses offered in a FIDER accredited program. It eventually grew to become the first Green Design Area of Emphasis in a FIDER accredited program in the country. I also cowrote a book, *Designing for Privacy and Related Needs,* which won the 2005 ASID Foundation Polsky Prize for outstanding contribution to the body of knowledge of interior design. Both of these "doors" opened areas of my career I had never dreamed of while in college.

When I began—many years ago—to study the effects of the built environment on the ecological health of the planet, I was shocked to learn of the impact that design and construction has upon resource and habitat depletion, pollution, energy use, and global warming. I realized it was no longer possible for me to practice and teach design that contributed to these environmental problems, so I began a quest to learn everything I could about sustainable design philosophies, processes, and products. As a result of this quest, I became an environmentalist both personally and professionally and created the Green Design Area of Emphasis at Rocky Mountain College of Art + Design.

Because sustainable design education is relatively new to design curricula in most institutions, many design professionals who have a great deal of experience in traditional design methods find that they need help in addressing the sustainable design requirements and requests of their clients. I consult with architects, builders, realtors, and interior designers to provide project-specific sustainable design information and education.

I think that the combination of being a sustainable design educator and sustainable design consultant is the very best of both worlds! The challenge is to find the time to take advantage of the many opportunities this career path has presented to me.

To be successful in this field, you have to have an open, curious mind and the desire to never stop learning. You also have to enjoy finding creative ways to share information and ideas. The time spent in the classroom is a small portion of the time required to make a class interesting, informative, useful, exciting, and inspiring, so you must also have a strong commitment to devoting the time necessary to create an effective learning experience.

It has been tremendously rewarding to learn and share how we can integrate considerations for sustainability with principles of aesthetics, function, and comfort, to create spaces that are as comfortable as they are healthy, energy and resource efficient, functional, and aesthetically pleasing, and that ultimately promote the well-being of both people and the earth. I believe this is the definition of good design, and it is the responsibility of all designers to learn and practice sustainable design for the future of our profession and the planet.

Photograph from the
Colorado Convention Center
*Photograph by
Michael Brian Gates*

Professional Responsibilities
Finding and Securing the Project

8

The winds and waves are always on the side of the ablest navigator.
—Edward Gibbon

Objectives

After studying this chapter, you should be able to:

* Discuss decisions made in the creation of an interior design business.

* Identify methods of determining a firm's target market.

* Explain your responsibility for marketing and securing clients.

* Describe the subject matter contained in standard contracts for interior design services.

The first sections in this book concentrated on helping you understand yourself and determine what types of professional situations would suit you best. The remainder of the book provides an overview of the professional environment and gives you some idea of expectations your employer may have of you as a beginning professional interior designer.

Procedures and approaches to project work within firms may vary depending on the focus, location, and employees, but many activities will remain relatively constant in each firm. These are activities required to sustain an ongoing, healthy business in interior design. This chapter provides an overview of these common activities including identifying target markets, finding and securing clients, and focusing on representing your company appropriately based on its place in the market. Chapter 9 continues the discussion of what is required to proceed through a standard project in terms of programming and the production of the design or the solution of the project once it has been secured. Chapter 10 finishes this business section by discussing the efforts required to finalize the project once the design is complete and presented.

UNDERSTANDING THE FOCUS OF THE FIRM

Earlier chapters in this text provided information and activities related to conducting research about firms—the types of projects they do and the work environments they create for their employees. It is easy to imagine that successful firms have "always been there," but the reality is that the principals probably did an enormous amount of preliminary work before opening their firm to create a high potential for success. Because this preliminary work influences the firms' business environments into the future, it is helpful to understand it.

Business Plans

Small and large businesses typically create business plans before opening their doors. The business plan provides an organized format for looking at issues such as the type of business, target market (or potential clients), potential competition, marketing strategies, financial resources, physical resources, and other topics relevant to the business's success. Many financial institutions require a completed business plan before they will consider providing loans to new business owners. We will not discuss the creation of a business plan in detail in this book, but we will talk about the parts of a business plan briefly to see how they influence the start-up and ongoing directions of companies. Several resources in the back of this chapter provide

Business plans.

additional information regarding the creation of a detailed business plan if you want to research this further.

Some of the initial decisions the principals make reflect their personal strengths and interests. They determine whether they want a small, medium, or large firm and whether to focus on residential or commercial projects. They choose their geographic location and the basic services they will provide. Based on these initial decisions, a business plan is compiled to evaluate the business' potential for success. The business plan consists of several broad sections including (1) a description of the business, (2) marketing, (3) finances, and (4) management, according to the Small Business Administration (www.sba.gov/starting_business/planning/writingplan.html). Each section helps business owners identify and evaluate elements that will potentially contribute to or challenge the success of the venture.

Description of the Business

Although the heading of this section seems self-explanatory, writing a detailed description of the business is one of the most critical elements in the creation of the business plan. Putting information on paper regarding the type of business, the products and services offered, and the organizational structure of the company helps business owners think through their ideas. In addition to detailing facts about the proposed company, the business description also addresses the elements that make the proposed company unique and the qualifications of the owners and employees that will add to the potential for success.

The unique characteristics of a firm are often identified by conducting an internal analysis of the owners and potential employees. One method used for this type of evaluation is referred to as SWOT, which stands for strengths, weaknesses, opportunities, and threats (Pinson, 2004). Just as you analyzed yourself in earlier chapters to determine what you could and wanted to do, this process helps business owners decide what services they can and want to provide. This method can also indicate how to improve the service and the outside influences. Step 1 is to compile information relating to the assets and liabilities of the firm. After listing the firm's strengths and weaknesses, owners should identify the opportunities that exist. Finally the threats to the success of the firm must be acknowledged. An example of a threat would be too many firms in the area already offering the same service. Another threat would be an indication of very few potential clients who may need the service. An opportunity would be the discovery that no one else is offering the service in the area or a change in a law or the economy that would create a significant increase in the demand for the service or product. Table 8-1 shows some examples of strengths, weaknesses, opportunities, and threats.

Table | 8-1 | SWOT Analysis Information

Strengths	Weaknesses	Opportunities	Threats
All employees of the firm will have passed the NCIDQ.	No lighting design expertise in the staff.	No one in the area is offering sustainable design.	The principal with a sizable amount of money to invest may want to retire soon and leave the country.
All designers involved will be LEEDS certified.	No real understanding of business in the parties involved in the venture.	No products offered in the marketplace for accessorizing well-designed spaces.	A qualified firm outside of the area wishes to expand its services to the area.
One principal has a sizable amount of money to invest.	There are no parties involved with good people skills.	A natural disaster destroyed many elegant homes and businesses in the area.	
All principals have a passion for providing exceptional service.			

After gathering SWOT information, owners must analyze and creatively evaluate it to find unique opportunities not obvious to others in the design business. This may remind you of the process you used earlier to define a fit for yourself within particular companies. Business owners go through similar steps to define a focus for their firms.

▬ REFLECTION

Read through Table 8-1 and imagine this is a SWOT analysis for a general design firm concentrating on small to midsize commercial design. Think about characteristics that may fit under each heading for this imaginary company and jot down at least one example for each heading.

Marketing

The next broad section of the business plan deals with marketing and includes information about the company's target markets, marketing strategy, and competition. The owners first have to identify who would buy their product or service in the geographic area they define for the business. Remember, that area could be local, regional, national, or international, but the buyers must be available, and the company must have a strategy for reaching them.

A target market is defined as a particular group of potential customers with some common characteristics that would make them likely candidates to purchase the product or service offered by the firm. The business plan must not only identify the target market, but also describe it in detail. These details may include age, gender, number of people located in the company's identified geographic market, how much disposable income they have, and their current spending patterns. This information obviously tells the business owner whether there are enough people in a given area to feasibly support the business venture. Discovering the potential customers' current purchasing trends helps identify products they are interested in. Identifying needs and wants that are not currently being met by existing businesses suggests possible niches that the new business may target. Defining the target market is plainly a critical component in the business plan. The more clearly a business owner can articulate who will be considered a customer and how the business will meet those customers' needs, the more potential there is for success in the marketing approach.

The purpose of a marketing strategy is to make people familiar with the product or service and entice them to buy. The marketing strategy includes information as simple as pricing products and services and as complex as selling and advertising approaches. This is often referred to as a "marketing mix" and is made up of the four Ps of marketing: product, place, promotion,

and price. Often the specifics of these four items grow out of a marketing analysis. The product or service to be offered, the place or area of distribution, how it will be advertised to the public, and the audience to whom it will be offered are important considerations that affect the success of a company. The right price and the promotional activities used to inform potential clients are equally important components in the success of a company.

Once the business owner has identified the market, it is imperative that the message be carried to these people in a creative and informative manner. Whether this includes television advertising, billboard displays, print ads in local or national magazines or newspapers, a web presence, or face-to-face networking with potential clients, the marketing must be carefully planned and focused on the interests of the target market. Marketing is an expensive venture and can take a significant percentage of the start-up budget of a new firm. Only by carefully analyzing buying trends and the locations of potential customers can a business identify the most appropriate methods of reaching the right people with the right message. For example, if the target market is small healthcare providers and the goal of the firm is to design their offices and specialty clinics, the business owner must research the trade journals, magazines, and other media read by healthcare providers. Buying advertising space in a local newspaper may get the name in front of a lot of people, but if very few of them are a part of the target market, the advertising money and efforts are less than effective.

Finally, a new company must know the competition it will face in order to identify methods of securing a section of the market as loyal, paying customers. Identifying the competition is typically easy—it consists of the firms that are offering the same or similar products and services as the proposed business. Further searching, however, may uncover less obvious competition such as a company that provides products or services that make your company's offering's obsolete. An example of this can be seen as digital archives of physical products become more prominent in the market. Discovering competing businesses pricing and advertising strategies and specific services, as well as additional perceived needs they have created, also adds more detail to the analysis. New businesses must identify who does and does not purchase the products of their competitors, and the reasons for their decisions. This information helps any business create and market unique services to attract customers who both do and do not perceive a need for existing companies offerings. The more time new owners spend researching the market they are about to enter, the more information they have to make good business decisions regarding the direction of the company. Understanding the potential customers (target market), how to reach those customers (marketing strategy), and who the company is competing with for clients (competition) helps any new company have a better chance at success.

Finance

The financial section of a business plan is probably the most important set of documents an investor will need to assess the potential for financial success of any proposed business. Evaluating all areas of the finances of a new business can take time, but it is critical to knowing the requirements for solvency and financial viability of any new venture. First, the owner must determine how much money is needed to actually start up the business. This obviously depends on the type, size, and location of the business. For a small service firm, start-up costs may be minimal. Office space may be a dining room table initially, and the only equipment may be a personal computer, a fax machine, a business phone line, and a few other peripheral pieces of equipment. A retail establishment, on the other hand, must lease or purchase space for display and warehousing, purchase product, hire employees to sell and handle materials, buy insurance to cover both employees and product, and obtain a business license. The owner must then project potential income for set periods of time, typically one-year, two-year and, five-year projections. These projections must also include projected expenses to determine how much money is needed to keep the company in business. Basically, the financial section of the business plan includes three vital documents:

1. Income Statement: A projection of money coming into the business.

2. Cash Flow Statement: A projection of the money movement, what is needed to cover expenses, time frames for spending and receiving the money, and the sources of money.

3. Balance Sheet: Yearly projections of a business's assets, liabilities, and equity (Tiffany, 2001).

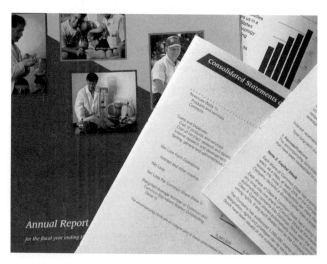

A formal annual financial report for a business.

The goal is to have enough gross income (all the money taken in) to cover all overhead (all expenses incurred in running the business including taxes, insurance, space, employee salaries, products, etc.) with some profit (net income) left over. Although this is a very simplistic way of looking at business finances, it is the overall goal of all businesses.

Detailed financial information is necessary for a successful business plan. Some new owners get professional help from financial counselors or accountants to ensure that all important documents are included. As a new employee, reviewing this part of the business plan of your company may help you understand the money flow and future plans for the business. If this is not possible, at least spend some time with your supervisor discussing departmental budgets to establish an overall understanding of the business's finances. This information can help you plan your strategy for success as you align more clearly with the financial goals of the company.

Management

The management section of the business plan identifies elements related to the everyday operations of the firm. It includes the organizational structure and describes the hierarchy of the reporting structure within the organization. It identifies who is responsible for decisions related to specific areas of the business and provides information about the personnel numbers and the qualifications of all people employed in the firm. An outline of the personnel management plan that discusses compensation, vacations, benefits, and expectations of all employees should also be a part of this document. In addition to internal employees, the management plan also identifies any groups or individuals engaged as advisors or professional guides. These groups may include advisory panels, members of a board of visitors, accountants, lawyers, and other professional consultants. Information regarding the cost of labor and other overhead expenses may also be included, as well as other operating information such as conflict resolution strategies and the protection of employees and proprietary information. The more detailed the management plan is, the fewer surprise problems an organization will have to deal with upon start-up.

Business Plan Summary

A business marketing plan includes a goals statement, the capabilities of the firm, clients or the target market, the strategies and policies of the firm, evaluations, and forecasts for the future. The plan of a firm targeting the commercial client will be somewhat different from the plan of a firm targeting the residential client. All of the information gathered in the previously described processes is reviewed and contributes to the comprehensive business plan

necessary for the success of a business. Generally, the plan is developed for a specified length of time and it addresses short-term and long-term goals. If you are a new employee, you may want to request a copy of the firm's business plan to familiarize yourself with the company's direction. This will strengthen your understanding of the company's expectations of you.

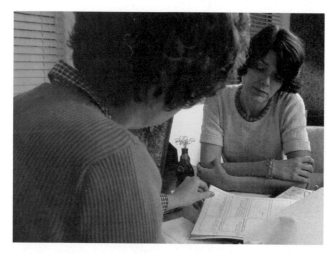

Finding clients.

FINDING CLIENTS

Identifying the target market of a business is typically done in conjunction with the creation of the business plan discussed in the previous section. *Finding* those clients, however, is another matter. It requires daily efforts on the part of all employees in a design firm. Some firms hire people to perform marketing duties exclusively, whereas others rely on each employee to aid in the process of finding and securing clients. There are many methods of connecting with potential clients, but we will concentrate on the four most common methods: advertising and publicity, networking, walk-in clients, and responding to requests for proposals.

Advertising and Publicity

Advertising and publicity are cornerstones of any business and are required to inform potential clients of the firm's presence and capabilities in meeting their design needs. Advertising and publicity are, however, different methods of capturing public attention. Advertising is space or time in different types of media (e.g., television, the Internet, newspapers) that the company pays for. The intent of an ad is to sell a product or service. Publicity, on the other hand, is attention

by the media that is not paid for and may or may not be formally structured by the company. For example, a television commercial for a specific office chair (the T chair) is an example of advertising, because its intent is to sell the T chair to the consumer. Conversely, a newspaper article on a recent *Consumer Reports* comparison of office chairs that identifies the T chair as the most comfortable office chair of the group compared is an example of publicity.

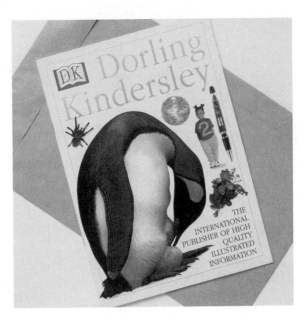

Advertising is exposure the company pays for.

Standard advertising methods are familiar to us all and provide proven opportunities to get the message of our firm in front of the right people. Television ads give the greatest opportunity to share both a visual and audio message, but are also the most complex and often the most expensive form of advertising. Firms must evaluate "the return on investment" potential of this type of media exposure to ensure that the desired target market will be reached and influenced enough to cover the advertising expense. Radio ads are also well recognized, but may be more appropriate for specific events or to highlight special promotions. Print media such as newspapers, magazines, trade journals, and brochures are also effective and can be targeted to specific audiences.

More and more today, a regularly updated website is expected as a way to share information and attract customers. Design firms are often tempted to create their own websites. The time required to create a well-designed, professional, and functional website, however, is time taken away from the firm's mission—designing physical environments for people. If the expertise, time, and desire are available, designing the website in-house may be appropriate; otherwise, it is advisable to hire a professional to at least get the site set up appropriately so that the company can maintain it easily.

Internet advertising, in addition to a company website, is also gaining popularity. Purchasing advertising space or having a link on media websites such as www.hgtv.com, professional associations such as the National Restaurant Association (www.restaurant.org/), or humanitarian organizations such as Eden Alternative for elder care (www.edenalt.org/) also increases digital exposure in specific industry-related venues.

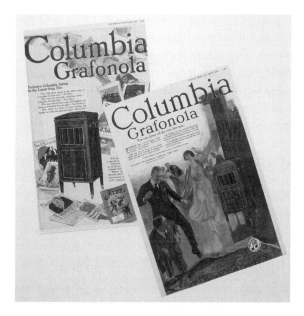

American magazine advertising Thomas Edison's phonograph.

As defined in the beginning of this section, advertising is exposure the company pays for, whereas publicity is free media attention related to a firm's activities or involvement in community affairs. Press releases, one of the most common methods of publicity, are somewhat controlled by the design firm. A press release may appear in any form of media, but they are more commonly found in local papers or magazines. They announce events the company sponsors, promotions or movement of people within the company, or new projects awarded. Press releases are often written by the company and provided to the community service sector of the television, radio, or print media organization. The media organization decides whether it will run the press release and when it will be published. Sometimes a newspaper, magazine, or television station will see a potential story related to the press release, or the design firm may inform them of a possible human interest topic they could pursue. Stories of this type increase the exposure of a design firm as local people read about their services without feeling the pressure of a formal advertising campaign.

In addition to the varied promotional and advertising activities discussed in this section, promotional tools are also effective in keeping a firm's

name in front of the public. Advertising to clients usually includes a standard collection of promotional tools that work together to create a corporate identity package or to "brand" a product. These tools are an assortment of storytelling and image projection materials, both visual and text (in a printed or virtual format), and include items such as a company logo, company website, business cards, letterhead, business forms, brochures, and other forms of unified representative paper and visual promotional materials. They are carefully designed to project an image and tell a story about the firm and its services. Consumer-oriented products such as calendars, pens, T-shirts, hats, and bags may be constructed with the company's logo or visual identity and used to promote the firm to the public. Some of the types of promotional tools you used to secure employment with the firm may bear a similarity to the type of tools used to promote the firm. Both are concerned with telling a positive story, and both are concerned with influencing attitudes and behavior.

Networking and Word of Mouth

Finding clients through networking is based on building relationships. Genuine connections with homeowners or others in business who might benefit from your product or service are symbiotic relationships, meaning that both parties benefit from the connection. Initial connections can lead to new customers, but to create repeat customers, the relationship must be nurtured, and the customer's needs must not only be met but anticipated. Repeat customers who are satisfied become loyal supporters. But how do you find these people with whom you are supposed to be building lasting relationships? Every community has opportunities for connections, whether they are on a business basis, personal basis, or shared service basis. We will discuss some possibilities in this section, but you will likely think of many more as you begin to engage in marketing and service activities for your firm.

One of the easiest and most enjoyable methods of networking is to join an organization involved in activities that interest you. This may be anything from a Toastmaster's group (public speaking), to a craft group, to a golf club. Your involvement with other members provides you opportunities to talk about your company and the work you do. When organization members need services that you provide, they may then think of you. Although this is an enjoyable and sometimes productive method of networking, it may not be sufficient to provide the number of clients necessary to keep a business healthy. For this reason, you may want to become involved in organizations that target people in the market within which you work. For example, if you are engaged in commercial design and you need clients from the local business community, you may want to join a club such as the Rotary or Lions or become involved in the local chamber of commerce. Other organizations

Networking to find clients.

may target your market even more directly. If your business concentrates on healthcare, become involved in groups focused on healthcare issues. Banking, hospitality, and retail businesses also have organizations that concentrate mainly on their unique issues. Becoming active in those groups provides a ready-made opportunity to discuss methods for improving their businesses through design. Attending industry-specific conferences (e.g., the Healthcare Design Conference, Greening the Hospitality Industry Conference, International Retail Design Conference) and conducting presentations may also raise potential clients' awareness of your products and services. Hosting events such as the local real estate meeting at your firm, especially if there is a showroom that showcases the firm's capabilities, is another way of allowing the public to see your interior design ability.

In addition to simply being involved, you may make yourself available to speak to different groups and talk about what you do or how design benefits people in specific ways. Organizations are often looking for programs for their meetings, and creating a small, entertaining presentation allows you to meet their needs as well as provide publicity for your company. This works equally well in both residential and commercial markets—simply choose organizations that are geared to your type of design.

Another method of connecting with people and making them aware of your services is to participate in local events such as designer show houses. Many cities throughout the country host annual designer show houses where different designers in the area either volunteer or are invited to design

one space within the house. Tickets are sold to the public for tours, and the money generally goes to support organizations in need. By being involved in a show house, you are illustrating your abilities and providing an example of your "product" to everyone who comes through. You have opportunities to meet many potential clients if you are present during the tours and can talk to the public about your work.

Home shows are another venue in which to introduce your services to a wide variety of people in a relatively concentrated period of time. Home shows may be extremely large and held in arena-type spaces, or smaller and located in malls or small auditoriums. They showcase vendors with products and services geared to the homeowner and provide good exposure to participants. The fees to participate range widely, but the exposure may be well worth the investment. To create a smaller version of a home show, design a vignette in a vacant storefront with information about your firm. This approach is more suited to residential design, but done appropriately can be successful for commercial designers also.

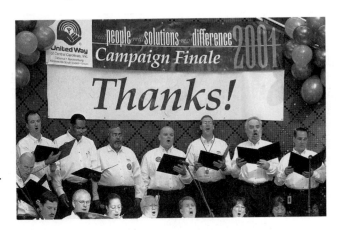

Getting involved and giving back to the community.

Closely related to participating in local events geared to your profession are philanthropy and volunteer work. A certain amount of work in a city, community, or town does not get done without volunteers. Developing an attitude of giving back to the community that supports your business is a way to network and at the same time help to strengthen the economy. Your company may decide to volunteer for charitable events related to humanitarian issues or become involved in activities to help local people in need. Participating as a team in a charity walk-a-thon to help breast cancer research, sponsoring and helping with events associated with the Special Olympics, or hosting events related to fundraising for a local animal shelter will raise the profile of your organization, provide publicity, and give you an opportunity to support causes you believe in. Sometimes firms related to the

design and construction industry collaborate to provide philanthropic support to organizations by designing or building housing for the homeless or shelters for abused children. Each community has specific needs, and the time you and your company spend helping to address those needs illustrates your commitment to the health of the people and economy in your area. It also provides needed exposure for your firm.

Some networking activities you will do individually; others you may be asked to participate in on behalf of the firm. When you are representing the firm, remember that the impression you make reflects on the firm. Understanding the vision and mission of the firm will help to guide some of your actions and help you showcase your firm's capabilities and strengths. There are many creative networking avenues for design firms. Some of these events will be specific to the location of your firm. Brainstorming other ways to create a positive image for the firm and making suggestions may be very helpful to the firm as well as helping your employer recognize your willingness to make contributions beyond your job description. This is a good image to leave in your employer's mind!

Walk-In Clients

Walk-in clients are most often found in retail establishments with showrooms that entice people to come and view products. Some design businesses that are service-only will also have walk-in clients, but often these clients have some prior knowledge of the firm through networking efforts or word of mouth. Walk-in clients are not restricted to the residential design market, but they are certainly more common in this venue than in commercial design. A firm must plan its location carefully if it relies on walk-in clients for a significant amount of its work. A storefront location in a high foot-traffic area is ideal and will provide an opportunity to visually engage people moving past the firm. Businesses must create an inviting entry experience to ensure that people walking by the establishment feel comfortable "dropping by" and eventually becoming clients. Window displays must be interesting and eye-catching and must change on a regular basis. Employees must be attentive but not overbearing when someone walks through the door. The volume of walk-in clients can be difficult to predict, especially early in a business' establishment, so a combination of strategies to find and attract clients may be necessary for ultimate business success. Working in a firm with a showroom will influence your day-to-day activities. As you interview for positions, be clear about the firm's expectations of you in relation to showroom design, selling, and walk-in client contact to ensure a good fit between your expectations and the expectations of your new employer.

Requests for Proposals

The final method of finding clients that we will discuss is the request for proposals. A request for proposals (RFP) is a formal document asking companies to submit an application of sorts to compete for a specific design project. This request may be sent to specific companies targeted for a project, or it may be open to any firm interested and be advertised in a newspaper or trade journal. The Internet is another tool for finding requests for proposals and new design or construction projects. Sites such as the McGraw-Hill Dodge Reports (http://fwdodge.construction.com/) include thousands of project possibilities and are updated on a daily basis.

The RFP is generally associated with larger commercial projects and is rarely used for residential jobs. The RFP document describes the project, may include some base building drawings to help identify the scope of the work, and outlines the requirements for submittals. The requirements may be a detailed description of services provided; costs for the described work; time schedules for completion of the work; conditions under which the work will be completed; and insurance and legal issues such as arbitration, liability, and litigation. A formal RFP will have a deadline for submission that includes the place, time, and method of submission required (i.e., digital, hard copy). It is necessary to follow all directions carefully, or the document your firm submits will be disqualified. The AIA website (www.aia.org/prac_submit_rfp) provides additional information about the details of a typical RFP document. It is highly probable that you will be asked to contribute information to an RFP during your design career if you are involved in a commercial design firm. Consequently, being familiar with the process and expectations of a formal request for proposals can help you in your career planning.

Any business's success depends on having sufficient clients who are interested in the products and services offered, understand the value of the offerings, and have the money to pay for them. Finding clients is ultimately the responsibility of every person working at a firm. By working to further the success of your company, you are ultimately providing more opportunities for you and your co-workers to be more satisfied in your working environment, both personally and professionally. Continue to refer to the personal profile you created earlier in the book to guide you in your decision making about both appropriate professional and extracurricular activities.

SECURING THE CLIENT

Locating potential clients is an important element of the marketing process, but if those people don't buy your services, the business will fail. This section addresses some of the activities you may be asked to participate in to ensure

that your contacts become clients, as well as the paperwork necessary for the client–designer relationship to be safe for all parties involved.

Selling is a large part of any designer's responsibility. As you are networking, you are "selling" the abilities and image of your company to help people understand how your designs can meet their needs. When a person or business is interested in hiring your firm, your selling abilities go a step further to help assure them that you will capably follow them through the entire process, and that the end product will be something they can be proud of.

Through networking, word of mouth, and advertising, your potential client has become aware of your services and perceives that you can fill his needs. These needs may be for a fully detailed design job or simply for parts of the project he needs additional support to complete. Clients contact the firm either directly by phone, or by adding your firm to the list of firms invited to participate in a request for proposals (RFP). Residential and smaller business clients often call directly and ask to set up a meeting to discuss their project. They may be meeting with you exclusively or discussing their project with several firms to determine the best fit for their job. Expectations for this meeting may vary, and it is important to be clear about the agenda. Firms are sometimes expected to provide a presentation of their capabilities, skills, and past projects to help the potential client get a sense of their ability to meet the needs of the project. With commercial projects the initial meeting is simply to discuss the project, and a presentation meeting will follow at a later time. Residential projects, however, may be less competitive, and the client may expect the project work to begin immediately after the initial meeting.

Presentation meetings may involve one or several people from the client's firm. Expectations may vary, but generally the presentation is geared

Project presentations may involve one or several people.

to the design firm's ability to provide appropriate services and resources to complete the project within the client's parameters. Presentations typically include information about the design firm's principals and designers, as well as any support or specialty people who may be required for the specific project. For example, if a client needs a design for a new, upscale restaurant, the design firm may have sufficient expertise to design the public portion of the space, but may need to hire a commercial kitchen consultant to aid in the design of the kitchen area. This would be identified in the presentation, and the skills of the consultant would also be presented.

Presentations will also include examples of past projects, typically those that show the firm's abilities in a specific area of design. In the restaurant example, the firm would showcase examples of previous restaurant designs as well as other hospitality design projects it was involved in during the course of the presentation. Although the presenters may include examples of other types of work, the concentration will be on projects that help the client see their approaches in a familiar venue.

A client occasionally requests a conceptual presentation directly related to her project as part of the competitive process. The client provides information about the project as well as some specific expectations if they are available. Members of the design firm present a general direction they envision for the design and discuss how they will address the specific expectations of the client. This allows the client to see the design directions of each firm regarding her project and to make decisions based on the conceptual presentation. There are obvious advantages for the client in this approach, but the design firms are investing considerable time and expertise with little guarantee of a return on their investment. There is also the possibility that the potential client will use ideas presented by a firm either in whole or in part without choosing the firm to do the project or compensating it for the ideas. The risks involved in this approach deter some firms from participating in this type of competitive process.

There is always an investment of time into a proposal or marketing presentation, and the risk that the firm may not get the project. This time and effort is calculated into the operating budget of the firm, with the projects received covering the time spent on projects not received. Firms strive to balance the time spent on a proposal or marketing presentation with the likelihood of actually attaining the project.

Contracts

Once a project is awarded, whether it is to redesign a family room or to provide full design services for a multistory corporate headquarters, the next step before proceeding with any work is to negotiate a contract. A contract is a written

Even if the job is simply to design a family room, the next step is to negotiate a contract.

agreement between the participating parties that spells out the work to be done, the conditions under which the work will be done, and the compensation for the work. Contracts are drafted in many forms. For some projects, a simple letter identifying the work to be performed and signed by both parties is sufficient. Other, more complex projects require larger documents with a great deal of detail. Some firms take advantage of standard contracts for designers; other firms create their own documents either tailored to their firm or written specifically for each project. The standard forms are available from ASID or AIA.

Contracts are legally binding documents that should be reviewed by a lawyer or legal counsel before being finalized. There are several reasons for signing contracts prior to starting a design project. First, a contract is legal protection for both parties. When both parties sign the contract, it indicates that they have reached an agreement that is satisfactory to both of them. Second, signatures often encourage a more thorough understanding of the responsibilities of each party and a clearer description of obligations. The written contract can serve as a guideline during the project because it describes what the designer will provide and the compensation for those services or products. Finally, contracts can also be used as reminders of the terms both parties agreed to. Some projects continue for extended periods of time, and people's memories of discussions and negotiations become fuzzy. A well-written contract can serve as a reference if there is some discrepancy between the client and the designer during the project. The contract document may also be used as a basis for litigation if major disagreements arise about the final product at the completion of the project.

A formal, legal contract can be a very long document that addresses many issues in great detail. Although each contract should be modified to meet the requirements of the specific project, contracts do share many common

elements. We will not elaborate on the details, but will provide an overview of the general topics that should be covered in all contracts. More detailed information about contracts is available in the resources at the end of the chapter.

Identification of Parties Involved

Each contract must spell out the people or companies involved in the work. This may seem elementary, but sometimes this information is overlooked in smaller contracts. A simple statement indicating that Mr. Smith is contracting on behalf of the Inner City Bank with the Ariel Design Firm to provide design services and furniture for the facility meets the requirement of party identification. A more elaborate statement may be included, but this is the basic information necessary.

Definition of the Project

A definition of the project can be much like a problem statement in the design process. The definition provides information about the general expectations of the client, the location of the project, and a brief description of the building or structure to be designed. Again, a more detailed definition may be included in larger projects to avoid any misunderstandings about the representation of the project.

Scope of Work

The scope of work describes the expectations of the client for the amount of work to be done in detail. This may include an identification of the number of square feet to be designed, a listing of rooms to be included in the project, or an overall description of the space to be created. This section also defines the level of work expected from the design team, as well as the full complement of services needed. Details regarding phases of work may be included with elaborate descriptions of the process and product expected from each phase. Information about the "deliverables," or products expected by the client, must also be described in this section. Deliverables may include programming documents, drawing sets, presentation boards, models, digital representations of the design, construction documents, use and care manuals, and a host of other design-related items. They may also include furniture and fixtures if the firm designing the space is also providing furnishings. Typically, the furniture and fixtures are handled in a separate section of the contract or on a separate contract altogether to avoid confusion and separate the expectations and compensation clearly for tax purposes.

Time Frames

Schedules of work and time frames for providing each of the deliverables are also included in the contract. This ensures that each party understands the

Project deadlines must be negotiated and written into the contract to allow for sufficient time to accomplish the work.

time required to produce different phases of the project and agrees that the dates are acceptable. Depending on the type and scope of the job, this section may be written based on each specific phase or deliverable, or it could simply identify a completion date for all of the work identified in the contract. Designers must pay close attention to the time frames in the contract to make sure they have allowed sufficient time to complete the work. Also included in this section should be a time frame required for client approval of the work submitted. For example, a schedule may call for the design development to be completed six weeks from the presentation date. If the designer presents a schematic design, but the client does not approve it for four weeks, the designer has only two weeks to finish the work based on the contract dates. If the contract states that approvals must be received within five working days of the presentation, the client understands that taking more time for approvals may affect the overall schedule and a change may have to be negotiated. Time frames for payment for services are also clarified in this section.

Compensation

Methods and amounts of compensation must be clearly defined in any contract. These are the fees to be paid for the design work, furniture or other product supplied by the design firm, and items such as travel and printing. There are many ways of calculating fee structures, and we will discuss several in a later section of this chapter. For now, it is important to understand that the method of, as well as the time frames for, compensation must be clearly spelled out in any contract. Payments for services may begin at the signing of the contract, may be retroactive if some services have been provided prior to the signing, or

may be delayed because of project schedules. Firms may require a retainer, or money "up front," before beginning any work, or they may require a down payment on products and furniture to be supplied. The designer must understand the details of the project prior to identifying or calculating any compensation amounts or methods. In addition to identifying the compensation required, the contract should also spell out the documentation required to verify the work that has been performed or the reimbursables submitted for payment. Having a lawyer review this part of the contract is critical because there are many ways of writing and interpreting information included in this section.

Method for Terminating Work

The most positive outcome in a working relationship is to have everyone in agreement, happy, and satisfied throughout the project. Unfortunately, complications can occur that result in contracts being terminated by one of the parties involved. A company may change directions in the middle of a project and decide it no longer needs the space for the function planned. A family may be transferred to a new location in the middle of remodeling a home. A design firm may experience a reorganization or loss of critical design team members. Although it is never a wonderful thing to terminate a project prior to completion, such a decision must be made occasionally. As a result, contracts must include an agreed-upon approach to termination just in case. This section of the contract discusses conditions under which the termination may take place, methods of and time frames for notifying all parties of the decision, and compensation for work produced and in production. Although all parties should try to avoid this action if at all possible, including information in the contract regarding termination will avoid many escalated conflicts in the worst-case scenario.

Other Issues

Most contracts are job specific and may need to address additional issues for each project. Many larger companies require design firms to have a certain amount of insurance or specific types of insurance before they can begin the project. This limits the hiring company's liabilities in case of default or accident. Some projects require that consultants be hired to provide expertise not available in the design firm. These consultants should be identified, to the extent possible, in the contract, and the method of providing compensation determined. The expertise necessary will be obvious in some projects, such as in our earlier restaurant and kitchen design example, but other projects may require expertise not anticipated. If a designer believes specialty consultants may be necessary, it is helpful to include at least a statement indicating that potential.

As we discussed earlier, some firms provide furniture and fixtures as part of the design package. Specific information must be included in the contract

regarding payment, storage, delivery, insurance, damage, and installation when that is the case. Separate contracts for product are best, but whether it is separate or included in the service contract, great attention must be paid to the details related to providing the product.

Client approvals may also be addressed. Clarification of the person or position permitted to provide final approvals for design decisions, changes, and expenditures is necessary to avoid wasted time and unnecessary effort that comes from having the wrong person approve the work. The contract may also include a statement about the ownership of the project documents. Sometimes clients assume that they own the documents, but often the design firm retains ownership, even though the client paid for the services. The right to use the documentation and/or photos from the project may also be a negotiated part of the project. Some companies like to have their space published for publicity. Others refuse to allow design firms to even photograph the spaces, often for security reasons.

Clarifying the expectations and opportunities in the contract will avoid conflict at the end of the project. And if conflicts do arise, the contract should provide some direction for resolution. Contracts often identify conditions for litigation, who is responsible for payment, and how arbitration is to be handled in case of disputes.

Ongoing Contracts

Many contracts are job specific and are written with particular expectations in mind. Others, however, are more open-ended and provide for an ongoing relationship between the design firm and the hiring company. This may happen when a company needs design services for a long period of time and has created a strong, trusting relationship with a particular firm. Ongoing contracts may also be negotiated for projects with an unspecified scope of work or undefined final goals available at the time of contract negotiations. Long-term contracts may contain provisions for a retainer to be paid to a design firm, against which the company charges its fees until a billing cycle begins. Other agreements may simply include hourly fees for all work produced. As with job-specific contracts, certain elements must be included to cover all parties involved. Having a legal expert review the agreement will help to avoid potential problems.

Fee Structures

Because of its nature, design work requires some flexibility in billing methods to cover different levels of expertise or different approaches to projects. The billing method must be defined in the contract, and expectations must be clearly outlined. Different fee structures meet different needs. To make

One type of fee structure is an hourly rate.

appropriate decisions about fee structures and methods of billing, a design firm must fully understand its own capabilities and financial needs as well as the full scope of work for a project. Several of the most common fee structures used by design firms today are explained in the following sections.

Hourly Fees

Hourly fees are often the basis for contracts, especially when the scope of work may change or the firm does not have a history in the type of work it is being asked to perform. Specific fees are charged on an hourly basis for each of the people working on the project. Each of these fees should be described in the contract because different fees are charged for different types and levels of work. The expertise and time of a principal in the firm may be worth more than the expertise and time of a beginning designer. As a beginning design professional, you may take longer to produce work than someone with more expertise and knowledge; therefore, your time may be charged at a lesser rate. Sometimes the hourly fee will be based on the description of the task. Less knowledge and skill is required to take inventory than to design the means of egress for a public building. Therefore, the hourly fee will differ based on the knowledge, skill, and experience required to perform the task.

Fixed Fee

A fixed fee is a single figure for the services to be provided. Fixed fees are used when a firm has a strong history of providing the type of work expected so it can estimate the hours and effort required to complete the job. A clear definition

of the scope of work must be provided, and any additional work expectations must be identified in the contract as requiring negotiations for additional fees. The amount charged must cover both the overhead and the profit needed from the job, and every element of the job must be considered.

Not-to-Exceed Fee

Contracts can also be written for a not-to-exceed fee, which means that the firm will bill an hourly fee up to an agreed-upon amount. After that amount has been reached, the firm cannot bill for any more services under that contract. The exception to this rule occurs if the client has asked for additional services, the scope of work has changed, or additional time has been added or subtracted from the schedule. In these cases, a design firm may negotiate for additional compensation. If the design fees do not reach the not-to-exceed number, the firm bills only for the services provided and time expended to deliver the described project. Again, it is important to describe specifically what is entailed in the services to be supplied. The advantage of a not-to-exceed number is that the client knows how much to budget for the overall project from the beginning.

Fees could be based on a percentage of the product price.

Percentage of Product Sold or Percentage of Total Job

Contracts may be written to describe fees based on percentages. Because some firms also provide products in addition to design services, some contracts are written based on the supply of a product. Contracts may identify a price for a specific product plus an additional amount of money that is a

percentage of the cost (e.g., the chair is $100, but the amount charged is $100 plus 25 percent, or $125). The additional money over the cost of the product is the firm's compensation for providing items directly to the client. This is referred to as "cost plus" pricing: cost plus a percentage of the item's cost. Delivery, installation, and freight fees may also be described in the contract. Sometimes the fee or compensation is based on a percentage of the total constructed project. Typically, this is used in new construction and more often for larger projects than for small ones. Because the fee is related to the entire scope of work, if significant changes are made in the overall design and construction of the building, appropriate compensations are made.

Because of the many ways designers can charge for services and products, interior design contracts can be fairly complicated. As a result, it is important to have a lawyer involved in the creation of a contract. You may not need to know all the laws governing the business of interior design, but you should know enough to understand when you need a lawyer!

SUMMARY

In this chapter we provided an overview of the decisions made in the start-up of a typical design firm. Although you may not have been involved in making these decisions, they will certainly affect you on a daily basis. The decisions made by the principals form the foundation of the business. In addition to the start-up decisions, we discussed the important elements of finding and securing clients. Not all of these processes will be your responsibility, although you may be required to assist or support the senior staff members with these tasks at first. Hopefully you will have the opportunity to be mentored while you move into a position of full responsibility for design projects. The responsibility for the success of a firm rests on the team. Some of the tasks will be your responsibility, and other tasks may be performed by other members of the team. The descriptions provided may help you to understand what is required to secure clients and define projects for a design firm and how you fit into the plan of success for the firm. Knowing how you fit into the plan will help you to understand how you can contribute.

Chapter 9 continues the discussion of what is required to proceed through a standard project by addressing the design itself. Some of what is required will be your responsibility, and some of your job will be to assist others who will bear the overall responsibility.

ACTIVITIES

Activity 1

Choose a partner or create a team of no more than three students to work on this assignment. As a team, select a well-known firm and describe the image the general public has of that firm. Identify specific tools that create and enhance that image based on the information provided in this chapter.

Activity 2

Using the information provided in this chapter about contracts, work with a partner to write a contract for a project you are currently working on in one of your studio courses. Be sure to provide clearly written descriptions that address the client's expectations and go beyond the information provided as part of your assignment. Decide on the levels of service provided and think about appropriate fees to associate with each level of work.

RESOURCES

Business Plan Information

Anatomy of a Business Plan: A Step-by-Step Guide to Building a Business and Securing Your Company's Future (6th ed.) by *Linda Pinson* (New York: Kaplan Business, 2004) ISBN: 0793191920.

Elements of A Business Plan. Compiled by Laura Tiffany, 2 March 2001: www.entrepreneur.com/article/0,4621,287355-1,00.html.

Small Business Notes: Marketing Plan Components: www.smallbusinessnotes.com/planning/marketingplan/marketplancomp. html.

10 Key Business Plan Components: www.lartauniversity.org/Online-Resources/10BusPlanComponents.asp.

Writing the Business Plan: www.sba.gov/starting_business/planning/ writingplan.html.

Contract and General Business Information

Business and Legal Forms for Interior Designers by Tad Crawford and Eva Doman Bruck (New York: Allworth Press, 2001) ISBN: 1581150970.

The Interior Design Business Handbook: A Complete Guide to Profitability (3rd ed.) by Mary V. Knackstedt (Hoboken, NJ: Wiley, 3, 2001) ISBN: 0471412325.

Start Your Own Interior Design Business and Keep It Growing! Your Guide to Business Success by *Linda M. Ramsay* (Oceanside, CA: Touch of Design, 1994) ISBN: 0962991805.

Davis Kitchen Tile (DKT) was incorporated as a limited liability company in the state of West Virginia in 2001. It is operated as a retail store in the Glenmark Centre. We offer for sale and installation several lines of cabinetry, tile and stone, countertops, plumbing fixtures, and other related items primarily for the residential market. Our selling range is generally within a 50-mile radius of our location.

Established in 1911 as F.E. Davis Tile and Mantle Company by Florence Edward Davis, the business originally built fireplaces and then installed the tile, marble, and mantles around them. In the 1930s Florence's son, Henry Coleman Davis, took over the business and continued the traditional product line, but focused more on the growing popularity of ceramic tile. The business thrived as customers appreciated the combination of quality products and service. In the early 1960s, Henry Coleman Davis Jr. stepped into his father's footsteps and set a new standard for craftsmanship in the ceramic tile industry. During this time many new tile manufacturers appeared on the market and introduced new products and methods, which Henry Jr. readily incorporated into his company. The year was 1989 when once again a new generation took the helm. Ed Davis, after years of apprenticeship under a master, was ready to lead a local landmark into a new century.

Realizing there was more to a home than tile, Ed Davis soon incorporated full lines of cabinetry and design services to accommodate the most discriminating customer. With new lines of product came expansion and a brand new location at the Glenmark Centre, just off of I-68.

Although location is not quite as important in our industry as perhaps it is in the fast-food business, we have found that customers are attracted to our store because of our presence in a popular shopping center. DKT is sandwiched between Michael's Arts and Crafts and a Heavenly Ham. Most important, we are across from a Lowe's Home Center. A major point of our business concept is that

everyone building or adding to a home needs something from a home center, which brings a huge client base within sight of DKT. This is a winning formula that has resulted in a steady source of leads, and most encouragingly, sales.

Our goal in business is to offer our clients top- to middle-line products that accurately reflect their tastes and status, while consistently maintaining the highest level of service. Although fair pricing is offered, personal service and a relaxing, upscale store atmosphere are most important. Our sales personnel offer detailed professional design services and are backed by purchasing, accounting, and installation staff. We are committed to treating each project and customer as unique and important. This mind-set along with superior product lines has led to success and is what our clients demand.

Our company offers nationally known product lines that not only lead to consumer confidence in what we sell, but also give us exclusiveness in our market. Brands such as Wood-Mode Custom Cabinetry, Pratt Larson Ceramic Tile, and Country Floors Tile and Stone are examples of recognized and highly desirable products.

DKT has positioned itself to take advantage of the current trend in kitchen remodeling fueled by the baby boomer interests in home entertainment and gourmet cooking. Many new and existing homeowners are investing large amounts of money to make their dream kitchens and baths materialize. What they want from the kitchen and bath industry is confidence in their choices and superior performance.

Photograph from
the Moonlight Diner,
Denver, Colorado
*Photograph by
Michael Brian Gates*

Professional Responsibilities
Designing the Project

9

Progress lies not in enhancing what is,
but in advancing toward what will be.
 —*Kahlil Gibran*

Objectives

After studying this chapter, you should be able to:

* Identify the critical elements of programming a project.

* Describe what it takes to produce a conceptual presentation in the real world.

* Explain the goal and activities of the schematic design phase and what the firm may expect from you as a participant.

* Describe the expectations for your participation in the programming and design of professional projects.

Chapter 9 continues the discussion in Chapter 8 about your responsibilities as a new professional. Once a business has been created, potential clients identified, and a plan implemented to secure their project for your firm, you must then take the necessary steps to provide them with a creative and appropriate design. This chapter describes the typical path followed from programming the project through the design and presentation of your firm's ideas. Many of these activities will be familiar to you because you will have implemented some processes in your design projects in studio classes. We also identify typical responsibilities you may be given as a new designer during these design phases and provide some tips for being successful at your new professional assignments.

PROGRAMMING THE PROJECT

Programming is typically one of the first activities you are introduced to as you begin projects in design school. Classroom programming may consist of reading a programming document prepared by your professor or conducting programming interviews with a real or imaginary client. Reviewing documents provided in class and conducting extensive research have also been part of your initial project activities. It may appear that the programming phase of a project is linear, beginning when a project is assigned (or awarded in the case of professional work) and ending as you begin the next phase of design. As you proceed through this chapter, you will realize that programming, or information gathering, often begins well before a contract is signed and does not truly end until the project is finished. It is a circular, or iterative, activity, meaning that as you make some decisions, additional information will be necessary. This will lead to other decisions, requiring more information, and so on, and so on.

Some programming is essential prior to signing the contract for services. Determining the scope of work as discussed in Chapter 8 requires a clear understanding of the client expectations of you and your company. Your project may include working with an architect on new construction, retrofitting an existing structure with furniture the company already possesses, or redesigning a set of spaces in a loft condominium. Each of these requires a different level of engagement, activity, and time commitment, and initial programming will provide necessary information to negotiate an appropriate contractual agreement.

Although programming takes many forms, we will cover only the three primary programming activities: project research, client interviews, and the collection of on-site information through collecting spatial data and through client observation. We will also discuss methods of organizing the

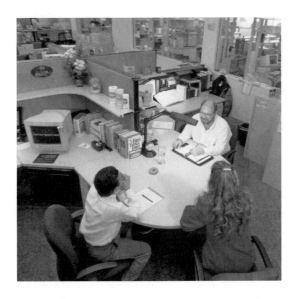

Programming, or information gathering, begins well before the contract is signed and does not end until the project is finished.

information gathered so it is available and usable to you and your team during the entire project.

Project Research

Research is necessary for every project to help the designer gather information about the specific project and about the state-of-the-art design in the client's industry. Residential research may center on new products available for home use or new ways of looking at living spaces. Two types of research will be customary for any project: general research and client research. You have probably conducted some level of research for your studio design projects.

General Research

Each type of project will require some research. Technology, products, and information are growing exponentially, and it is your responsibility as the designer to stay on top of these changes. Some changes are general; some are industry specific. As you embark on contract projects, you must have some understanding of your clients' industry, or how they fit into the larger picture of what they do. For example, if you are designing a retail space for a client whose target market is young adults, you must have some knowledge of not just retail design, but also retail approaches. What is the company selling? Is a unique retail experience part of their offerings? What are the latest techniques for attracting young adults into a retail establishment? What do

young adults find important in a retail environment? How do young adults interact with retail spaces and salespeople? Responses to these and other questions will help you make better design decisions for your client.

Information to help you with general research is available in newspapers, trade journals, research journals, periodicals, and books, and on the Internet. Talking to people in the industries for which you are designing is another method of obtaining relevant and current information. If your firm has designed spaces for specific industries, you will also want to talk to the designers involved in previous projects. Even if the firm has handled this kind of project, though, the information needed should be updated to ensure that you are applying current knowledge to the problem at hand. Once you have a clear understanding of your client's industry, you are ready to move to gathering and compiling research about the client's specific project.

Client Research

Client research consists of compiling information exclusive to the company or family that hired you to produce a design. Much of this information is outlined in the contract in general terms and is related to the scope of work typically included in the contract. The purpose of the scope of work is to define overall requirements of a project and to outline the design firm's responsibilities. Project requirements must be thoroughly developed and detailed to avoid any confusion between the client and the designer. This section of the text organizes information related to the scope of work by dividing the discussion between "existing conditions" and "client expectations." Existing conditions and client expectations may shift in size and complexity between residential and commercial clients, but the overall approach will be very similar with both.

A description of the existing conditions is important to understanding the starting point. You must recognize what information already exists and what will need to be generated and by whom. You need to know whether, for instance, there is an existing floor plan. Many times there is a plan of sorts but there is no record of construction details or the location, type, or quality of the lighting, electrical, heating, plumbing, and so on. If these do not exist and are not being done by others, you must determine whether it will be your responsibility to generate the necessary drawings to define the present conditions.

It is possible that the architect who originally designed the building has a set of drawings that are to be used for the design. You will need to determine whether these are "as-builts" or conceptual drawings. An as-built drawing should be accurate and reflect the space as it was completed and accepted by the client. Conceptual drawings are based on the architect's idea of

how the space should look, not necessarily how the space was built. Even with architect's as-built drawings, however, you should do an additional level of research to determine whether there have been any client-directed changes since the original construction.

Existing conditions also include existing furniture, finishes, and accessories to be reused. These must be fully described in order to develop a successful design. To determine existing elements, you must make an inventory list. Some information may be available from your client. You may want to ask the following questions to clarify your next steps in the inventory process:

1. Is there a list of existing furniture to be reused?
2. What is the condition of that furniture and equipment?
3. What are the sizes and existing finishes?

More details regarding the collection of information about existing conditions will be included in a later section.

Client expectations are part of the research for a particular design project. As with the identification of the existing conditions, many of the client expectations will be named in the contract. Having a conversation about the details of those expectations will ensure that the design and the project will meet all of the client's needs. Following are some questions you may ask to engage the client:

1. What spaces are included in the project?
2. Will the design to be presented be conceptual only?
3. Will the designer's services include specifications?
4. If so, exactly what will the firm be specifying?
5. Does the scope of services include addressing the carpet, wallcoverings, and vinyl tiles? If so, exactly what areas are to be addressed?
6. Will the designer be expected to generate the finish schedules?
7. Will cabinet drawings be expected?
8. If cabinet drawings are to be included in the scope of work, what specific cabinets will be drawn?
9. Will the designer be responsible for reviewing and signing off on shop drawings?

The design firm may have to define some of the necessary work to be done to complete the job properly. Because clients do not always know what is required to accomplish the task responsibly, the firm should help them

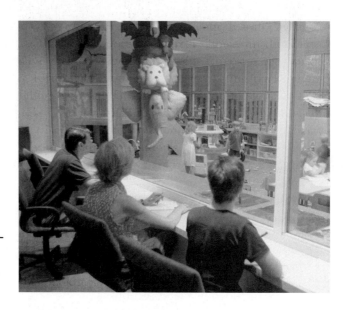

Client, or behavioral, observation is one method of research for an interiors project.

decide what is needed. It is necessary to clearly determine and state exactly what the firm will be responsible for. The way the project responsibilities are defined will make a difference in the fees charged. If responsibilities are not discussed and clarified, the client may claim that the firm did not tell him that there would be a charge for a particular service and therefore be unwilling to pay for it. Consequently, the firm may end up having to spend time on an activity without being reimbursed for it. This could be quite costly for the firm and also create a feeling of ill will. With a clearly written agreement of client expectations and the work to be performed by the firm, the client will get a better project and the firm will be able to recover the cost of its time and hopefully make a profit on the project.

Another reason to be as careful as possible in defining the agreement up front is to ensure that the client is ultimately happy with the services. Trust is an important part of any relationship, and with a great number of unexpected changes the client may begin to lose confidence in your ability to determine what needs to be done. Good communication skills are absolutely necessary. Further, putting things in writing and asking for signatures of agreement will avoid misunderstandings later on in the project.

Client Interviews

Let us imagine that your firm has successfully competed for a project, and that preliminary information about general budgets, schedules, and client expectations has been collected as a basis for a contract. It is now time to

begin a more detailed programming approach for the project design. How do you begin? First, you must understand the details of the context, client needs, goals, budget, time constraints, and other pertinent information. The way to approach this is to interview the client. Many firms have standardized guidelines to follow when conducting programming interviews, but you must always remain flexible and follow the client's line of conversation to be sure you obtain all of the necessary information. Residential and commercial interviews differ in several ways because of the nature of the client and the size of the project. In the following sections we will discuss some of the unique characteristics of each type of interview.

Residential Interviews

Residential client interviews are meant to collect information about the client's needs, dreams, and goals for her home. Sometimes the interview will take place in the client's home, and other times it will take place in the design office. Meeting in the client's space can be advantageous because you will often learn as much from visiting the existing environment as you will by asking questions. Also, the existing space will, in many cases, be the site of the design or the basis for the redesign. Many times the residential client interview is more casual than the commercial client interview. If the interview is to take place in the office, it may be nice to gather around a small table and relax with a cup of coffee or tea. You may choose to have several meetings with the client on neutral ground over lunch or dinner. Some interview sessions may also be done in a showroom so the client can point out items she likes.

Clients often have difficulty expressing or envisioning what they want in their space. Designers sometimes ask clients to collect pictures of things they like from magazines and put them in a file to be discussed in an interview session.

If possible, everyone living in the home should be involved in at least the initial interview because each person will have unique information to contribute to the process. Interviewing everyone concerned might avoid designing the whole space around the thoughts of one person only to have the design rejected by the party not included. Children should be encouraged to express them opinions also; after all, the children will inhabit the space as well. Too often children's spaces are not given the attention necessary to make them functional and a delight for the child. It is the designer's responsibility to communicate with many different people to draw out their needs, wishes, and dreams for the newly designed space.

Having a list of questions for clients will keep you on track. Clients are often unsure of the type of information you need; you must lead them to

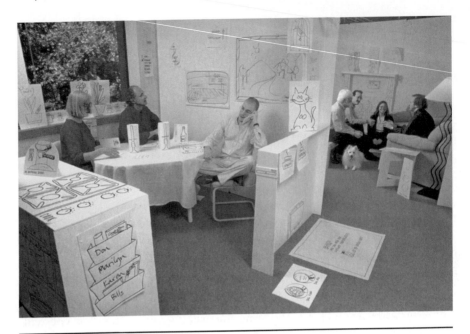

The goal for client interviews is to understand their lifestyle, their children, and even their pets as a part of the research for programming.

share the right information for the project. Much can be gained from general discussions, but sometimes vital information is missed if you do not organize questions beforehand and have at least an outline or simple list to keep the conversation on the right track. If you are charging for your time, you should be organized and efficient but not abrupt. The client does not want to pay for time spent meandering and musing, but she does not want to be whisked in and out the door too quickly either. The project needs to reflect the client, not you. For that to happen, the focus must be on the client.

Remember that a home can be many things to a client: a shelter and a respite from a busy world, a party house, an open home, or a very secure, womblike environment. In the interview, you begin to peel the layers from this onion and discover your client's definition of home. The psychology of the space is as important as safety, and both must be addressed for a successful project. The interview may begin by finding out how many people will live there and how they plan to use the space. How they plan to use the space and how they will actually use it may be two different things, however. The psychologist in you will have to balance this information and provide a design that will please the client and still serve his needs. Establishing a budget is important and will affect your decision making. An understanding of the physical orientation and the exterior environment will also influence

the decisions you make on the interior. Any special needs of the inhabitants and how they like to work and spend their time are also important topics to explore. Many times a home is a family's personal museum, telling the story of their life. People often want to keep the things they love around them. Determining questions to ask and topics to address prior to your client meeting will help to ensure that you are gathering all of the information critical for you to begin the design of the space.

Commercial Interviews

Interviews with commercial clients are almost always conducted at the client's place of business during business hours. The client is generally busy and will most likely want you to travel to her. Reading the contract and understanding the scope of work prior to the interview is important and allows you to use your time with the client efficiently. This knowledge also allows you to target specific questions to the project focus and direct conversations intelligently. When you come to the interview prepared, you give the client a sense of confidence that you are knowledgeable about her project and that it is important to you.

To begin the interviews, you will need be organized and know what types of information you need to gather. The firm you work for may have an interview sheet or sheets to be used as a part of its routine. Four primary questions will form the basis of your conversations about the space:

1. What does the company want to accomplish with this project?
2. What image does the company (the client) want for the space?
3. How many people will occupy the space?
4. How will the occupants use the space?

Although these may seem like simple questions, getting complete and appropriate responses to each will entail a great deal of questioning and conversation. The firm may already have its own form and its own method of working through this part of the information-gathering phase of the project. Be sure to check with your supervisor before constructing an interview document to avoid duplication of efforts.

It is important to establish the lines of communication and the equipment needs within and between the departments throughout the business. You will need to understand the company's image and how the business works. Listen closely to their descriptions of their mission and their vision for the new space. If it is a restaurant, you must understand the goals of that type of business. If it is a healthcare facility, the approach and mission will be different. That is why the research you do will be important to guiding the

Interviews may be done in groups or individually. Focus groups are another method of getting face-to-face information.

interviews. The client at this time will not be so much the individual you are talking to but the business itself. Productivity, employee retention, profitability, image projection, quality of services or product, along with client satisfaction will be a part of their vocabulary and their goals. The business is your client and what you are profiling for this project. The individual worker is one entity within the larger picture.

The contract should include information about the number of people to be interviewed in the programming phase and the necessity of generating an inventory of existing furniture to be reused. This information would be important to the fee structure and the schedule. At this point the details of this information will be addressed. Interviews may be conducted with a variety of people, but you will typically begin with the person hiring your firm for the project. In addition, you may be talking to the head of operations or a group of managers. If some interviews are conducted with groups, they will often be small and include people in similar types of positions or within similar groups. You may also be expected to do individual interviews with the other employees involved in the changes as the leaders deem necessary. After your individual interviews with the workers it is a good idea to check back with the supervisor to make sure everyone is on the same page regarding equipment needs and job descriptions.

Creating surveys for the employees is one method of getting input from more people within a limited time frame. Interviews are time intensive and provide a depth of information. Surveys are time efficient, but may only give surface input. Consider a combination of methods to obtain the greatest contribution from employees with the most efficient use of time. Focus groups are another method of getting face-to-face information from a larger number of people in a limited amount of time.

As always, you should be dressed professionally for any client interactions. Because most of the programming will take place on the client's premises, you should take your cues from the dress of the employees and managers and represent your company well. If you are unsure about how to dress, ask your immediate supervisor for advice. It is not likely that you will be sent on an interview for the first time without supervision. If you are expected to conduct interviews, remember the things you learned in school and ask for ideas and tips from your supervisor. It is also important for you to keep track of your time and what you are doing. Different hourly fees may be charged for different activities, so breaking down the "programming" into specific tasks affects the client's billing. In addition to being efficient and effective, it is always important to be courteous to all the workers no matter what their status. Treat all of them with the respect that a client deserves. Remember to respect the confidentiality of any information you gather. It is to be used to complete a successful project, not as a topic of conversation in the presence of others outside the firm.

Collecting On-Site Information

Conducting interviews on-site allows you to obtain more detailed information than you could from surveys and conversations. Two important areas of programming include gathering data about the existing space if it is to be reused and gathering information about how the employees interact with each other and with the existing space. These areas are addressed in the following sections.

Collecting Spatial Data

The two main areas of concern when collecting information in the existing space are to confirm as-built plans if the space is being reused, and to catalog existing elements that must be reused in your design. Measuring spaces, comparing architectural details with drawings, and photographing unique elements within a space are all important parts of confirming existing documentation. Of course, before you can confirm existing documents, you must acquire them from the architect, client, or building owner. Spend time with the drawings and specifications prior to visiting the site. Familiarity with the space will help your evaluations go more quickly and smoothly. When collecting spatial data, it is always helpful to have another person with you. A partner can help with measurements and offers a second set of eyes to look for discrepancies in the drawings. Unidentified differences may affect the success of the final design significantly, so you want to be as accurate as possible when confirming or creating illustrations of the space.

Creating a thorough and accurate inventory of existing elements to be reused is also critical to a project's success. In some cases the client may provide an inventory, and your responsibility will be to confirm that the appropriate information is included. In other cases the client will expect you to compile information on community spaces, but each employee is responsible for providing accurate information about his or her personal furniture and fixtures. Finally, in some cases design firms are hired to do the complete inventory of all elements to be reused. The expectations must be clear because this information will help you organize your time. You may need to schedule several trips to the site to conduct the necessary inventory activities. With most inventories, a written and visual record is made of each item to be reused. Measurements, condition, finishes and fabrics, and other details must be recorded for each piece. Note any repairs necessary on the inventory document too. Photographs that accompany each description are an important addition to the record. Video images are another method of recording the space and inventoried items. One technique is to have one person videotape and the other person measure and speak the measurements, which can be written into an inventory list later at the office. In all cases, accuracy is vital. If you base your plan on four existing chairs and there are only three, you may have some difficulty explaining the discrepancy to your supervisor and the client! Be clear about items the client intends to reuse and those he intends to discard to save time during the inventory.

Again if you are the one to go to the site and make the inventory list, precision and accuracy are imperative. This basic information is the foundation for the rest of the design. The senior designer does not want to build on

Video images are another method of recording the space and inventoried items.

inaccurate information. The firm you work for will probably have its own version of the inventory form that you will use to do their work.

Client Observations

Another advantage of spending time in a client's home or workplace is that it provides you an opportunity to observe how people interact with the existing space. Observation is a skill that is developed with experience and can provide a great deal of information about what is working and what causes problems. For example, you may be asked to redesign a kitchen in your client's home. Upon observation, you realize that the way the back door opens into the space creates a traffic pattern that leads everyone directly through the work triangle and into the adjacent living space. Your redesign should incorporate that knowledge and provide a clear path to the living space that does not interfere with the cooking activities. The same concept is used in office spaces. You may draw maps of people's movements, or simply make notes of their movements throughout the day. You may identify that the location of a snack machine invites employees to stop and chat, which disturbs the adjacent work group. With this information, your design could provide a protected snack area out of the main traffic path to meet the needs of employees needing sustenance and those of the employees needing to work. Obviously, this type of information gathering can take some time, and the hours must be included in the budget from the beginning.

Banks, law firms, and many other businesses may have very tight security controls. Be sure to identify yourself and state your purpose for being there when you arrive. Ask permission to videotape or take pictures before you begin to inventory. As you leave, stop by the office of the person in charge of the project just to say you are leaving, and always thank the person for his or her time. If the person in charge is not there, just check out with the secretary and thank him or her for relaying the message. If you are not yet finished, explain that you will probably be back at a later time. If it will be next week before you return, call in advance to say you are coming back and what time to be sure it is acceptable. These things are a matter of courtesy, and the client will appreciate the consideration.

Compiling Client Information

During the programming phase you collected information about the needs, goals, and dreams of your client. Now it is time to organize this into a coherent descriptive report. The report should include both client and site profiles and provide a means to organize, analyze, and retrieve information as needed throughout the project.

Client Profiles

The client profile is a compilation of the interviews along with the observations of the site, inventory, time line, and budget. Sometimes the client profile is a formally written document that the project team reads and discusses. Other times the profile may just consist of notes extracted from the observations, interviews, and research. The purpose of the profile is to capture the character of the client, whether it is a company, an individual, a patron, or a guest.

A residential client profile should capture the spirit and desires of the people who will own or occupy the residence and those who will visit. How they need and hope to use the space now and in the future should also be recorded. A commercial client profile is about the business. Of course the business is made up of people who have an impact on its mission. You will be designing this space so that the company can encourage the best in its workers and invite the confidence and comfort of its patrons. The design must support the mission of the company while also supporting the individual workers. The client profile must define the goals and mission of the company, as well as the management style. In some cases, providing a profile of the target market will also be helpful. Client profiles will differ depending on the focus or type of project but will always describe the client in ways that will influence the design decisions that will hopefully produce a successful project.

Site Profiles

In addition to a client profile, each project also requires an analysis of the site. The site analysis helps the design team determine the context within which the design will occur. You may visit the actual site or make a virtual trip to the location. You may need to study drawings and site information provided by the architects or engineers. Like the client profile, the site profile should include a list of the assets and challenges of the site. Following are some suggested questions:

- Where is the space located?
- What is the climate of the area?
- What are the applicable codes that will dictate the parameters of the project?
- What are the views of surrounding nature or the man-made environment?
- What is the physical context for this project?
- Is this a waterfront property surrounded by trees and water with a view of the sunset, or is it on the 20th floor of a high rise in the heart of Chicago?

The purpose of a site profile is to describe those things about the site that will influence the design decisions that will ultimately lead to a successful and innovative design.

The complete programming of a space is a critical step in designing a space that will meet all of your clients' needs and go beyond their expectations. Listening and observation skills are paramount in this phase. Curiosity and the ability to ask questions that lead clients to talk about their visions will add valuable information to your programming documents. As was emphasized at the beginning of this section, don't let yourself believe that the information gathering ends when the next phase of design begins. Continual data collection throughout the project is necessary and ensures the success of the project.

SCHEMATIC DESIGN

You are all familiar with the schematic design phase of a project based on your experiences in studio courses. This phase provides the initial design concept and approach and allows the client to evaluate the design direction before decisions are made on all of the final details. This section addresses some of the activities in which you will be expected to participate that go beyond your classroom experience.

Let us imagine that the initial programming is complete and you are ready to begin producing solutions for the client. Begin with a review of the client's goals, the constraints of the project, and the context. Often the client is unable to completely express her needs or may not have considered all of the problems or goals that could be a part of the project. As a designer, you should be sensitive to unexpressed problems and trained to encourage clients to articulate their desires. Your knowledge base includes an awareness of solutions to problems that you have used successfully in the past. You should also be trained to use your creativity and to consider a variety of possibilities. The design team may write down and discuss the goals and constraints of the project to clarify them and to be sure that all issues are addressed. Once the assets, liabilities, and goals have been clarified, it is time to begin dreaming for the client. How can the project be designed to go beyond the client's dreams? What must be done to meet accessibility and other codes? What must be done to ensure the durability and financial feasibility of your ideas? Designers must be both creative and realistic and have the best interests of the client in mind.

All of your initial visions may change as the project evolves. You must always remain flexible and open to change. Unlike the presentations you produced in school where you had one professor to please, you will have

You may want to get out your pencil and tracing paper for quick explorations.

many people to satisfy and many constraints on what you will be able to se-lect. Budget and time will play a bigger part than you may like. Sometimes you will have to reselect when you are "in love" with your first choice. The "perfect" choice may be too expensive, may not meet codes, or may not be available in time to meet the deadlines of the project, or the senior designer may have another direction in mind. Flexibility and the ability to see the proj-ect from several vantage points will be a great asset. Being unable to produce more than one solution to a problem will be a liability to your future success. Hopefully you have been asked to rethink your designs in your school proj-ects, and you have been trained to back up and redirect your thinking to sat-isfy another vision besides your own. If it did not happen to you in school, brace yourself because it will happen to you in the field.

Planning the Space

Once you have established some of the major goals of the project and de-cided on a tentative direction, you will begin to develop the different parts of the conceptual design. Although this development will be presented in a rather linear fashion, the design process is more of a circular process. Some

things will occur at the same time, many things will require revision, and others will happen out of order. Relax. This is the nature of the design process and part of the joy of creating new solutions.

The space plan does not refer to the floor plan alone: It refers to the design of the entire space. That includes visualizing what the three-dimensional space will feel like to clients when they inhabit the interior. You will have an idea of the look of the space as you begin, but it will certainly change as the design progresses. Most often the absolute requirements are plugged into the plan first, and then the other desired or suggested items are attempted next. Sometimes the absolutes will change because the designer will find a new way to solve the problem. This creativity allows for new approaches to the problem and perhaps an innovative solution.

A lot of design problems cannot be solved only by drawing the floor plan. You may need to consider questions such as the following:

1. How will certain walls influence the view?
2. What should be the height of the ceiling and the height of the doors?
3. How will doors and windows be framed out?
4. Will the window locations allow us to see the sunset or a brick wall that is part of the structure next door?

Be sure to consider the architectural details when you are planning as well because they give character to a space and often provide a kind of unity throughout. Remember that people who inhabit the space will not fly around the space looking down on the floors and furniture as you have drawn it in plan view. Planning the *whole* space is critical! Many times as an idea is sketched in the third dimension, unanticipated problems or spatial conflicts are revealed. These are often easily solved, but could cause major problems if not discovered until the project is almost complete. Regardless of whether a computer program is used in the firm to draft and draw, you may want to get out your pencil and tracing paper for quick explorations that are not as easily generated on computer. The sketches do not always have to be three dimensional to solve the problems; elevations and sections may work just as well or better to help you visualize the design solutions. Developing the design for the space may result in a floor plan but should reflect your vision of the entire environment.

Codes and accessibility checks need to be done to make sure that safety issues have been solved by the plan you are going to present to your client. Sometimes you may not be clear about the interpretation of a code; other times there may be a need to request a variance for the space. Whenever there is any question or concern, you should talk directly to the state fire marshal or the local codes inspector to address the concern. Once the

Plans, sketches, and elevations are all a part of telling your story clearly.

written approval is received, it should be filed in the job file in case there is any question later during construction and installation.

When designing the plan, you may be asked to try some ideas and work on a preliminary solution for the senior designer to approve. It is important to address circulation space, traffic flow, the size and location of furnishings, storage needs, the zoning of relevant spaces, and other definitions of the space in plan view. But, very often the ideas need to be tried in three-dimensional or detail sketches to make sure your mental picture appears on paper the same way it does in your head and the details are well thought out. Alternately, you may not be asked to generate ideas. The senior designer may do a rough draft of some ideas and then you will be expected to "clean up" his sketched ideas by drafting to scale and adding details to make sure the idea will fit.

Aesthetic Directions

Aesthetic direction is another important part of the design and often the component that provides the most visual impact. Determining the overall concept and design direction is vital to providing a cohesive design. The purpose of the schematic design phase is to choose elements that provide the client with an overall view of the space and the design direction determined by the designers based on the programming information. These choices are only preliminary. They may become part of the final design, or they may be discarded for more appropriate choices or choices that better meet the parameters of the project. Ultimately, the aesthetic direction tells clients' visual stories—how they live, work, play, and care for themselves and others occupying the space.

Furnishings and Fixtures

As a new professional, you may be asked to contribute to the selection of the furniture and fixtures in addition to being asked to participate in the development of the space. The senior designer may ask you to make preliminary selections for his approval, or he may begin the process and ask you to make sure the selections are actually appropriate by doing some research. Drawing the furniture and fixtures into the plan will be done in concert with the selection and approval of your choices. The plan may need to be redrawn based on the actual selections. Sizes and styles along with other attributes may necessitate changes to the scaled plan. If the sizes of the actual selections are not drafted to scale on the plans, the furniture may get lost in the space if it is too small. Worse yet, the final clearances may not be adequate if the furniture is too large. Accuracy and accountability on the designer's part is important in the conceptual presentation just as it is in the construction drawings.

If you are making selections from the firm's library, function and style will probably guide your initial selections. Once you have pulled some possibilities from the catalogs or online resources, you need to use other qualifying information to determine the best selection from your preliminary choices. Besides fulfilling the functional and aesthetic needs of the client, you may be asked to further qualify your selections. It could be necessary to check on general pricing, availability, sustainability, durability, and suitability for the type of installation. Style and function will still be a part of your decision in actual projects, but other criteria will need to be considered as well. You may not have been asked to check on availability, sustainability, or even pricing for many of your projects in school. However, these items will factor into the final choices as a professional.

If you are working in the firm's library, function and style will probably guide your initial selections.

The professors guiding you in studios often require that you revise parts of the design projects you produce. This experience is valuable and teaches you to be able to create multiple solutions to the same design problem. As a professional, you will have to compromise on your choices and re-think design solutions on a regular basis for a multitude of reasons. Flexibility is an essential characteristic of all designers. Many changes may occur before the project is completed. These changes may be necessary because of durability, codes, availability, pricing, or other constraints. A part of your job as a designer will be to vigilantly maintain the visual concept and overall functionality within the compromises you make. Because these changes will occur frequently throughout the conceptualization and construction of a project, your talents will need to include resilience and the ability to gracefully provide more than one solution.

Once you have dreamed on behalf of your client, you must also operate as the client's advocate. You must make sure you are providing responsible choices for the client as well as appropriate aesthetic choices. Conducting research is essential as you check on factors that will influence decisions and choices. Sources that provide vital information include the technical sections of catalogs in the firm's library, the Internet, manufacturers, and even crafts- and tradespeople. If the project calls for an early deadline, it would not be responsible or ethical to present a design that requires a very long lead time. Ongoing research is necessary as the preliminary design is created. The preliminary design selections must be available, appropriate, and within the given budget so that the design can be realized as closely to the direction in the presentation as possible if it is approved by the client. Not much is to be gained by continually disappointing the client with substitutions because of a lack of basic research on your part. Satisfying the client is always a project goal. There is no better marketing tool or promotional endeavor than the words of a satisfied client.

Finishes and Fabrics

As the plan unfolds and the furniture and fixtures are being selected, the finishes and fabrics also need to be coordinated with the total concept. You may be asked to pull several samples from the library for the senior designer's review, or she may give you some samples to begin and ask you to complete the choices. Doing initial research on each sample as it is pulled will save time and effort in the long run. Finishes and fabrics need to be aesthetically pleasing, but more than that, they must pass codes, be available, be priced right, and be durable and sustainable.

The method used to research the appropriateness of the selections is similar to the method used to research the fixtures and furniture. The first

You must make an excellent aesthetic selection but also a responsible and appropriate one.

reference to check is the back of the fabric sample and or the back of the catalog it came from. Often the yarn type, dye method, and weave will be listed on the sample packaging along with the flammability categories and durability test results. If it is a carpet, the face weight, pile height, type of backing, and other pertinent information will also be stated.

Commercial products are labeled with more information than residential products as a rule. Some products will not have labels with information adequate to allow you to make a decision. Catalogs and online resources may provide additional information, but may still not be adequate to make a responsible assessment. Most manufacturers have technical divisions that have more information about the contents, density, flammability, and sustainability of their product. A phone call to the manufacturer will often supply information not contained in the catalog.

In some cases, the samples available in the firm's resources are not adequate to evaluate the visual impact of a fabric or finish. When this is the case, you may need to order a larger sample or memo sample for evaluation and for the presentation. Usually this is called for when the pattern is large or the sample you have in the library is too small to show a total repeat. The presentation must portray the conceptual design clearly enough for the client to make a selection from the samples with as few surprises as possible when the final installation is in place. Another phone call to the manufacturer, an online order, or a trip to a designer's showroom will allow you to accomplish this task.

Presenting the Work

Most of you have learned the processes necessary to arrive at the presentation stage of a project. Putting a schematic presentation together in the real world may take a different path than the one used to put together a studio project in school. There will be a chain of command and probably a senior designer or project manager to convince before the client is ever encountered. Many of the initial selections made will need to be reselected based on other qualifiers as discussed in earlier sections. Once the presentation is finalized in-house, the preparation begins for the client presentation. The presentation will most likely be a face-to-face encounter with visuals and a verbal component. The approach may be similar to your school experience for a visual presentation, but the media, materials, and style may change considerably. Each firm has its own approach and methods for presentation. This does not make one method right and another wrong; the accepted system for conceptual presentations may just be targeted toward a specific type of practice and particular clients.

The visual presentation should be put together in a logical sequence. Both the verbal and visual components should tell a story that is well crafted, easy to follow, and sells the design to the client. If the visual is difficult to follow, poorly crafted, or poorly presented verbally, the client will probably not approve the design. The visual design of the presentation should be set up to support the sequence of the presentation and the specific highlights of the design in relationship to the audience. You may be given the responsibility of developing the initial layout and organization of the presentation with the approval of the senior designer, or you may be given a basic direction and be expected to develop the details yourself. In either case, rely on your training and direction from the senior designer to guide you. The firm will likely have its own style of title blocks or a system of organization that has been rather standardized. It might be helpful to look at some of the other visual presentations produced by your firm to give you some idea of how others have approached the task of selling their conceptual designs. Once the order and layout have been decided and approved, you can begin to finalize the production. Understand that this is not just informative, but it is meant to sell. Consider your client and the highlights of the design.

A professional presentation of a schematic design often begins with a discussion of the context of the design. The context includes a description of significant characteristics of the site, the surrounding geography, and areas immediately adjacent to the project. These characteristics could include a southern exposure, a view of a sunset over the mountains, or easy client access for walk-in traffic. The design is not an island without connections to a context. Often the presentation begins with an overall picture and works

The usual manner is to begin a presentation with the context, which may be the floor plan, the building type, or the geographic and surrounding immediate area.

down to the details, which are generally presented last. Once the design context has been explained, the overall space plan is generally shown and explained. Most often this is done with a rendered floor plan and perhaps the addition of elevations or sections. After organizing the visual introduction of the space, each section of the floor plan will be explained in greater detail. Pictures, actual samples, and other drawings and sketches needed to clarify and highlight important points of the design should be included. Often it is best to repeat the order in which the client was introduced to the overall space for simplicity. If you walked him through the foyer first on the floor plan, that is the space you would present in detail first. The purpose of the presentation is to educate and excite the client, so at key points throughout the presentation, you must relate the design decisions to client benefits.

Presentations may be conducted in a variety of environments. Residential presentations often occur in the client's home or in the conference room of the design firm. Commercial presentations may take place on the client's premises if a group of people is to be involved. With smaller groups, or with more complex presentations, the clients will be invited to the design firm. You may or may not be invited to participate in the client presentation. Often the senior designer or principal makes the presentation to the client; however, you may be invited to sit in on the presentation. Observe the details of the presentation carefully because this opportunity will prepare you for presenting in the future.

The schematic design phase begins the design process for the client and provides opportunities for the generation of preliminary ideas and feedback. Often this phase is part of the contractual agreement, but it could be the final

step in a competitive design arrangement. Your responsibilities will be to generate ideas, conduct research, and support the lead designer in creating a client presentation that explains the design and enlightens the viewers. Many of the activities will be familiar based on your experience in design studios; others will be new and unique to your firm and to professional presentations. Take advantage of every opportunity you have to learn from your leaders, and prepare yourself for more responsibility as your experience increases.

DESIGN DEVELOPMENT

The design development phase of professional projects is defined in the contract and often reflects your experience in your academic design studios. Design development is a continuation of the schematic design, and the goal is to provide a finished design to the client.

Planning the Space

The presentation of the schematic design to the client should have resulted in conversations about necessary changes and ultimately a sign-off on the design direction. With the design direction approved and revisions identified, the planning should continue toward the development of a final space plan. As in the previous phase, three-dimensional sketches will continue to be used to explore design possibilities and to identify areas of conflict that must be resolved

The design development phase requires attention to a level of detail not addressed in the schematic phase.

during this phase. Final floor plans will also be created and must reflect furniture and other design elements exactly to scale to ensure a successful installation. Any changes required by the client should also be incorporated.

This phase also requires attention to a level of detail not addressed in the schematic phase. Architectural details of the space must be designed, and placement on the drawings must be exact. Custom work must also be finalized, and fabricators should be included in the process. Some projects require specialists who may be included at either the schematic design phase or the design development phase, depending on the type of work they perform.

As revisions are completed and new selections made, an interim presentation to the client may be warranted. The contract should be specific about the number of major revisions your firm will provide without asking for additional fees. Checking in periodically with the client to ensure that revisions agreed on in the schematic presentation are appropriate will provide necessary feedback to the design team and keep the client informed of the designers' progress. An in-house codes review should be conducted on the new plan, and if there are any questions or concerns, the local code inspectors should be asked for a clarification or interpretation of the code in relation to the project.

Once the plans are finalized, preparations may begin for the final presentation. Of course, final decisions must be made on all elements contributing to the aesthetic direction before the presentation can be completed.

Aesthetic Direction

The aesthetic direction was presented with the plans during the schematic design presentation, during which the client gave feedback on elements that were acceptable and those that needed to be changed. If you did your homework while collecting samples for the previous phase, much of your work is almost complete. If not, you will need to find the specifications for each sample to be used, conduct the necessary research, and create files to contain the information.

Writing specifications for each item chosen in the design is an important responsibility. Specs should be written when you are fresh, alert, and not rushed. You have most likely already written some proprietary specifications for your design projects. Proprietary specifications include specific information from the manufacturer about a particular product to be used in the space. For example, if you want to provide a Steelcase Leap chair for your client, you must provide the following information:

- Manufacturer
- Product description

- Model number
- Finish name and number
- Fabric name and number
- Type of arms desired
- Type of casters required or glides
- Special features

Specifications must be provided for each item planned for the space, and numbers must all be correct and in the appropriate format. Given the amount of information required, you should double-check your work and keep detailed records as you proceed through the design. Having to retrace your steps with each product to find specification information is a waste of valuable time and effort!

Some projects require a performance specification as opposed to a proprietary specification. Performance specifications do not limit the item to one product from one manufacturer, but instead identify what the product must do or how it must perform. When a project must be bid, these specifications allow bidders to use products that meet the performance specification and that they can obtain at a reduced cost or within a reasonable time frame. There are obvious risks with a performance specification if the success of your design hinges on particular products or finishes, but in some projects this approach is a necessity. Be sure you are familiar with your client's specification and purchasing requirements prior to beginning your design. You may design a bit differently if a performance spec is required, and you will still provide the client with a well-designed space upon completion of the project.

It is always a good idea to confirm pricing, delivery dates, and lead times for products, even if you did so in the previous phase. Time frames for some projects become extended, and price increases, decreased supply, or material shortages may affect the information you were provided earlier in the project. Remember that economic factors, natural disasters, and cultural conflicts can have an effect on the price and availability of materials we use every day.

Presenting the Work

Final presentations of work done in the design development phase may be very similar to those in the schematic design phase. The primary difference will be the level of detailed explanation and visuals necessary to help the client fully understand the design. This presentation may include a

The goal is to have an
approved plan and proposal.

computer walk-through of the space to help the client visualize your
ideas. Additional sketches and renderings will also help answer any questions. Clearly labeled samples and a well-organized plan provide critical
information for clients. Continue to expect some minor changes as the
client and the design team tweak the details. The goal, however, is to have
an approved plan and aesthetic proposal at the end of the presentation
meeting.

Residential presentations may not be as formal or as structured as commercial presentations, but the goal is the same. You want the client to "sign
on the dotted line," indicating that she approves the work and is ready for
the design team to move on to the next phase of work. With some commercial projects, you may need to present your work to more than one group.
These presentations may be to acquire approvals, or, more likely, to inform
the client's employees of the plans. These informational presentations can be
crucial to the smooth transitions into new spaces. Change is difficult for
many people, and the more employees are included in the planning and informed of the goals, the greater the possibility of obtaining their support during the construction and move phases.

Client Support

In some cases (more often in residential projects), your firm is hired to provide
design services, but is not expected to implement any of the design decisions.
This arrangement is part of the contractual agreement and is understood by
all parties from the beginning of the project. At times these arrangements are
prompted by the fact that the client has existing relationships with fabricators

and contractors who can provide the work to them directly. Some clients simply prefer to handle the arrangements themselves. They may need to oversee each step of the project for various reasons, or they may choose to do the work in phases as time, money, or circumstances permit.

Many times the client will want some leads regarding a company that might supply the carpet and the installation, or a carpenter that might build cabinets from the drawings executed by your firm. A client may ask about an upholsterer for an existing piece of furniture or about your recommendations for a person to make the window treatments. Therefore, knowledge of these crafts- and tradespeople will be necessary even if those are not included in the services of the firm. Any contract will be between the client and the trades- or craftsperson. Unless the firm is to profit from the service, there should be no contract between the firm and the client pertaining to the supply of the service or product because that implies responsibility. Assuming responsibility for the quality of someone else's work without some control over the work and a portion of the profit is, among other things, a questionable business decision.

NEW EMPLOYEE RESPONSIBILITIES

As a new employee, you will rarely be expected to handle large tasks unassisted. Your assignments in the beginning will probably be in support of a more senior designer, giving you an opportunity to listen and observe before you are assigned projects on your own. Assisting another designer is an important task in itself, and you must show your mentor that you are committed and capable of aiding him appropriately. This will mean listening closely, taking notes, anticipating needs, and taking initiative. Showing that you are responsible and learn quickly will instill confidence in your senior designer that you can handle more tasks on your own.

Research and Library/Sample Room Work

Besides assisting a senior designer, you will probably work in the library and sample room as well. This type of work is one of the best ways to get to know product and in turn understand the firm you work for more clearly. Do not take this task lightly. If you are actively learning while you are filing and gathering information for others, you will have a good understanding of the knowledge sources that are important to the firm and how to quickly navigate them.

Conducting research about products, fabrics, finishes, and details is an important responsibility and may determine whether the project meets codes, is delivered on time, or meets the client's budget. Two important pieces of

information commonly needed are the item's price and its lead time. This information is generally supplied by the customer service department of the manufacturer.

Requesting pricing can be confusing, and it is important for you to understand all of the parameters of the numbers quoted. A price may be quoted wholesale or retail. A wholesale price is the amount your company is expected to pay for the item, and a markup is added to that price before it is quoted to the client. A retail price is the price the client is expected to pay. Identify any discount structures your company may have with the manufacturer to help determine actual costs. You must also determine whether the price quoted is the delivered price, or whether shipping, handling, and freight need to be added to that price. If additional fees must be added, it is critical to get an estimate of those fees to add to your pricing. International shipping may entail different port or customs fees, and further research will be necessary.

In addition to price, you will also be expected to ask about the lead time on a product. This is the amount of time necessary to order, manufacture, and ship the product to the site. Many factors may affect the time necessary for manufacturing and delivery, so updating this information each time you specify an item is essential. Go beyond researching the requested information and provide the designer with additional data that she may not have thought she needed. This extra effort shows initiative and lets her know you are willing to think independently and take on additional responsibility to help the project team.

Keep a phone log to record the information you are given about lead times and technical information.

As a part of your responsibilities around the materials, you will probably be expected to make phone calls to technical departments of the manufacturers. You will be asked to get specification or installation information for the appraisal of an appropriate product or to ask specific questions about a product. Keep a phone log to record the information you are given. The firm will probably have a form for you to fill out. If it doesn't, you should log the phone number, business, purpose of the call, and any pertinent information and dates.

When calling the manufacturer or supplier, identify yourself and your firm at the beginning of your conversation and ask for the appropriate department. Acting professionally and communicating your reasons for requesting the information in a succinct manner with a pleasant voice will generally gain access to the information you need. Once you have been connected with the technical department, identify yourself again and give the name and stock number of the fabric or finish you are inquiring about. You may need to explain how you plan to use the material if there are special circumstances or you are using the material in a nontraditional way. If the technical person says that the material is not appropriate, you can ask if they make a product that would do well in the kind of environment being designed. At times, the product specified may not be made for the type of installation you have in mind, but the company may manufacture a product that would meet the needs. The technical department may recommend the product only with a particular installation method. In this case you may request that they send you a written copy of the exact installation methods needed for the company to stand behind its product. You may want to request the written information about the product and its use for your files so that you are sure you are making a responsible choice. This information may also come in handy as a resource to show a client or building official that the manufacturer stands behind the performance of a product when it is used under particular conditions. It will be necessary on some projects to present this information in a written request to a fire marshal or building inspector. Whatever the circumstances, it is a good idea to have a written description of the product in your file to indicate that you have made not only an excellent aesthetic selection but also a responsible and appropriate one.

Once you have the information you need, ask for the person's name and use it when thanking him or her. At the completion of the phone call, be sure to write down the name of your contact, the time of the call, and the results of the inquiry in a phone log so you have a written record. This information is important if you need more product information or if the order does not come in a reasonable time. When you are calling to check on price, availability, or allergy information, use the same general approach and be sure to write the information in your phone log immediately after your call.

Bear in mind that this is a learning opportunity for you in addition to being helpful for the senior designer. Absorb information that may be valuable to you when you get your own projects to manage.

You may not be required to fill out purchase orders with stock numbers and pricing in a design firm that does not sell products, but there will typically be a library for product information with specifications, construction drawings, documents, and contracts. There will also be books and catalogs on how to write specifications and draw construction details along with contract data and other pertinent information about design, materials, construction methods, and details.

Often one of the duties of the junior designer is to maintain the library. You may feel that this part of your job is not as exciting as working on the design of a project. It is, however, one of the best ways to learn about the firm and the myriad of products and construction details specified by the firm. Working in a library is a way to become literate about many things that cannot be taught in the time frame of a four- or five-year education.

Maintaining a current library involves filing and cataloging information that arrives through the mail or is downloaded from a computer. Prices generally escalate, and as they rise, new pricing information must be inserted into the catalogs. Including the date that the updated information was entered helps to ensure that designers and specifiers are using the most current pricing and product data. Not only do the prices have to be updated, but the new products and new materials also need to be added. Because designers in the firm should be updated on new products, devising a method of circulating new information is important. Sometimes the product updates are brought by the manufacturer's representative, who meets with the design staff to acquaint them with a new line or new series of products. It may be your responsibility to set up convenient times for the representative to educate the staff. Many times the designers are too busy designing and specifying their projects to spend much time listening to a talk on new products. It is always a difficult balance to stay on top of new knowledge in the field. You may be the person designated to meet with the representative and then to pass that information on to the staff. With this knowledge, you may also become expert at suggesting furniture, fabrics, or finishes that meet designers' expectations. Your expertise and familiarity with products could save designers valuable time and show them that you are ready to handle more design-oriented activities.

Firms frequently have their own procedures for using library information as well as having different lists of products from which they pull their specifications. Updating and maintaining the resources and conducting research using the resources is valuable experience that will serve you well in your future professional projects.

Site Visits

New employees are often asked to do "behind the scenes" work to familiarize them with the firm's processes. These less visible tasks are not glamorous, but as you saw in the previous sections, they are critical to the success of the project.

When you are asked to make visits to the site, whether for observations, to conduct an inventory, or to check drawings, always remember that you are representing your company. The impression you make will reflect either positively or negatively on the firm and may influence the client in future decisions about project work. Your dress should always be professional, even when it is less formal during inventory and site measurement activities. Conduct your work quietly, and always allow the client's workers to do their jobs uninterrupted to the greatest extent possible. If you must disturb them temporarily, be sure to let them know what you are doing and how long it will take and ask if there is a better time for you to conduct your work in their area. Thank them for their patience when you are finished. In addition, be sure you know what you are expected to accomplish before you leave your office so as not to waste time or concentrate on activities not relevant to the project.

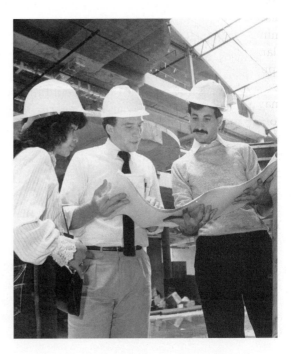

Site visits may be a part of your responsibilities.

Visits to the project's construction site may also be your responsibility. At first the site may seem dirty and dusty and smell of glue, sawdust, and paint. However, it is very exciting to actually watch the design ideas become reality. When you visit the construction site, check in with the contractor before entering the space, not just as a courtesy, but as a safety issue. Some areas might be temporarily restricted because of specific activities being conducted. You may be required to wear a hardhat while you are on the site taking measurements or checking details. Planning your wardrobe around site visits will help you be comfortable, safe, and appropriately dressed. High-heeled shoes, short skirts, expensive suits, and designer handbags are not conducive to allowing you to perform your duties well on a construction site. Flat shoes, professional pants or pants suits, and a rugged briefcase are better choices for construction sites. Chapter 10 will discuss more about the construction phase of the design.

Presentations and Meetings

Project meetings are held for a variety of reasons, but there is always one common denominator: You are all on the same team and you are working together to satisfy the client and produce a successful project. Your responsibilities at an informational meeting may be different from those at a design presentation. During meetings you should be attentive, take notes, and observe styles of conversation that lead to the sharing of important information. The senior designer or leader of the meeting may ask you to take minutes, provide some design suggestions, or simply observe. Be sure to clarify his expectations prior to the meeting so you will be able to perform appropriately.

Design presentations take more coordination, and your responsibilities may vary. You may be asked to help set up presentation boards, arrange the computer for a PowerPoint slideshow, or hand out supplemental brochures. Your role will likely be that of an assistant at least for the first few presentations. You may be asked to take notes on comments and any changes the client suggests in the design. Another responsibility you may have is to gather the presentation materials after the presentation is complete. This may allow the senior designer the freedom to discuss details with the client. You should be cordial, observant, professional, and helpful in a supportive role in your first presentations.

The dress at meetings or client presentations will depend on the client and the place of the presentation. As discussed earlier, meetings may be conducted in the client's home or office or in the design firm's conference facility. Design presentations will typically require more formal dress than informational meetings, but you should always take your cues from

the more experienced designers in the firm. If you have any concerns about what you should wear, ask your immediate superior or the senior designer making the presentation. By now you have probably been with the firm long enough to see designers go to client meetings, and you may have an idea about the expectations for dress. The rules you used for dressing for a job interview would be good guidelines as well and in most cases would be appropriate for these meetings. You need to appear professional and businesslike. This is a business meeting, and you are a part of selling your firm.

Observe and listen at client meetings. Watch the persuasive people skills the senior designers exhibit and make the good ones a part of your resources when you have your own projects.

Drawings and Schedules

As the design is developed, your responsibilities will probably include assistance on drawings. You may be expected to do preliminary schedules for finishes and furniture. The firm will most likely have its own system and formats. There will probably be examples or programs on the computer to help you fill out and draw a schedule in the manner the firm desires. Do not panic if the system is not exactly as you were taught in school. The purpose will be the same, and the systems will probably be similar. Take your time to be accurate and concise. Ask questions when you don't understand, and try to be resourceful and logical when the senior designer is out of the office.

You may be asked to try your hand at some preliminary cabinet drawings. There will be examples in the files, and your senior designer may be able to pull an existing drawing for a reference. Generally, no drawing will go out of the firm without a second signature. Even though you may draw the preliminary, someone will check it and suggest corrections or initial his or her acceptance before the drawing will go to a craftsperson. A request for shop drawings from the cabinetmaker for the senior designer to approve may also be required before it actually goes into production.

There will be more paperwork and signatures involved in each of the design phases than you probably think. During the design development phase, the products chosen must be rechecked for final use. You will be involved in making sure the finishes and fabrics are still available and that they all will pass codes. This is the stage at which letters for permission to install may go out to the fire marshal and others who make decisions on compliances. You may be asked to write "permission to install" requests and secure signatures for the final finish selections. Be sure that signatures are in

It is important to keep
good records of your time.

the correct file or in the right hands when you return to the office. Also, keep
a copy of all your memos and communications in the project file so you will
be prepared to address any question or problem that may arise. Most proj-
ects have changes, and you may be asked to create new drawings that reflect
those changes.

Time Sheets

Time sheets are important documents that record your activities during
the course of a day and the amount of time you spend on each activity. The
purpose of a time sheet is to provide accurate billing information for each
of your projects. Your records must be precise or your clients will be billed
incorrectly. To produce a time sheet that accurately reflects what you did
during your workday, you must keep good records. For example, from
8:00 a.m. until 9: 45 a.m. you may spend time in the sample room pulling
samples for the Smith project. At 9:45 you may take time to rearrange your
papers and organize your desk. Desk organization would not be billable
time; however, the time spent in the sample room would be. There will
probably be a place on your time sheet to register a symbol that will dis-
tinguish billable time from nonbillable time. Sometimes the time sheet will
allow for a breakdown at the bottom of the page to indicate how many
hours were spent in billable tasks and nonbillable tasks. Many firms as-
sign a project number to each client, and that must be included in your
time sheet next to the activity. It is a good idea to fill in your activities on
your time sheet daily or keep very accurate details in your booklet con-
taining a daily time schedule.

A small booklet that will allow you to write in the task on a daily time schedule is necessary; functioning without one in a firm that sells a service is neither efficient nor effective. There are many types of booklets appropriate for recording time; choose a format that works best for you. Because you will want to carry it with you daily, it should be small enough to fit into your pocket, purse, or briefcase.

As a point of clarification, usually your time is billed at a lower price than the senior designers' time in the beginning. Many times junior designers find out the billable rates for their time and become confused or aggravated because they are not being paid at the rate the firm is charging. Remember that built into the hourly charge for your time is also money to cover such items as the rental of space, the purchase of equipment and supplies, travel and promotional expenses, advertising, insurance, benefits, taxes, and loans. The hourly fees also provide pay for times when you cannot charge your activities to a client (remember the time you spent organizing your desk earlier?). This was explained in Chapter 8 when we discussed the overhead required to operate a design firm. Obviously, not all of your hours will be billable, but as time goes by, more of your time will be project focused. One estimate of a reasonable balance is that 80 percent of the designer's time should be billable, and 20 percent should be overhead. This is only a guideline. Many situations call for more and some may call for less depending on the overhead, benefits, and salaries peculiar to the firm.

SUMMARY

Chapters 8 and 9 discussed specific responsibilities you may be assigned once you become a part of a design firm. Designers are often responsible for helping the firm find leads, meeting with potential clients, and conducting client interviews. Depending on the type of firm you work for, a programming document may be put together very formally or rather informally. Once the programming is completed and the problems defined, the creative problem solving can begin. You will individually or as a part of a team design the project, present the designs to the client, and provide design services as outlined in the contract. If the firm you work for supplies a product, your job responsibilities will expand well beyond design. Some design students believe that once they have completed the design of a project, their part in the process is complete. This belief is far from the reality of professional expectations. Chapter 10 discusses the responsibilities you may encounter during the final stages of a project and potential client needs regarding services and support.

ACTIVITIES

Activity 1

Design a format for a time sheet and keep a record of the time you spend working on one of your design projects. Be sure to detail your activities and record the use of your time in 15- to 30-minute increments. This activity will give you practice in being mindful of what you do with your time and how much time it takes you to perform certain tasks.

Activity 2

Imagine that you are going to redesign the offices of the design professors in your program. You must reuse their existing furniture, so it is important for you to have a detailed accounting of everything within their current spaces. Design an inventory form that will support you in collecting all of the information necessary to design with the existing items. Conduct a mock inventory in at least one office, including as much detail as possible on the form.

Barbara Lingle is the owner and senior designer at BL Interiors, a locally prominent residential/commercial interior design studio. BL Interiors is a diversified and professional design group that devotes meticulous attention to quality control, design, and color to create an environment that reflects the lifestyle of each individual client.

The basic philosophy is "to create spaces for people to live or work where they can be surrounded by things that they like and that make them comfortable." The design staff at BL Interiors can achieve this without sacrificing function, creativity, or beauty.

They work with builders, architects, and clients to achieve a truly integrated design plan. This often includes reviewing house plans, lighting plans, and kitchen and bath plans, and may also involve custom or built-in furnishings. The company offers a full selection of designer materials, including woods, marbles, granites, floor coverings, wall and window treatments, fabrics, and finishes as well as the full complement of furniture and accessory styles. Projects have included restaurants, banks, medical clinics, country clubs, hotels, offices, commercial spaces, and numerous residential projects.

"I guess that in a way I grew up in this business," Barbara muses. "My father was in the furniture business, and I used to meet him after school at the shop. I would hang out with the designers and put fabrics away. I was certain that I was going to be a designer when I grew up."

It didn't actually turn out that way for Barbara in the beginning. When she did go to college, she majored in education, ultimately earning an M.S. in Educational Administration. She moved to Los Angeles to teach while completing postgraduate work, but she retained her interest in design and studied it at the University of Southern California. Many of her closest friends in her new home came from the Los Angeles design community. Every summer when school let out, she would work with them in their businesses.

It was obvious to all who knew her that design was what she was passionate about. One day her father called to entice her back home. "Come back," he said, "and we will open the design business that you have always dreamed of." That was 27 years ago, and BL Interiors is still thriving.

Barbara is the creative end of the operation, the lead designer, and the face of the business. She is the ultimate people person. One of her favorite parts of the business is the interesting people that she meets. She also values the fact that every day is different and interesting. Husband Dave takes care of business (ordering, receiving, scheduling, bill paying, record keeping). They work as a harmonious and complementary team. The business is central to the life they have built together. Barbara says even entertainment time is generally spent with favorite customers these days.

Asked what attributes are needed to enter her niche in the field, Barbara replies, "a sense of humor." There are many details to be addressed in any project, some of which are not going to go exactly right the first time. Customers are new to the process and can get very uptight. A good sense of humor helps defuse the situation and put the problem-of-the-day in perspective.

Her advice to those just entering the profession is to "remember that this is a profession, a wonderful profession. It is not easy. You will have to be willing to work hard. And, despite what you might see on television, this is not work that can be done well by homemakers or celebrities playing house. Don't lose sight of the fact that this is your career, and you need to stay on the cutting edge of new developments."

Professional Responsibilities
Implementing, Completing, and Surviving the Project

10

It takes less time to do a thing right than it does to explain why you did it wrong.
—Henry Wadsworth Longfellow

Objectives

After studying this chapter, you should be able to:

* Identify methods used by designers to communicate their designs to construction professionals including construction drawings, project manuals, and specifications.

* Explain the designer's responsibilities in managing the administrative elements of a project and coordinating project activities.

* Consider project scheduling methods and activities to be included in the schedule.

* Describe project budgeting and items that must be included in the final budget calculations.

* Identify methods for conducting postoccupancy evaluations after clients have occupied the space.

* Reflect on your personal needs for bringing a project to a close.

Chapters 8 and 9 discussed specific responsibilities you may be assigned once you become a part of a design firm. Designers are often responsible for helping the firm find leads, meet with potential clients, and conduct client interviews. Once the project is awarded, you will, individually or as a part of a team, design the project, present the design to the client, and provide design services as outlined in the contract. Many design students believe that once they have completed the design of the project, their part in the process is complete. This belief is far from the reality of professional expectations. This chapter discusses the responsibilities you may encounter during the final stages of a project, and potential client needs regarding services and support.

COMMUNICATING THE DESIGN FOR CONSTRUCTION

Creating designs that meet clients' needs is a critical part of a designer's job, but the responsibility does not end there. The designer must create documents that communicate her designs in "construction language" to enable contractors to actually build the project. These documents include three types of notations: construction drawings, project manuals, and specifications. Each document includes detailed information about the design, materials, construction details, and other important elements that will ensure that the final product is aligned with the designer's vision. We provide an overview of the documents in this chapter, but more detailed information is necessary before attempting to produce a construction document package. Many of you will cover this information in great detail in your studio courses; others may need additional support in this area. Resources to help you understand construction documents more fully are provided at the end of the chapter.

Understanding and having the ability to create construction documents not only communicates your intentions to contractors and fabricators, but also enhances your abilities as a designer. Because these documents are a major form of communication in the design fields, they become a common language with which to discuss the design with other professionals such as architects, landscape architects, mechanical consultants, electrical consultants, contractors, and other specialists. As such, it is as important for you to fully understand construction documents as it is for you to create them. Interior designers often work with existing structures or on a design team to create whole structures. As a designer, you must understand base building plans, architectural details and specifications, HVAC and plumbing information, and other construction elements and know how they will affect your

Construction documents are a major form
of communication in the design fields.

design decisions for the interior of the space. Coordinating your designs with
the architectural aspects and infrastructure of a building (e.g., structural, me-
chanical, electrical, plumbing) will help you avoid conflicts and problems
and minimize or eliminate disputes during construction. Another advantage
of creating construction documents is that they force you to think about your
design in greater detail, compelling you to make more appropriate decisions.
By thinking through the feasibility of your designs related to the reality of
construction techniques, you will facilitate greater coordination among the
trades, while ensuring a more successful project overall.

Construction Drawings

Construction drawings, as the name implies, are drawings that reflect differ-
ent aspects of the design and include details that support the appropriate
construction of each aspect. Each design and consulting field associated with
a structure will create some type of construction drawings that will be in-
cluded in the complete construction drawing packet. These may include site
plans; foundation plans; structural plans; mechanical, electrical, and plumb-
ing plans; window and door elevations with schedules; and construction sec-
tions. Interior design decisions and drawings must coordinate exactly with

drawings from other design team members. Following are some common construction drawings produced by interior designers:

- Dimensioned partition plans
- Demolition plans
- Reflected ceiling plans
- Electrical and data placement plans
- Lighting plans
- Finish plans
- Furniture installation plans
- Sections and elevations
- Fabrication details for custom items such as furniture, cabinetry, etc.
- Other drawings as needed

Construction drawing packets are bound sets of drawings that include all illustrations needed to build a project. A cover page identifies the client and project, the design professionals working on the job, and the consultants included in the project. Drawings are organized according to their application, and each drawing has a title block that includes the client and project information, dates of production and revisions, designers, and page numbers. Drawing formats are consistent throughout the packet, but may change from design firm to design firm. Today drawings are typically created using computer-aided drawing software such as AutoCAD and may be reproduced as many times as needed without compromising the quality. Computer drafting software also allows for greater ease of coordination between drawings. By using different layers for specific design elements, designers recognize potential conflicts immediately, allowing them to implement more coordinated design decisions. Some drawing packets for simple projects may include only four to six pages. Other packets for large, multifloor commercial projects could include 100 pages or more. Page count is secondary, though, to the production of drawings that are clear and easy to read.

Demolition plans and dimensioned partition plans provide the basis for wall placement. Demolition plans are used for projects in existing spaces where walls and other existing elements must be removed prior to construction. Standard symbols indicate items to be removed and items that will remain (e.g., walls, cabinets, electrical and data outlets, finishes, lighting, and other "attached" items). If a portion of an element is to remain, instructions regarding the finishing of exposed elements must also be included. For example, if part of an existing wall is to be removed, the demolition plan will

Through the use of standard symbols, designers communicate the details of how to construct their designs.

indicate the exact measurement of the portion to be removed and the method of finishing the "raw" edge of the remaining wall. Dimensioned partition plans show new walls and constructed elements to be added. Each element must include dimensions to provide contractors with exact measurements to correctly locate and construct the component. Including appropriate dimensions is important. You will need practice to be able to provide enough detail without overwhelming the drawing and the contractor!

Reflected ceiling plans show all construction and treatments on the ceiling plane. They are produced on a plan showing the footprint of the building, but indicate only elements that occur on the ceiling plane or touch the ceiling plane, such as partitions. Ceiling materials and finishes are indicated using standard symbols, and specifications are provided appropriately. Lighting installed within the ceiling will appear both on the reflected ceiling plan and the lighting plan. Specialty ceiling treatments such as cove lighting or tray ceilings may need additional detail drawings to clarify the specifics of the design. Depending on the complexity of the design, it may be necessary to dimension placement of some elements to provide information for correct installation.

Electrical and data placement and lighting plans may be included on one plan or separated into individual plans for each. Typically they appear as separate drawings when the project is large or complex and when including information about both on the same plan would create confusion. Electrical and data placement plans show the placement of outlets, switches, and other power and communication components as they relate to the partitions and floor. Mounting heights of each item must be indicated. Wiring plans and detailed specifications are generally done by an electrical engineer, communications specialist, or a combination of both. Lighting plans show all installed and freestanding lighting throughout the space and typically include specifications for each fixture. Dimensions are generally included for outlet and switch placement as well as fixture placement to ensure the correct positioning of each component. Detailed specifications are shown in a schedule placed on the same drawing or a page adjacent to the drawing in the packet, and/or included in the project manual.

Finish plans are created to provide placement and specification information for all interior finishes to be applied to surfaces. These may include floor coverings, paint, wallcoverings, ceiling finishes, and the application of any other finish designed to enhance the space. Finish plans are generated on undimensioned partition plans and include a finish schedule and legend to clarify the placement of each finish. Formats for finish plans may differ based on the size and complexity of the project, but it is vital that the designer choose a format that provides clear, unquestionable information for finish applications to avoid confusion during construction.

Furniture installation plans, like finish plans, are produced on undimensioned partition plans and show the placement and specifications of all furniture to be installed in the space. Although furniture installation plans are often included in the complete drawing set, design professionals, sales representatives, and furniture installers use them more often than construction contractors do. Providing the information, however, does allow for an additional level of coordination between furniture placement and construction elements. Each piece of furniture in an installation plan must be given a symbol that coordinates with the specifications provided. This allows installers to place the correct furniture piece in the appropriate location without having to consult the designer each time a piece of furniture is delivered. Furniture installation plans can range from very simple (e.g., a small reception area with a reception desk, swivel/tilt chair, and two guest chairs) to a large, complex panel system plan that includes specifications and placement for each component of the system. As with the finish plans, choose a scale and format that allows you to provide clear and precise information for ordering and installing.

Designers often use rendered elevations and sections during presentations to help clients understand the designs more fully. These orthographic drawings are also used to provide construction information not readily available in plan views of the space. They are not rendered as they might be for formal presentations, however. Construction elevations often occur when design details have been included on a vertical plane, and information must be provided that may not be clearly indicated on a plan. These details may include custom cabinetry, detailed molding, or a specialized finish treatment on a wall. Construction sections are generally produced when a construction element such as cabinetry is planned for installation on a vertical surface and details of the interior of the element and methods of attachment to a wall are important. Elevations and sections often include finish information, hardware specifications, and/or specifications of other items that must be purchased. They may include dimensions and may be produced in a somewhat larger scale than the base plans if necessary to provide more detailed information. Construction elevations and sections are also necessary when designing the types of custom elements that will be discussed in the following paragraph.

Designers often include custom work in their designs to provide a unique look or solution to a client's needs. Custom pieces may include desks, tables, cabinetry, shelving, display areas, and a multitude of other articles that are not available commercially. For custom work the designer must produce accurate, detailed drawings that give the fabricator sufficient information to create the custom piece. Detailed drawings are often a set of views including plans, isometrics, elevations, and sections, each coordinated and

referenced to other drawings to provide a coherent package of information. They are normally drawn in a larger scale to allow for the inclusion of more detail and require an understanding of construction methods to correctly represent the designs. As with construction elevations and sections, materials indications, finish methods, and hardware specifications are generally included. Designers provide these drawings to fabricators, who in turn may produce shop drawings showing final details of construction methods, structural components, and finish details for approval.

Some projects require additional drawings to communicate information not available on the drawings discussed earlier. These could include axonometric drawings, signage placement drawings, and details for special needs. Just remember that all drawings must be clear, easy to read, and fully coordinated with all other drawings in the design package. Minimizing questions, conflicts, and confusion is your goal, and a carefully produced drawing packet can go a long way in the achievement of this goal.

Project Manual

Project manuals are the second part of a construction document set. They are bound notebooks containing narrative information that is supplemental to visual information provided in the drawing packet. They serve important roles in two phases of the project. First, they provide detailed information needed by contractors to bid for the project. Contractors review information given in the drawing packet and project manual and estimate construction costs for the project. These costs are submitted to the client, and the most appropriate (not necessarily the lowest) bid is accepted. Project manuals also serve as reference documents throughout the construction of the project. They include information that is directly related to not only specifications of the project, but also to the quality, budget, and schedule of the project.

Project manuals may not be compiled for smaller, more residentially focused projects, but are necessary for all public projects and larger private commercial projects to provide necessary information regarding bidding, contracts, and expectations. Information contained in project manuals is legally binding and is awarded the same priority as information contained in the drawing packet. This means that close coordination is necessary to ensure consistent information between the drawing packet and project manual. The format of project manuals may vary, but the content remains fairly consistent.

Section 1 of the project manual typically addresses information on bidding requirements that must be followed to be chosen to participate in the project. Typically, this section applies to contractors building the space, but

may also apply to suppliers or consultants. The "invitation to bid" letter outlines the project and provides an overall description of requirements. Any instructions provided to potential bidders are included in this section, as well as all information available about the project and any required forms to use for bidding. Contractors must carefully read this section to ensure that they are meeting all of the administrative requirements identified before they submit a bid for the project.

Section 2 provides any supplementary information needed to clarify the bidding forms. Some companies provide lists of approved subcontractors that are cleared to work on the project, and the general contractor must choose workers from the given list. Section 2 also outlines the requirements for ensuring the security of the bid. In other words, when the contractor is chosen, they have an obligation to take the project; this section outlines any consequences for refusing the job.

Section 3 includes contracts, bonds, and insurance certificates required to perform the work identified. Contracts with terms of agreement are a crucial component of this section. (Contracts were discussed in detail in Chapter 8; review information provided in that chapter for clarification of any questions.) Contractors must also provide legal documents, typically called performance bonds, ensuring that the work will be completed as bid. In addition to performance bonds, contractors must also ensure that they will pay the workers and materials suppliers. These are labor and materials bonds, and all bond requirements are included in Section 3 of the project manual. Finally, Section 3 includes certificates of insurance required to confirm that the contractor has sufficient insurance of the appropriate type to cover any liabilities that may be incurred during the construction process.

Section 4 identifies "conditions of the contract," including additional information related to the project or agreement. This section is extremely important, is typically written specifically for a particular job, and deals with conditions unique to the project. Primarily the duties, rights, and responsibilities of the owner, contractor, and design professionals are outlined in detail to avoid any misunderstanding about expectations. The Uniform Commercial Code (UCC) is often referenced, providing standards for buying and selling materials related to the project. Information about the quality of workmanship; schedules; specifics of installing materials, furniture, fixtures, and equipment (FF&E); and payments are also delineated in Section 4.

Section 5 includes instructions for handling any changes required after construction has begun (change orders); methods of protecting people and property during construction; and responsibilities for uncovering and correcting work performed unacceptably. This final section exclusively addresses the specifications for the project (Ballast, 2006).

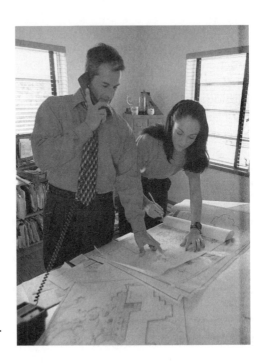

Editing a drawing packet.

Specifications

We know that specifications (specs) are written descriptions that communicate the details of project requirements and are found in the project manual. Some specifications may be included in the drawing packet, but a comprehensive collection of specs for the entire project is included in Section 5 of the project manual. The project manual includes specifications for elements such as materials, equipment, construction systems, and quality of workmanship, but interior design specifications address only a portion of these topics. Interior designers generally provide specifications for materials, finishes, furniture, and equipment. They may also address specifications for the quality of workmanship as they relate to the installation and application of interior components. Chapter 9 addressed the writing of specifications, but we will briefly review here the types of specifications that may be included in Section 5 of the project manual.

There are two general categories of specifications: prescriptive specifications and performance specifications. Each has advantages and shortcomings, and the type of specification chosen should be carefully considered in relation to your needs before making final decisions.

Prescriptive specifications are very restrictive and allow the designer a great deal of control over elements within the space. The most common

prescriptive specification is the proprietary spec. Designers provide specific names of brands, manufacturers, models, and finishes for proprietary specs, and the contractor or supplier must provide that exact product for the project. These specs are typically considered "closed," meaning that there is no latitude for options or substitutions of products or materials. A less stringent prescriptive specification is the base bid spec, which calls out a proprietary specification, but allows for acceptable substitutions to be suggested by the contractor or supplier.

Performance specifications are considered "open" because the contractors and suppliers have a great deal of autonomy regarding the specific products used. Specifications detail the expected product performance, construction methods, construction materials, installation requirements, and/or operation, and suppliers can provide any product that meets the requirements. These specs are typically long, are more difficult to write, and require a comprehensive understanding of product performance and construction to write them correctly. Performance specifications called reference specs may also reference accepted standards such as the American Society for Testing & Materials (ASTM) and the Underwriters Laboratory (UL) to ensure that appropriate standards are met (McGowan & Kruse, 2005).

Some specifications are used in multiple projects, making recreating them for each project an inefficient use of designers' time. As a result, firms often use prewritten specifications for items they use often. There are three common sources of prewritten specifications, and designers must determine which source is the most appropriate for their needs. Some commercial products contain a variety of performance and reference specifications. MasterSpec is a well-recognized package that provides exceptional specification formats for most products used in the interior design profession. You can find additional information about this product at www.arcomnet .com/visitor/masterspec/ms.html. If commercial specification formats are not suitable, many firms create their own specification libraries that are used by all designers and specification writers within the company. Specification libraries are found quite frequently in firms that concentrate on one or two types of design that require special expertise (e.g., medical facilities). Finally, some companies prefer to hire consultants to write specifications tailored exclusively to specific projects. This allows for a great deal of control over the specification writing, but does not require the designers to move their attention from design to detailed specification writing in the middle of a project.

Choosing appropriate specification formats and writing appropriate and coordinated specs is a vital component of the success of any design project. Paying careful attention to the details, coordinating written specifications with the information provided in the drawing package, and ensuring

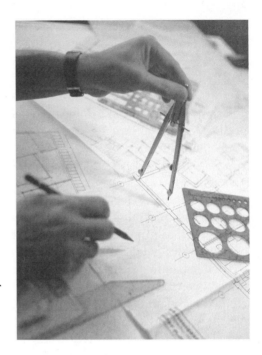

Coordinating written specifications with the information provided in the drawings is critical. Sufficient time must be dedicated to this phase of the design.

that specifications are included for each element needed are critical, and sufficient time must be dedicated to this phase of the design process.

MANAGING THE DESIGN FOR CONSTRUCTION

Designers frequently have responsibilities beyond the actual design of the space. They may be involved in the administrative management of the project from the beginning, or they may be responsible for monitoring the construction and coordinating the installation of materials once the design is complete. Responsibilities will vary according to the level of the management required and the point at which the designer or project manager enters into the project activities.

As discussed in Chapter 3, some firms engage a project manager to oversee the project from its start, but others rely on members of the design team to make sure the project is completed as planned. Project managers may be associated with construction companies or with the design firm responsible for the project. Still others are outside consultants hired on a job-by-job basis to run specific projects. The contract identifies the scope of

the designer's and project manager's duties for each project. Designers need to be prepared, however, to generally watch over the final phases of their projects, even if project management does not fall under their contractual obligations.

Overall Coordination of Project Activities

Because the primary responsibility of the person managing the project is to coordinate all aspects of the work and to ensure that schedules are met, budgets are followed, and the completed project is satisfactory to all parties involved, interior project managers must have a comprehensive understanding of all key phases of the project. Interiors projects must be coordinated with any exterior or new construction because much of the sequencing for the interior is based on the completion of the design and the construction of the overall structure. Following are some of the most common activities that the interiors project manager may be responsible for:

- Creation of an overall schedule for the interiors portion of the project
- Creation and continual monitoring of budgets, ensuring that bills are processed promptly, and reviewing bills to guarantee that work has been completed as described
- Coordination of interior construction with base building construction (must complete certain elements of new construction such as structural components, exterior walls, installation of windows and weatherproofing the building before interior construction can begin—if one contractor is handling all work, coordination will not be an issue)
- Continually reviewing plans in relation to construction to ensure a match
- Conducting meetings regarding interior issues as they relate to other building and construction issues
- Reviewing change orders and monitoring their effects on the budget and schedule
- Coordinating deliveries of furniture, equipment, and accessories with construction
- Arranging for the use of loading docks, elevators, and possibly surrounding roadways to unload trucks carrying products
- Preparing storage and staging areas for delivered materials if needed
- Scheduling furniture and equipment installation in relation to the construction schedule

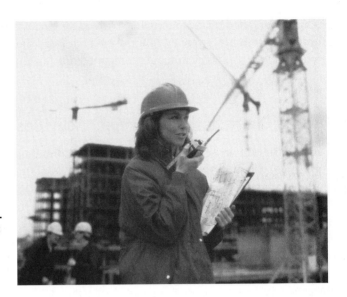

Project managers must continually review plans in relation to construction to ensure a match.

- Coordinating with electricians and telephone installers to have outlets installed in concert with furniture delivery if necessary (as in the case of many panel systems, electricians may be needed to hardwire the power from the building to the panels)

- Working with clients to orchestrate or administer moves of employees into the space upon completion

- Ensuring that all debris (boxes, trash, etc.) is removed after installations

- Reviewing the completed project prior to move-in to create a "punch list" of items that need to be corrected, cleaned, completed, or repaired

- A multitude of other responsibilities that relate to different portions of any interiors project!

Designers and project managers responsible for managing interiors projects work with a variety of professionals to coordinate and synchronize the phases of a project. These professionals may include other designers, consultants, construction managers, developers, contractors and subcontractors, and sales representatives. Establishing good working relationships with each of these professionals and understanding the work to be completed is essential to the success of any person with project management responsibilities. High levels of organization, attention to details, and strong decision-making skills are critical to project managers success. They must understand what is happening at all times for each phase of the project. Because of the expertise level required for this position, project managers generally have

several years of experience in the design, construction, or project management field before they are assigned to manage large projects.

Contract Responsibilities

Contracts provide a legal agreement among design professionals, clients, contractors, and other consultants needed on projects. The types of contracts customary in design projects were discussed in Chapter 8. A person with project management responsibilities must be familiar with all sections of the contract and the responsibilities identified for each party. It is not necessarily the project manager's duty to enforce the contract and supervise each party's activities, but it is important that she understand what people are supposed to accomplish and can communicate with each person to maintain an overall view of the project at any given time.

A professional managing an interiors project may be involved in the project from the beginning and participate in the initial awarding of contracts for construction, furniture, and equipment. This can be helpful because familiarity with specific contractual agreements and the history of the project adds continuity to decisions and approaches. The manager may have input into the request for proposals submitted to contractors and can exert influence regarding information provided in the project manual and instructions for bidding. Project managers have many responsibilities; however, it is important to remember that they are not responsible for the "means, methods, techniques, or procedures" of construction. Rather, they should be aware of the design and level of quality regarding the construction and installation required by the contract to ensure that the final product meets the contractual expectations.

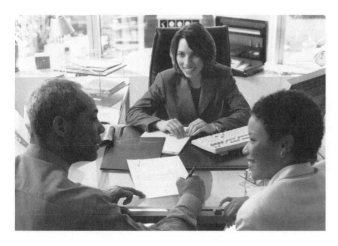

Contracts provide a legal agreement among design professionals, clients, contractors, and other consultants.

Identifying Project Schedules

Determining the schedule of a project and keeping activities aligned with the schedule are some of the most important elements in successfully managing a project. The design team leader, project manager, or principal of the firm generally takes the lead in establishing the design schedule; contractors determine the construction schedule; and the client ultimately determines the completion date. The professional responsible for the overall management of the administrative elements of the project (often the design team leader or a project manager) is responsible for blending all of the schedules into one coherent, workable schedule that meets the client's needs.

Scheduling the time required to design a project takes experience, an understanding of the design process, and knowledge about the people participating in the design. Many methods are used to establish a schedule. A common approach is based on the traditional sequencing of a project and is organized based on the phases of work identified by the contract.

The person in charge of scheduling begins by reviewing the scope of the work as defined by the client (e.g., a small interior renovation of an existing structure, or a 50-story, newly constructed high-rise structure). Then the schedule is broken down by the phases of work required. The people assigned to the project are then identified, and the scheduler reviews their levels of expertise. Less experienced team members often need more time to

A project management team examining the scope of work to determine a schedule.

produce than seasoned professionals with experience do. An estimate of the amount of time needed to produce each phase of work is then established. The scheduler must also take into account time for client presentations and approvals, because client review times can affect the schedule significantly. It is a good idea to establish a maximum time limit for client approvals and communicate that limit clearly to the client representative to keep a project on track. Time must be included for postoccupancy evaluations and wrap-up activities, even though they may not affect the client move date. Human resources must be allocated in the design firm to perform these tasks, and the hours must be scheduled to avoid conflicts.

In addition to design time, project schedulers must calculate delivery times, often called lead times, for all furniture, fixtures, equipment, window treatments, and specialty finishes. Lead times can drastically affect a schedule because some items require two to four months to produce. Fabrication times for custom work must also be calculated into the schedule, and the scheduler must often consult the fabricator (possibly a carpenter, fiber artist, or carpet designer) to obtain a reasonable amount of time to include in the schedule. Because the client's requirements for move-in dates guide the overall time available for the project, negotiations or substitutions may be required to facilitate an acceptable schedule.

Construction schedules are a major portion of the scheduling activity and are typically provided by the contractor. Other factors that may affect project scheduling include holidays, building plan reviews and construction inspections, weather, client requirements (e.g., relocation into a new school facility must take place during the summer months to avoid disruption of classes), and other unforeseen challenges that may arise during the course of the project. The design schedule, construction schedule, and delivery schedules must be coordinated and approved in relation to the identified completion date.

All schedules were created by hand in the past and required immense effort to formulate. Today many computer software programs are available to aid in project scheduling and monitoring the schedule on a daily basis. Computer scheduling still requires effort, however, because the scheduler must identify all of the activities associated with the project and estimate an approximate duration in order to enter them into the scheduling program. Computer-based aids are available to assist the scheduler, but ultimately the responsibility lies with the scheduler. Once the information is entered into the program, it can be displayed in a variety of formats, depending on how the data has been entered or organized.

The most common scheduling format used today is a bar chart, sometimes called a Gantt chart. This format provides basic information about activities and the times required for each. It is relatively simple,

straightforward, and easy to update. The Gantt chart does not, however, show any relationships between activities, which could cause challenges in larger, more complex projects.

A scheduling method often used for multifaceted projects is the critical path method (CPM). This method shows relationships between specific activities and is based on the identification and scheduling of activities identified as "critical" to the project. These critical activities drive the schedule and often determine the length of time required for certain phases of work. Because of the complexity of the CPM, it is rarely used without computer support.

Whatever format or method of scheduling is used on any project, it is necessary to update the information constantly to provide a current view of the schedule at all times. Projects can fall behind schedule quickly, and it is the responsibility of the person managing the job to find the cause, determine a solution, and get the job back on track immediately. Time is money in design and construction, so keeping a project on schedule will also aid in keeping it within the established budget.

Estimating Project Budgets

In most projects the client determines a preliminary budget prior to engaging a design firm. Sometimes design firms or consultants are included in the planning phase to assist in the creation of a realistic budget figure based on the scope of work the client requires, but often this is not the case. If, upon evaluating a budget and scope of work provided by a client, a firm determines that the project is not feasible, it is the firm's responsibility to inform the client that without significant changes, the project cannot be completed as identified. The budget and schedule are closely interrelated, and a change in one almost certainly signals a change in the other. A project budget must include information from the project schedule, so ideally they should be created simultaneously.

We discussed several fee structures in Chapter 8. Based on the contractual agreement, design fees must be determined as a part of the project budget. Many firms set a standard hourly fee for each position (e.g., design director, CAD operator, designer, etc.), and coordinating the scheduled hours per position with the hourly fees charged for that position provides an approximation of fees required for the design. For example, if the schedule identifies that it will take approximately 240 hours of CAD time to produce all of the drawings necessary for a project, and the firm charges $50 per hour for a CAD operator, the budget should reflect $12,000 for CAD activities. These calculations are repeated for each person or position identified in the schedule. Consultants hired by the design firm such as commercial kitchen

consultants or acoustic consultants must also be included in the budget figure. Budgeting for each phase of the work, including the postoccupancy evaluation and wrap-up activities, is important. Including a budget figure for the administrative elements of a project is also crucial. If a project manager is hired, her salary should be included; if a designer is managing the project, an appropriate number of hours should be included in the budget to allow him to perform the job adequately.

Projecting a budget for construction, finishes, furniture, and fixtures can be a bit intimidating, but experience and research will help to ensure that appropriate funds are estimated. Client expectations regarding quality of work and products will also provide useful information to determine whether high-end or budget-level products will be used. Identifying any discounts available on materials or additional charges for specialty items will also be helpful when creating the initial budget. Clients may have a single budget for the entire project, or they may have a design and construction budget with a separate furniture and fixtures budget. You must be clear about their allocations before beginning the project. Before submitting the final budget proposal, it is always a good idea to include some additional money as a contingency to cover the unexpected charges that will inevitably arise during the course of the project. Once the information is compiled and a preliminary budget is created and approved, the basis for the budget decisions must be shared with the design team to allow them to proceed in a suitable direction with design decisions.

The contractor will provide detailed construction costs in the bid, but the design team must also continually estimate general construction costs to ensure that their design decisions are reasonable in light of the given budget. Estimating costs for interior materials such as carpet, wallcoverings, window treatments, specialty finishes, and other installed elements throughout the design process will also facilitate appropriate design decisions related to dollars required.

Making a Profit from the Project

Design firms must not only bring in enough money to cover their daily expenses, but they must also make a profit to stay in business for the long term. When you begin to discuss fees with potential clients, you must be confident that the money charged is reasonable. To foster that confidence, you must understand where the money goes. Junior designers are often confused (and sometimes annoyed!) when they learn that the hourly fees charged to clients for their time are exceedingly higher than their actual hourly pay. Fees charged for each position include not only the salary for the person performing the work, but also overhead and profit to keep the

firm in business. Although we briefly covered overhead and profit in Chapter 8, the concept is very important to the success of the firm and bears a little review.

Overhead includes all of the components that allow a company to perform its day-to-day activities. These include rent or mortgage on the office space, equipment, supplies, and furniture. Salaries for all design professionals, marketing specialists, and principals are included in the overhead of a firm as well as salaries for support personnel such as secretaries, receptionists, administrative assistants, and interns. Firms often provide benefits to their employees that may include health insurance, paid vacation time, or educational opportunities; these are also considered part of the overhead of the company. Marketing expenses are also included in overhead. Firms must create marketing packages for many potential projects, allocating personnel and financial resources to generate the marketing presentation. Because firms are not hired for every project, successful projects must also cover the expenses associated with unsuccessful project proposals.

The profit is the money left after all salaries are paid, benefits are provided, overhead is covered, and all other expenses of operating the firm are handled. Depending on the firm, some profits may be shared with the employees in good years through a profit-sharing program, which may be considered another part of an employee's benefit package. The economy of this country moves through cycles, and firms that survive many years will experience times when work is plentiful and times when work is almost nonexistent. Some percentage of the profits should always be saved to help keep the business solvent and able to pay bills and salaries during times when projects are not as plentiful. Although you will most likely not become involved in the financial end of your employer's company until later in your career, it is important to understand your role in contributing to the company's long-term success.

EVALUATING THE DESIGN AFTER CONSTRUCTION

The postoccupancy evaluation (POE) is one of the most valuable tools in the design process to help designers learn from their design decisions. A postoccupancy evaluation is an assessment of your project once the construction, installation, and move-in are complete. Designers return to the site to determine what final issues need to be addressed and to assess the overall success of the space based on clients' and users' reactions. POEs

are conducted using a variety of methods, and you must choose and budget for the most appropriate method for your project and client.

Providing client satisfaction is one of your main goals, and the only way you will ever find out whether they are satisfied is by asking! This can be a bit scary, especially to a new designer, because the users of the space will in all likelihood have both positive and negative comments about the space. Accept the positive statements as validation of your design abilities, and look at the negative comments as opportunities to learn and grow in your design decisions. Sometimes the negative comments are a result of decisions that were out of your control. At times, though, you can gather enough information about the challenges identified to allow you to modify some design decisions and increase the users' satisfaction with the space.

The initial POE is generally scheduled soon after the client group moves into the space—often about two weeks after the move. This timing allows the users to be somewhat settled after the move, but allows you to quickly clean up any small problems that may have occurred during the move or design decisions that need to be tweaked. Most designers have an opportunity to conduct only one (often brief) POE for their projects. Ideally, returning to the site at regular intervals of 6 to 12 months allows you to evaluate the success of your design decisions on a long-term basis. Some clients require more long-term, detailed evaluations, but this is rarely the case in today's market.

Many methods are appropriate for conducting postoccupancy evaluations. A common method is written surveys distributed to the users of the space asking about their impressions of, reactions to, and concerns about the new space. Although this method allows you to collect information from a greater number of people, it does take some of the personal contact out of the evaluation, potentially compromising your opportunity to help people understand the space more clearly and feel better about their change in environment. Another relatively common method includes interviews with individual workers, allowing for a greater amount of personal contact, but reducing the number of people contacted because of the time involved. Combination methods using surveys, interviews, and observation of people using the spaces are often the most successful. This combination helps you maximize the number of responses with surveys, attend to people with specific concerns in the interviews, and personally observe how the users interact with the space.

Appropriate questions for a POE will be determined by the specifics of the project, but some areas of concern to address include the following:

- Aesthetics—overall impression of the space, colors, "feel"
- Inherent logic of the spatial organization—does the relationship between spaces make sense?

- Flow of the traffic within the space—is it easy for people to get to the spaces they must use during the day?

- Functionality of the design—does the design of the space support the activities users must perform in the space?

- Ergonomic considerations—were individual needs met?

- Physical comfort—is this a physically comfortable environment (temperature, lighting, noise)?

- Access to natural light

- Appropriateness of furniture—does the furniture specified support the activities within the space, and is it well placed to support the occupants?

- Do any elements need to be changed, eliminated, or added to make your interaction with the environment easier or more effective?

The POE should be included in the contract document as a part of the design process, and the level of assessment detail should be identified. Designers must budget time at the end of a project for this evaluation activity and include that time in the initial design budget provided to the client. The POE is part of the design activities and should be contractually treated as such. Clients often require written reports outlining the results of the POE, but whether or not the report is a client requirement, you should record your evaluations and reflect on the success of your design decisions based on client responses. Future projects will be more successful if you regularly incorporate this practice into your personal design process.

BRINGING THE PROJECT TO A CLOSE

The postoccupancy evaluation marks the beginning of the end of your project. Bringing a project to a close is a critical phase of the project, and surprisingly many designers do a relatively insufficient job of closing out projects. Wrap-up activities vary depending on the scope of the project, but may include compiling instruction, use, and care manuals for furniture, finishes, and equipment; writing POE reports; evaluating the internal and external team process with debriefing activities; and closing out accounting paperwork related to budget and purchasing activities. More personal wrap-up activities may include saying farewell to colleagues you have worked closely with for extended periods of time and sending thank-you notes to people who have been especially helpful through the project.

There are many reasons we do a better job keeping projects open than bringing them to closure. As designers, we often look at continuing possibilities and believe that if we keep a project open we will still have opportunities to improve the design in the future. Projects may also be long-term ventures, and in the process we become connected to the clients, consultants, and other team members associated with the project. Closing a project means significantly changing those associations, and this can be difficult on a personal level. Another reason for avoiding closing the project is fear. Related to our quest for "continuing possibilities," we can also become afraid that if a project is finalized, there will be things left undone or forgotten, and we won't have an opportunity to address and correct the situation. Finally, activities related to closing out a project can seem boring and tedious compared to moving on to a new, more exciting project with a new team.

To successfully finalize your project, you should have a plan in place from the beginning. Treat the wrap-up like a mini-project and assign a schedule and budget to it as you do every other phase of the design process. Establishing a structure at the beginning of the project will help you avoid the temptation to "move on" at the end of the project without performing the important wrap-up activities. Determine a deadline for completing all wrap-up activities, and work to the deadline as you would in any other design phase. When the activities are complete, you may want to have a more personal wrap-up by conducting some sort of closure activity such as taking pictures of the project participants, having a team dinner, or writing a personal reflection of the lessons you learned during the project. However you structure the completion of the project, be sure you do it! Without finishing all of the details and closing the files, you will constantly be drawn back into the project, generally with a very unhappy client, to finish the things you failed to complete.

SUMMARY

The final section of this book—Chapters 8, 9, and 10—presented information to you as a new graduate about professional responsibilities you will encounter in your first years in the design field. Chapter 8 discussed elements associated with starting a new company, finding clients, marketing services, and securing a project. Chapter 9 continued the discussion about project responsibilities, most specifically associated with the actual design of the project and working with the client during the design process to ensure satisfaction. Finally, Chapter 10 provided some insight into your continued project activities upon completion of the design

phases. Following the project through construction and postoccupancy evaluation helps you have a greater understanding of the direct impact of your design decisions on the final product. Recognizing the importance of correct budgeting and scheduling and the components of each of these extremely important activities also gives you a greater appreciation for the business aspects of your designs and your individual influence on a company's ability to become and remain successful. Information from these three chapters provides a snapshot of the breadth of your responsibilities, but is in no way comprehensive. Our hope is that the chapters give you a professional starting point you can embrace with confidence, and that you will move forward from there to become an experienced, self-assured interior design professional.

ACTIVITY

Contact a recent graduate of your interior design program and ask to conduct an informational interview at his or her convenience either face to face or over the phone. Using the information in Chapters 8, 9, and 10, create a list of questions about the person's activities and responsibilities as a new professional. Take extensive notes during the interview, and write a detailed narrative addressing what you learned. Don't forget to send a note thanking the designer for her or his time.

RESOURCES

Building Construction Illustrated (3rd ed.) by Francis D. K. Ching and Cassandra Adams (Hoboken, NJ: Wiley, 2000) ISBN: 0471358983.

Construction Drawings and Details for Interiors: Basic Skills by W. Otie Kilmer, Rosemary Kilmer, and Stephen Hanessian (Hoboken, NJ: Wiley, 2001) ISBN: 0471109533.

Interior Construction & Detailing for Designers and Architects (3rd ed.) by David Kent Ballast (Belmont, CA: Professional Publications, 2005) ISBN: 1591260329.

Interior Construction Documents by Katherine S. Ankerson (New York: Fairchild Books & Visuals, 2003) ISBN: 1563672545.

Interior Design Reference Manual: A Guide to the NCIDQ Exam (2nd ed.) by David Kent Ballast (Belmont, CA: Professional Publications, 2002) ISBN: 1888577746.

Learning from Our Buildings: A State of the Practice Summary of Post-Occupancy Evaluation by Federal Facilities Council (Washington, DC: National Academy Press, 2002) ISBN: 0309076110.

Post Occupancy Evaluation: www.postoccupancyevaluation.com/.

Specifying Interiors: A Guide to Construction and FF&E for Residential and Commercial Interiors Projects (2nd ed.) by Maryrose McGowan (Hoboken, NJ: Wiley, 2005) ISBN: 0471692611.

Understanding Construction Drawings, 4th edition, (Paperback) by Mark Huth (Clifton, Park, NY: Thomson Delmar Learning, 2009) ISBN: 0766815803.

This final profile celebrates the unlimited potential of careers in design as demonstrated by the life of Ingvar Kamprad, founder of the popular low-price home furnishings chain IKEA. Today, IKEA employs more than 84,000 worldwide, with over 205 stores in 32 countries. The company was named one of *Fortune*'s "100 Best Companies to Work For" in 2005 and was recognized by *Working Mother* magazine for two consecutive years among the "100 Best Companies for Working Mothers." Kamprad himself is periodically reported to be the richest man in the world, surpassing even Bill Gates. However, company representatives dispute that fact, citing the complex holding structure of the company stock.

The company has grown in size and stature over the years, relentlessly pursuing a simple and clearly stated mission "to provide a better everyday life." The IKEA business strategy is "to offer a wide range of home furnishings with good design and function at prices so low that as many people as possible will be able to afford them. And still have money left."

This decision to side with the many rather than the privileged few drives all business decisions. Rather than manufacture costly, fine furniture by traditional methods, IKEA has chosen to focus on elegantly simple solutions, smart production processes, low-cost global suppliers, and bulk purchasing. The company promotes a recognizable Swedish design aesthetic that is ever present, controlled from the macro rather than the micro level. Many, if not most, of IKEA products are compatible with each other. This allows the IKEA experience to be largely self-service, eliminating sales and service expenses.

Shipping and assembly expenses are reduced or eliminated by engineering the products for flat packing and self-assembly. Customers do not pay for anything they can do on their own.

Interestingly, this extraordinarily impressive commercial venture began prior to World War II with a young boy on a bicycle in Sweden selling matches to his

neighbors. The match route expanded to include other retail items that could be purchased and resold effectively, including pens, wallets, jewelry, and nylon stockings. Eventually, the route evolved into a mail-order catalogue with delivery by milk van to the local train station.

By the 1950s Kamprad had settled on locally manufactured furniture as his product line, discontinuing all other offerings. His decision to focus on low prices led competitors to pressure suppliers to boycott IKEA. It turned out to be a good thing. The company began designing its own furniture, which made it even more unique and competitive.

The rest is history. In 1999 the company won the coveted Red Dot award for Highest Design Quality for its Värde kitchen. Together with UNICEF, IKEA is currently working with 200 rural communities in India to improve the status of women and children with regard to workforce issues. Ingvar Kamprad continues to drive a venerable Volvo and maintain a modest lifestyle.

Career Planning
You've Only Just Begun

11

> We are what we repeatedly do. Excellence, then, is not an act but a habit.
> —Aristotle

Objectives

After studying this chapter, you should be able to:

* Explore future possibilities and begin planning for career choices beyond the entry level.

* Investigate the NCIDQ, looking at reasons for taking the exam as well as methods of preparation.

* Describe the benefits professional organizations offer to you professionally and personally.

* Consider your professional responsibilities regarding giving back to the community.

Each of the ten previous chapters provided a key in your overall package of self-discovery and investigation of potential career choices in the field of interior design. You have created a personal profile, investigated various professional directions, formulated your own self-marketing package, and explored the responsibilities you will face in your first professional endeavors. This final chapter takes a look at planning ahead, beyond your first couple of years of work, and discusses professional responsibilities we each have as committed, active interior design professionals.

PLAN AHEAD: MAKING A ROAD MAP FOR THE FUTURE

Much of the focus of this book has been on successfully reaching your first professional milestone: getting an interior design job that fits your unique characteristics and needs. You have explored your personal preferences and individual attributes and evaluated specific positions within the interior design industry to determine jobs that are most suited to you. You have created a self-marketing package that showcases your abilities and mastered interview skills that will show potential employers your proficiency in professional and social situations. You understand the responsibilities you will be expected to fulfill and your commitment to your firm and your clients. Now you can rest, right? Wrong!

Staying in control of your career path is essential. Your current priorities drive many of the decisions you are making at this point in your life. As you move through your life, your priorities will change, often making it necessary to make professional and personal changes as a result.

Planning Your Path While Staying Flexible

If you are like many newly graduated interior design professionals, you may have mixed feelings about your ultimate career goals. This is expected because your exposure to different positions and opportunities is generally limited to studio design projects, internships, and possibly some community service design work. This limited experience makes planning a lifelong path almost impossible upon graduation! But having a general idea about the directions you are interested in pursuing will help guide you in your

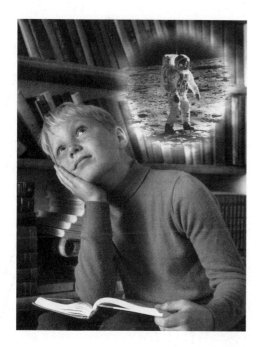

What is your dream job?

professional decisions while allowing you to learn about the multitude of options within this field.

A good exercise is to identify your dream job and identify all of the things you might need to know or the experiences you might need to have to feel confident that you could be successful in the position. Contact people who actually work in the position you would someday like to hold and ask them about their activities and responsibilities. Discuss your thoughts about the position, and ask for their recommendations about preparing yourself to ultimately occupy that job. Read articles and books that may give additional information. Once you have compiled a record of responsibilities and experiences needed, identify the responsibilities you currently have in your job and think about how they might help you achieve your ultimate position. What do you need to add to your current tasks to more fully prepare for your ultimate job? Consider asking for more opportunities to participate in specific types of projects, volunteering for additional responsibilities, or pursuing a different position altogether to place you on a more appropriate path.

The exercise outlined in the previous paragraph is only one way to approach your career path. If you can't currently identify a dream job, you may

take another approach by identifying all of the areas of design that interest you and make efforts to get experience in each of those areas. Or you may identify a design firm that you want to work for and target your experience to its needs and specialties. Maybe you want to work in a specific geographic area, and the type of position you hold is not as important as the location. In this case, your research revolves around companies with positions related to design in your chosen geographic area.

In addition to initially identifying your desired career path and basing decisions on that goal, it is important to periodically update your personal profile to determine changes in your goals, priorities, or life situations. Events such as marriage, the birth of a child, family illness, or dissatisfaction with physical or geographic environment may lead to personal changes. After the events in New York and Washington, D.C., on September 11, 2001, many people reevaluated their priorities. This reevaluation led many to decide that either the type of work in which they were engaged or the location of their job was no longer providing the satisfaction they needed in light of their perceived vulnerability and loss of safety. As a result, many relocated and took different positions that helped them feel more secure and balanced in their lives. Use your PRSM matrix as an ongoing tool, and regularly update it based on the changes in your life. Reflecting on your life and your work on a regular basis helps you manage your career and life decisions more closely. Consider updating your matrix once a year, maybe on your birthday, to take into account any new directions you may want to pursue.

Identifying your desired future career path.

Changing your mind and changing your job are perfectly acceptable alternatives to staying in a position that no longer meets your needs. When conditions of a job become negative and you are miserable, depressed, or anxious on a regular basis, your performance suffers and your quality of life is compromised. This is not a good situation for anyone. When you are not enjoying your life or your work, your family is concerned for your happiness and experiences your negative emotions, your coworkers are compromised because of your lack of passion and investment in the job, and your employer is not receiving the quality or quantity of work he or she deserves. You deserve better, and you can make that happen if you stay aware and in control of your career from the beginning.

Keeping Your Self-Marketing Package Current

Once you have a position, you may be tempted to let your portfolio, resume, and other self-marketing materials go untouched for years. You may be thinking, "I don't have time to spend updating documents that I may never use again. My job keeps me so busy I can't even think about my portfolio or resume!" This is a typical thought of new designers, and in many cases, they are correct. There is very little time for anything that is not directly related to their job! Accepting this thought, however, is a mistake and will often lead to either negative consequences or late night hours in the years to come. Keeping updated visual and written records of your accomplishments is important for many reasons. These records can provide you with a road map of your professional career. They show your project history, as well as verify the progression of responsibility throughout your career. More than a visual and written record for your own personal use, regularly updated portfolios and resumes can be used at any time to apply for new, exciting, and more appropriate positions when they become available.

Resume Updates

A regularly updated resume provides a record of projects you have designed or with which you have been involved. It also ensures that your contact information is correct and documents that your responsibilities have changed and increased as your experience level expanded. Keep a record of your involvement in organizations, offices you held, and the impact you had on the group. In your busy life, it is easy to forget many of your achievements, both professional and personal. Use your resume as a sort of ongoing record of your ever-growing repertoire of expertise. You may not choose to include all

of the information you recorded when you create an updated version to submit to a new prospective employer, but by regularly noting your accomplishments and activities, you will have complete and detailed records from which to draw your new professional resume.

Portfolio Updates

Like your resume, your portfolio should be updated at the completion of each project. Design firms often have projects professionally photographed, and it is reasonable to request copies of the photos for your portfolio. The design firm retains "ownership" of the design, but if you created the design or were involved with the team that designed the space, you should also have the right to include images of the project in your portfolio. It is a good idea to check with your design director or supervisor early about your company's policy regarding designers' access to project images to avoid conflicts at the end of a project. You may also need to check with clients to obtain permission to photograph their spaces. Negotiations regarding photographing a finished design are often undertaken at the contract stage before any design work has been completed. Many companies have strict policies about images of their offices, manufacturing plants, or other facilities. These policies may be tied to security issues, regulatory issues, or privacy issues and must be respected. For all projects you have worked on and wish to display in your portfolio, be clear about restrictions imposed by clients and uphold your responsibility to your client as a professional. At times, however, you may need to stand firm about your rights to display images of designs that you helped to create, and you should negotiate terms that work for you, your clients, and your firm.

NCIDQ—WHY BOTHER?

Chapter 2 briefly discussed the National Council for Interior Design Qualification (NCIDQ) exam and the importance of professional licensing and certification. The NCIDQ is the officially recognized professional exam for interior designers, and holding an NCIDQ certificate (after passing the exam) indicates that you can perform at or above the minimum competency level required for interior design professionals. This certification indicates to clients that they are hiring qualified professionals whose designs will protect the health, safety, and welfare of the public.

What to Expect

The NCIDQ exam is divided into three parts: two written sections and one design problem. The first written section has a time allotment of approximately three and a half hours and covers topics related to programming, schematic design, and design development. Three hours are provided for the second written exam section, which covers contract documents, contract administration, and professional practices. The final section is a design problem for a multiuse space and is scheduled for an entire day. The design problem requires that you analyze programming information and interpret it into a design solution, create a set of plans, and develop a set of specifications for the space.

The exam is rigorous, and to pass, you must maintain a high performance level in each section. Passing the exam is a signal to the general public that you can be trusted as a design professional, and you need to take this trust very seriously. Preparing for the exam is critical, and the time you spend collecting resources, reviewing information, and reflecting on your experience will be time well spent.

Preparing for the Exam

Most designers view passing the NCIDQ exam as a major milestone of their career and set a goal to take the exam as soon as they are eligible. Eligibility requirements for taking the exam include educational and work experience components and are described in detail on the NCIDQ website (www.ncidq.org). In summary, to take the exam, you must have graduated from an interior design program with no fewer than 120 semester hours, or 180 quarter hours, and have taken a minimum of 60 semester hours, or 90 quarter hours, of interior design–related courses. You must also have a minimum of 3,520 hours of work experience supervised by an experienced designer who is NCIDQ certified, is a registered designer, or is an architect who offers interior design services.

Because the exam is based on the practical application of the interior design body of knowledge, your work experience is an important component of your exam preparation. You must also spend time reviewing design resources you do not work with on a regular basis prior to taking the exam. Rarely will a designer's position allow him or her to practice all types of design in all situations covered by the exam. For example, if you work for a commercial firm and typically design contemporary office spaces, you may want to spend some time reviewing requirements for

Your work experience is an important
component of your exam preparation.

residential design, historic elements, and issues associated with other
types of commercial design such as hospitality, healthcare, and education.
Again, the NCIDQ website has many helpful resources that will guide you
in preparing for the exam.

Some professional organizations also provide study sessions or work-
shops that review practice problems and topics covered in past exams.
NCIDQ does not offer any specific support groups, nor does the organization
endorse any workshops available, but it is a good idea to check with your
local chapter of ASID, IIDA, or IDEC to see what support is available locally.
You may not choose to take advantage of the resource immediately, but
knowing that it is available may be helpful in the future.

How Does Passing the Exam Help You Professionally?

The professional benefits of NCIDQ certification range from minimal to over-
whelming. States that have certification or licensing requirements for interior
designers always include passing the NCIDQ as part of the legal require-
ments. In these states, sometimes the professional benefit is that you actually
get to practice! Other states may not restrict practice, but may restrict the use

of the title "interior designer." In these states, passing the exam gives you the right to call yourself an interior designer. Several states still do not have any certification, registration, or licensing acts related to interior designers; in these states the NCIDQ does not provide any state-based benefits.

Whether a state requires licensing or certification or has no legal guidelines for interior designers, passing the exam is still beneficial. The more we can voluntarily participate in testing and certification, even where it is not required, the more we can educate the public regarding the importance of hiring qualified designers who have passed the professional exam. This helps everyone as we strive to be fully recognized as professionals and continually raises the level of performance expected.

PROFESSIONAL ORGANIZATIONS AND YOU: BE AN ACTIVE MEMBER

Professional organizations are more than social clubs. Many of you may be a part of a student chapter of ASID or IIDA, so you are somewhat familiar with the goals of the organization and the support it can offer you as a new interior design professional. Membership in a professional organization should be a symbiotic relationship: You should support the organization with your time and effort, and the organization should support you professionally and personally. When the balance between giving and receiving is not equal, either you are not upholding your responsibility to the organization as a valuable member, or the organization is not performing its duty to assist you in becoming the best interior design professional possible. Evaluation of your commitment to the organization, and of the ability of the organization to provide appropriate support, is necessary if this lack of balance occurs.

Professional organizations provide many services, one of the most important of which is networking. We discussed the benefits of networking for the purpose of marketing our services in Chapter 8. The type of networking discussed in this chapter is a bit different and is often more beneficial from a professional development perspective, although there can be some benefits from a business standpoint too. People are often disturbed when they think of networking, perceiving it to be an insincere or phony way of using others for personal gain. Although some people do use networking in this manner, for the most part true networking is simply making friends and establishing relationships with other people who have similar interests. These relationships may provide professional opportunities but should also be enjoyable, interesting, and positive on a more personal level. Why would you want to spend time with someone who makes you feel uncomfortable

you want to spend time with someone who makes you feel uncomfortable just because he might be able to offer you a position in his firm? Wouldn't you feel equally uncomfortable (or maybe more so) if you were working for or with him? Establishing friendships with other designers provides opportunities for you to learn, share knowledge, explore common interests, and "talk the same language."

Professional organizations also provide concrete resources such as professional development classes, support for the professional exam, career guidance, research, conferences, trade shows, and business support. Many organizations establish a code of conduct or code of ethics that is adopted as a professional standard. Some offer practical resources such as liability and health insurance at reduced group rates. Professional groups may also become advocates for issues critical to the profession, or lobby local and national governments for the legal rights of members. When you join an organization, it is important to research the resources available so you can benefit fully from your membership. Many membership fees are seemingly high until you investigate the advantages organizational affiliation provides.

Professional organizations often have different levels of membership depending on your experience level, qualifications, and area of expertise. Professional memberships are typically reserved for designers who have passed the NCIDQ and can contribute their expertise to the organization at the highest level. Professional members are able to use the appellation of the organization behind their names (e.g., Marie Ward, ASID). Associate memberships are often for practicing professionals who have not yet taken the exam or wish to remain at a lesser level of membership. These members are able to vote and participate in all activities, but may not use the organization's letters after their names. Allied memberships in the design organizations are reserved for people working in the design industry who are not involved directly in design. These people may be in sales, manufacturing, distribution, or production. Finally, student memberships are specifically for students in design who want to participate in the organization and benefit from its resources, but have not yet begun to practice professionally. Chapter 2 identified many of the major organizations available to support interior designers as professionals and their definitions of an interior designer. The primary organizations for our profession are ASID, IIDA, IDC, and IDEC. Other groups exist for every conceivable specialty area within design, and some of those are also identified in Chapter 2.

▬ REFLECTION _____

Determine a particular interest you have in relation to design (e.g., color, environmental psychology, creativity, history). Try to locate an organization that concentrates on this topic.

Networking is establishing rela-
tionships with other people with
similar interests.

PHILANTHROPY: WHAT CAN YOU CONTRIBUTE TO THE WORLD?

As designers we have a unique ability to solve problems and contribute to the betterment of our world. We have a responsibility to contribute our visual sense and ability to change lives through the use of design, our professional work, and our personal activities. Philanthropy is the selfless giving of our personal resources. It is essential that we find outlets to contribute to that meet our individual needs and provide personal satisfaction.

Educating

The general public is still learning of the benefits and professional nature of interior designers. Contributing your knowledge through education aids your community in a greater appreciation of design and increases people's understanding of the importance of using qualified designers in their projects. Opportunities to share information with the public may come in the form of formal classes through a college or university, continuing education classes through community organizations, or presentations and talks to local organizations. Interactions with schoolchildren in K-12 initiatives provide opportunities to help them understand career options. If you decide to become involved in education about the profession as your philanthropic area, know that you have a great responsibility to act as a representative of and a voice for your profession.

Service Within the Profession

Many opportunities also exist for service within the interior design profession. Professional organizations have unending possibilities for involvement in a variety of committees, activities, and community service events. Becoming a leader in a professional organization provides an outlet for your leadership and problem-solving skills and allows you to become a very visible voice for the profession. Holding an office within your professional organization beyond a presidential leadership position also provides a chance to contribute your talents whether they be in financial (treasurer), journalistic (newsletters), or organizational areas (activities chairperson). Special events coordinators also contribute greatly and can add to the success of not only the event, but also the overall organization. Working as an advocate or lobbyist with governmental agencies gives you a chance to help further the profession from a licensing and certification standpoint. Many states are still in the process of fully defining interior design as a profession, and your voice may contribute greatly to the decisions made and their impact on local designers. Contributing your expertise to design organizations will help you develop more fully as a young designer and give you an outlet to play a part in the development of the next generation of design professionals as you grow older.

Volunteers raise a house frame while building a home for Habitat for Humanity.

Service Beyond the Profession

Opportunities for community service abound, offering you a multitude of choices for involvement and contribution. Regional and international projects always need willing people. Others choose to help closer to home and become involved in their children's school or community activities. Religious organizations meet the needs of many spiritual people who feel a calling to help others. Again, the experience you receive in your design profession increases your abilities in so many other areas. Staying involved with your children and their activities allows you to contribute not only to your community, but also to the quality of your children's lives. Local community service is another avenue of philanthropy. Giving your time and expertise to organizations such as Meals on Wheels, the Humane Society, or local elder care or child care facilities will give you a great sense of personal satisfaction and investment in your neighborhood.

Whatever venue you choose, always contribute to your profession and community in some way. You expect the people around you to support you and your employer by hiring you for their projects, so be sure they know you are willing to contribute personally as well as professionally to the community. In addition, design can be a very consuming profession, and giving yourself other outlets and activities helps you keep your life in balance.

SUMMARY

This book is about design. More specifically, it is about designing your life. Creating a comprehensive plan for the early years of your career, including strategies for landing your first design job, was the primary focus of Chapters 1 through 10. Chapter 11 took you beyond the first few professional years and encouraged you to formulate a plan and direction for your lifelong career. There will be twists and turns and sometimes abrupt stops along the way. But with a process in place and confidence that you can use the process to redirect yourself and continue to move forward in directions that work for you personally, you will always be successful. That is our wish for you.

This book is intended to help you create a compass for your life, not just professionally, but also personally. Our hope for you is that you have a happy life, a fulfilling career, and a wonderful balance between the two!

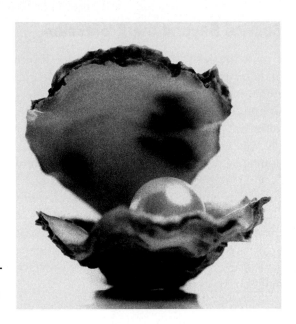

A happy life, a fulfilling career, and a wonderful balance between the two.

ACTIVITIES

Activity 1

Explore the NCIDQ website (www.ncidq.org) and create a list of resources that you want to collect that will help you prepare for the NCIDQ. Also, print out the format information and read through the topics covered in the written exam. Keep this narrative of topics handy and reread it periodically as you work with your projects. Now check to see whether the states in which you are interested in working have a certification or licensing legislation. What are the specific requirements to be certified or licensed in those states? Begin a notebook of information, references, and resources that will aid you in preparing for the exam.

Activity 2

Spend some time over the next week reading articles in your local newspaper. Based on your reading, create a philanthropic project you could propose to your local design group that would "give back" to the community. Explain thoroughly how their design expertise would be used and how the community would benefit.

References

Chapter 1

McDonough, W., & Braungart, M. (2002). *Cradle to cradle: Remaking the way we make things.* New York: North Point Press.

McFall, B. S. (2002). *Future promise: Designing Personal Resource Systems Management as a platform for quality of living and learning.* Ann Arbor, MI: UMI Dissertation Publishing/ProQuest Information and Learning.

McFall, B. S. (2006). *Qualities of Living: A platform for practice.* East Lansing, MI: Kappa Omicron Nu.

McFall, B. S., & Beacham, C. V. (2006). Ideal Design programming with photoethnographic data and systems analysis. *Journal of Interior Design, 31*(3), pp. 21–34.

McFall, B. S., Beacham, C. V., & Shambaugh, R. N. (2006). Personal Resource Systems Management (PRSM): Three co-ordinates for learner-centered technology development. *Educational Technology, 46*(2), pp. 39–42.

McFall, B. S., & Williams, S. (2004) Systems language for e-democracy: Personal Resource Systems Management (PRSM), a model and action research. *Systemic Practice and Action Research, 17*(4), pp. 40–52.

Random House Webster's College Dictionary. (1997). New York: Random House.

Chapter 2

Soanes, C., & Stevenson, A. (Eds.). (2004). *Concise Oxford English dictionary* (11th ed.). New York: Oxford University Press.

Chapter 4

Covey, S. R. (1989). *The seven habits of highly effective people: Powerful lessons in personal change.* New York: Simon and Schuster.

Csikszentmihalyi, M. (1990). *Flow: The psychology of optimal experience.* New York: Harper.

Foa, U. G., & Foa, E. B. (1974). *Societal structures of the mind.* Springfield, IL: Charles C. Thomas.

Kosko, B. (1993). *Fuzzy thinking: The new science of fuzzy logic.* New York: Hyperion.

Lindsley, D. H., Brass, D. J., & Thomas, J. B. (1995). Efficacy-performance spirals: A multilevel perspective. *The Academy of Management Review, 20*(3), 645–648.

McFall, B. S. (2002). *Future promise: Designing Personal Resource Systems Management as a platform for quality of living and learning.* Ann Arbor, MI: UMI Dissertation Publishing/ProQuest Information and Learning.

Vygotsky, L. (1978). *Mind in society: The development of higher psychological processes.* In M. Cole, V. John-Steiner, S. Scribner, & E. Souberman (Eds.). Cambridge, MA: Harvard University Press.

Chapter 5

American Society of Interior Designers (ASID). (2004). *Interior design profession: Facts and figures* (p.13). Washington, DC: American Society of Interior Designers.

Bolles, R. N. (1992). *What color is your parachute? A practical manual for job hunters and career changers,* (p. 167). Berkeley, CA: Ten Speed Press.

Davidsen, J. (2005). Back to business: Second 100 in *Interior Design.* Retrieved 10/20/2006 from www.interiordesign.net/id_article/CA626734/id?stt=001.

Davidsen, J., & Leung, W. (2006). Setting the pace: Top 100 in *Interior Design.* Retrieved 10/20/2006 from www.interiordesign.net/id_article/CA63-01962/id?stt=001.

Chapter 7

Doyle, A. (2005). Behavioral interview. About.com. Retrieved 8/12/06 from http://jobsearch.about.com/cs/interviews/a/behavioral.htm.

Peterson, T. (2005). The case interview. Monster.com. Retrieved 8/12/06 from http://interview.monster.com/articles/case%5Fstudy/.

Chapter 8

Pinsoy, L. (2004). *Anatomy of a business plan : A step-by-step guide to building a business and securing your company's future* (6th ed.). Kaplan Business

Small Business Administration. (2005). Writing the plan. Retrieved 8/12/06 from www.sba.gov/starting_business/planning/writingplan.html.

Tiffany, L. (2001). Elements of a Business Plan. www.entrepreneur.com/article/0,4621,287355-1,00.html.

Chapter 10

Ballast, D. (2006). *Interior design reference manual* (3rd ed.). Belmont, CA: Professional Publications.

McGowan, M., & Kruse, K. (2005). *Specifying interiors: A guide to construction and FF & E for residential and commercial interiors projects* (2nd ed.) Hoboken, NJ: Wiley.

Index

p. 8: Ted Poweski / Pearson Education/PH College
p. 11: © Judith Miller / Dorling Kindersley / Swann Galleries
p. 12: Michel Sima / Getty Images Inc. - Hulton Archive Photos
p. 38: Dennis MacDonald / PhotoEdit Inc.
p. 40: Pearson Education/PH College
p. 42: Ken Karp / Pearson Education/PH College
p. 46: © Dorling Kindersley
p. 47: Rob Crandall / The Image Works
p. 49: Alan Keohane © Dorling Kindersley
p. 50: Anthony Magnacca / Merrill Education
p. 51: Photolibrary.com
p. 62: Laimute E. Druskis / Pearson Education/PH College
p. 64: Laimute Druskis / Pearson Education/PH College
p. 67: Alan Keohane © Dorling Kindersley
p. 68: Sergio Piumatti
p. 70: Andy Crawford © Dorling Kindersley, Courtesy of the Silicongraphics, Reading
p. 71: Carroll Seghers 2 / The Stock Connection
p. 72: Max Alexander © Dorling Kindersley
p. 73: Laimute E. Druskis / Pearson Education/PH College
p. 75: Peter Anderson © Dorling Kindersley
p. 76: Peter Anderson © Dorling Kindersley
p. 78: Matthew Ward © Dorling Kindersley
p. 79: Jake Fitzjones © Dorling Kindersley
p. 81: Irene Springer / Pearson Education/PH College
p. 82: © Dorling Kindersley
p. 83: Pearson Education Corporate Digital Archive
p. 84: Joe Carini / PacificStock.com
p. 86: Brady / Pearson Education/PH College
p. 90: Carol Wiley © Dorling Kindersley
p. 91: Mike Peters / Pearson Education Corporate Digital Archive
p. 92: Nigel Hicks © Dorling Kindersley
p. 93: Demetrio Carrasco © Dorling Kindersley, Courtesy of the Himeji Castle, Donjon, Japan
p. 94: John Serafin

p. 95 (top): Teri Leigh Stratford / Pearson Education/PH College. Courtesy The Associated Blind Inc., 135 W. 23rd Street, New York, NY 10011

p. 95 (bottom): Scott Cunningham / Merrill Education

p. 96: Laima Druskis / Pearson Education/PH College

p. 104: Cosmo Condina / The Stock Connection

p. 106: Gep / Getty Images Inc. - Hulton Archive Photos

p. 109: UPI, Corbis/Bettmann

p. 124: M Stock / The Stock Connection

p. 134: Jochen Tack / Das Fotoarchivl / Peter Arnold, Inc.

p. 135: Peter Wilson © Dorling Kindersley

p. 136: Tony Souter © Dorling Kindersley

p. 137: Peter Anderson © Dorling Kindersley

p. 140: Bruce Forster © Dorling Kindersley

p. 141: John Heseltine © Dorling Kindersley

p. 142: Photolibrary.com

p. 148: Robin L. Sachs / PhotoEdit Inc.

p. 152: David Young-Wolff / PhotoEdit Inc.

p. 160: © Dorling Kindersley

p. 162: Library of Congress

p. 166: Tony Savino / The Image Works

p. 175: Andreas Pollok / Getty Images Inc. - Stone Allstock

p. 177: Michael Newman / PhotoEdit Inc.

p. 179: John Coletti / Allyn & Bacon

p. 182: Getty Images - Digital Vision

p. 183: DK Images / Lindsey Stock

p. 185: © Dorling Kindersley

p. 187: Rafael Macia / Getty Images Inc. - Hulton Archive Photos

p. 189: Frank LaBua / Pearson Education/PH College

p. 191 (left): Andy Crawford © Dorling Kindersley

p. 191 (right): © Dorling Kindersley

p. 192: David Young-Wolff / PhotoEdit Inc.

p. 194: Alan Evrard / Robert Harding World Imagery

p. 195: Harry Mole / Alamy Images

p. 205: © Dorling Kindersley

p. 209: Susan Van Etten / PhotoEdit Inc.

p. 211: Brady / Pearson Education/PH College

p. 212: Steve Gorton © Dorling Kindersley

p. 213: © Dorling Kindersley

p. 215: Laimute E. Druskis / Pearson Education/PH College

p. 216: AP Wide World Photos

p. 219: Stan Wakefield / Pearson Education/PH College

p. 221: Robert Pham / Pearson Education/PH College